Going to the Dogs

Neel Muller

Copyright © 2013 by Neel Muller

All rights reserved.

The use of any part of this publication reproduced, transmitted in any form or by any means, electronic, mechanical, photocopying, recording or otherwise stored in a retrieval system, without the express written consent of the publisher, is an infringement of the copyright laws.

First published in the USA by

SULBY HALL PUBLISHERS

Malibu

California

Artwork and words by Neel Muller.

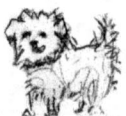

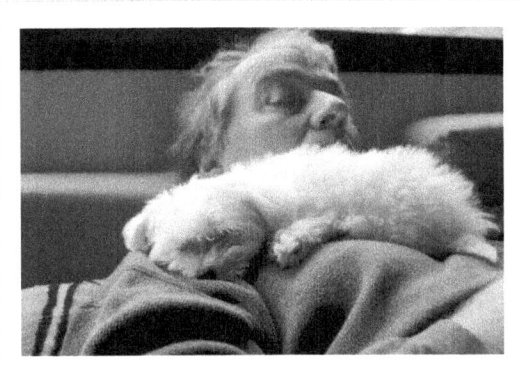 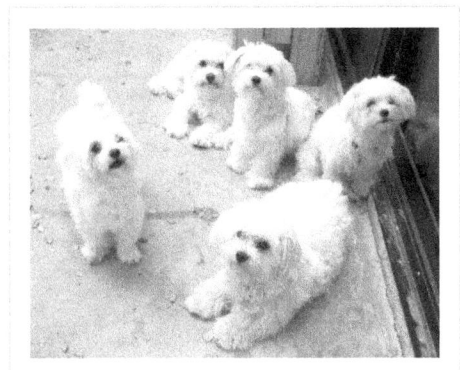

I've been drawing as long as I can remember. In high school I was constantly in trouble for drawing instead of studying.

Eventually, I became an art director in the advertising industry, working at many ad agencies in South Africa, England and here in Los Angeles. My drawing skills came in very handy at work, especially before the days of the computer. I was able to quickly sketch out storyboards and ad ideas for presentations. So, my drawing ability was a tool I used at work every day. Often, when I changed jobs, I would pretend I couldn't draw because I'd end up having to do everyone else's drawings.

Some years ago I started drawing for the sheer joy of it. Sort of like when I was at school, but thankfully without getting into too much trouble.

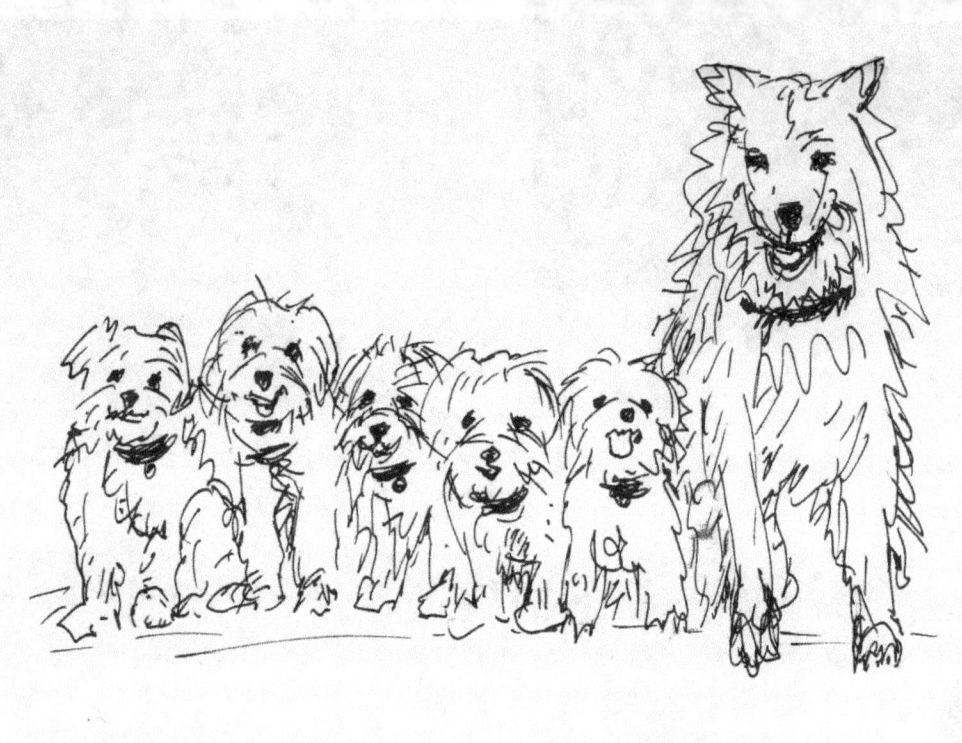

From left to right:
Mister Facky, Portnifoy, Mamalodie, Elodie, Lilyone and Luther.

These are all of my dogs who you will meet on these pages.

I have six dogs who give me endless joy: five Malteses and one Retriever/Chow mix called Luther.

When things in life go haywire and nothing makes sense, I go to my dogs, and within minutes, all seems well.

Our animals make us better people and show us what unconditional love really is.

Here are some of my dog drawings to help you get through the day without losing your mind.

Hope you enjoy.

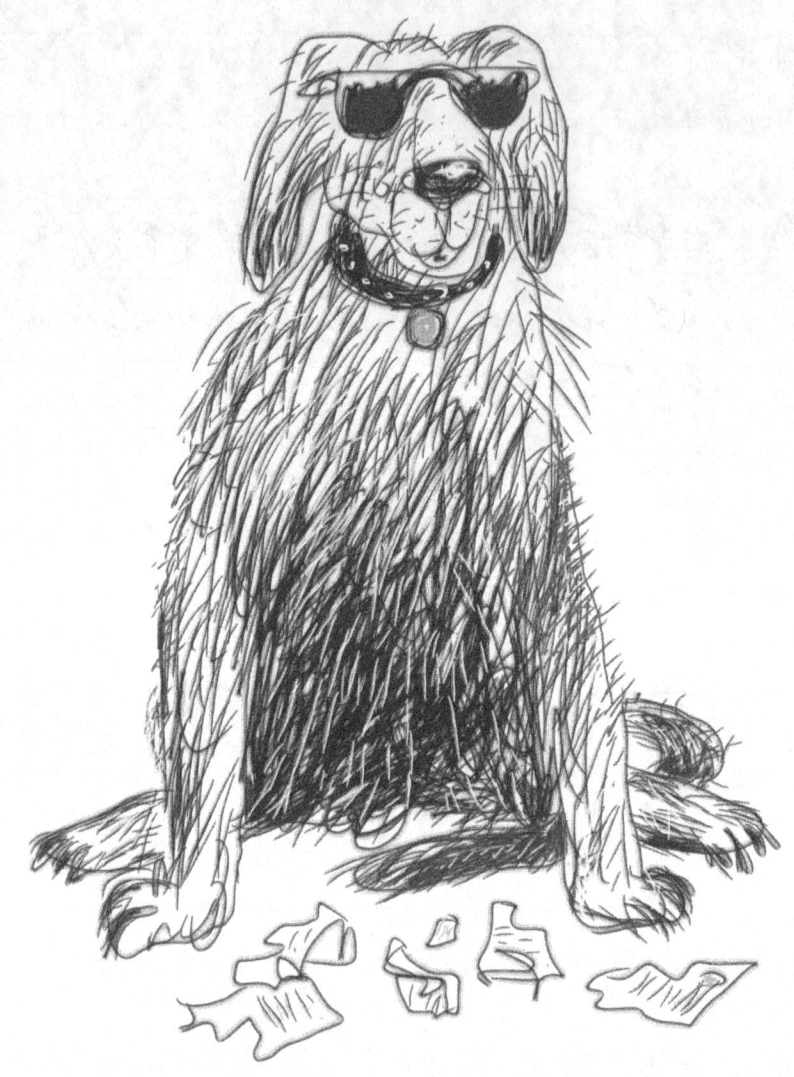

A chewer.

Prefers chewing on important mail.

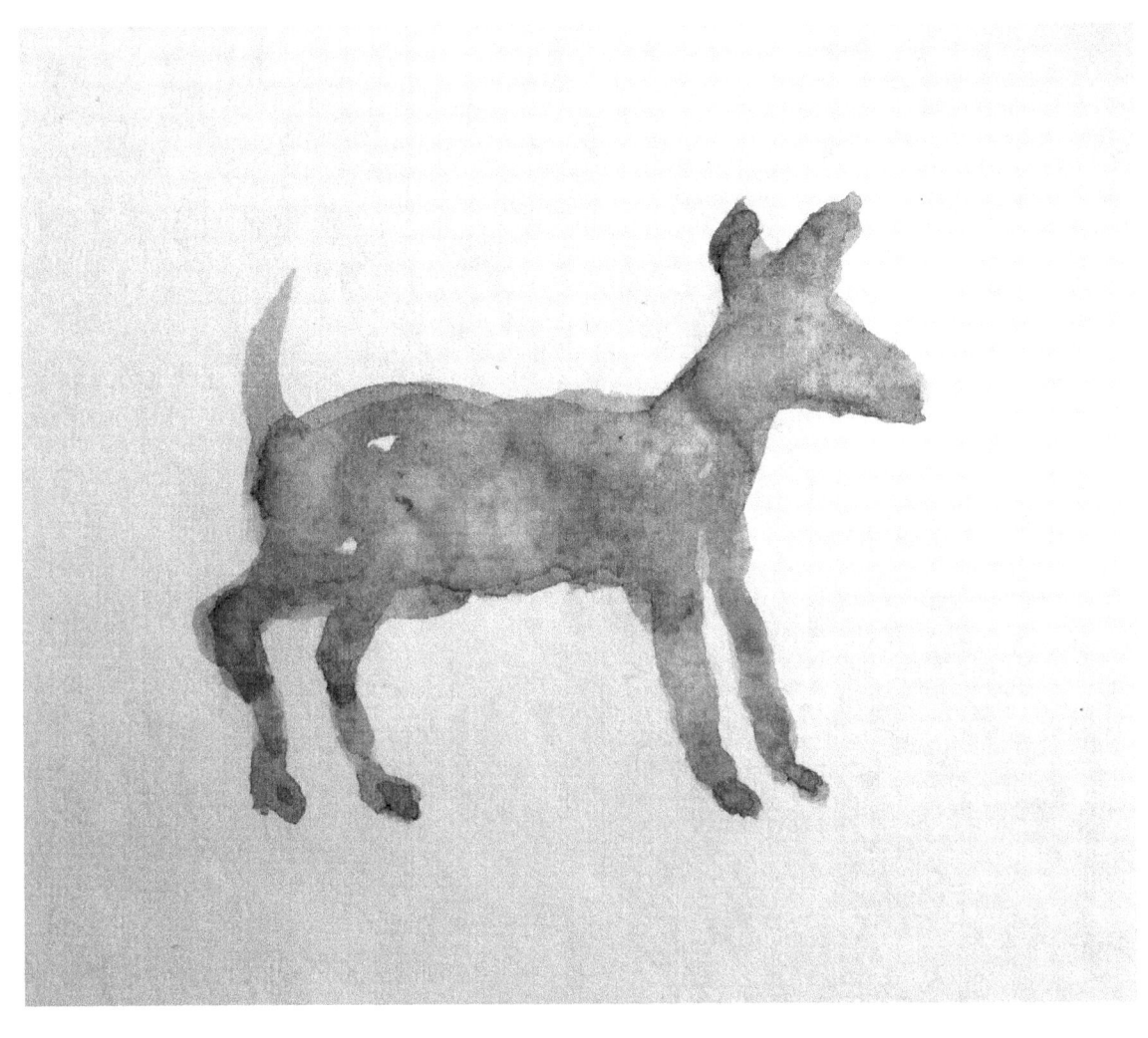

Grey hound.

He's extremely colorful regardless of his greyness.

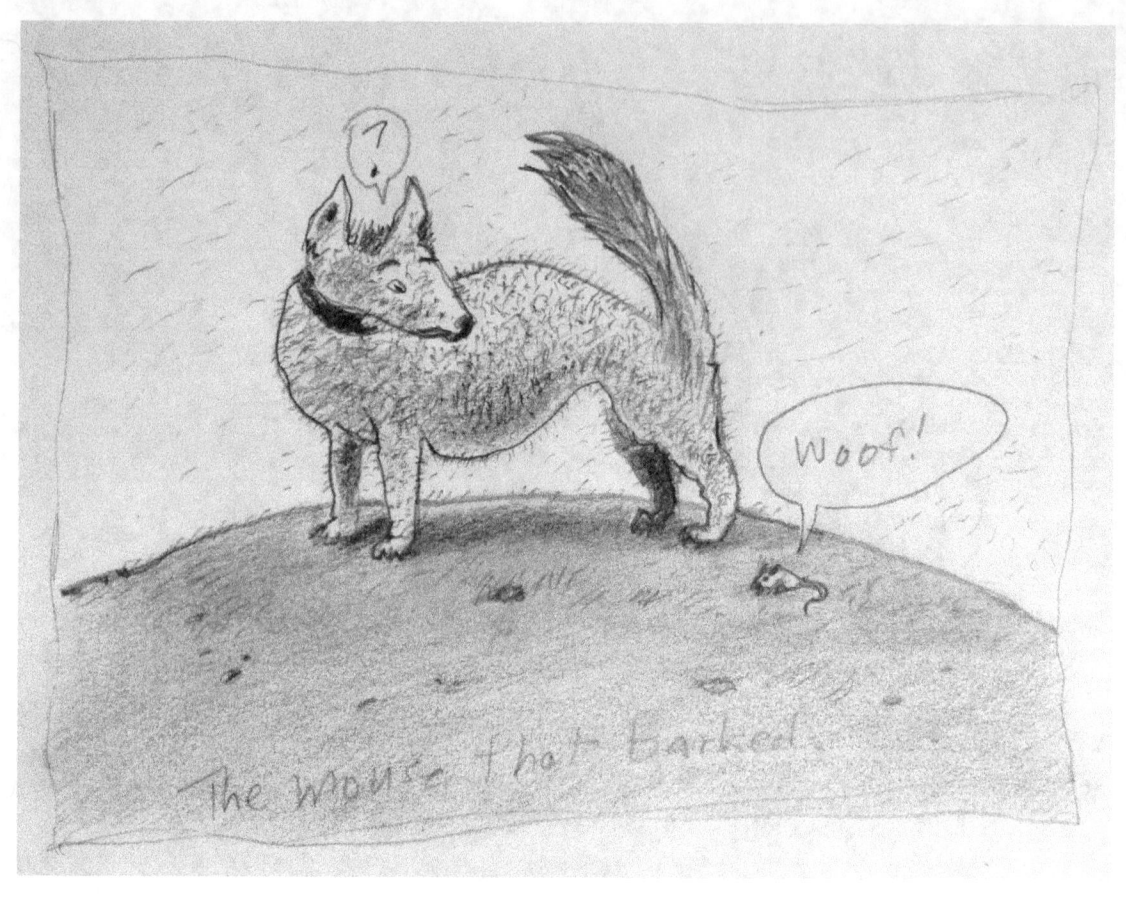

The mouse that barked.

This dog was going to bark, but when the mouse barked, everything changed.

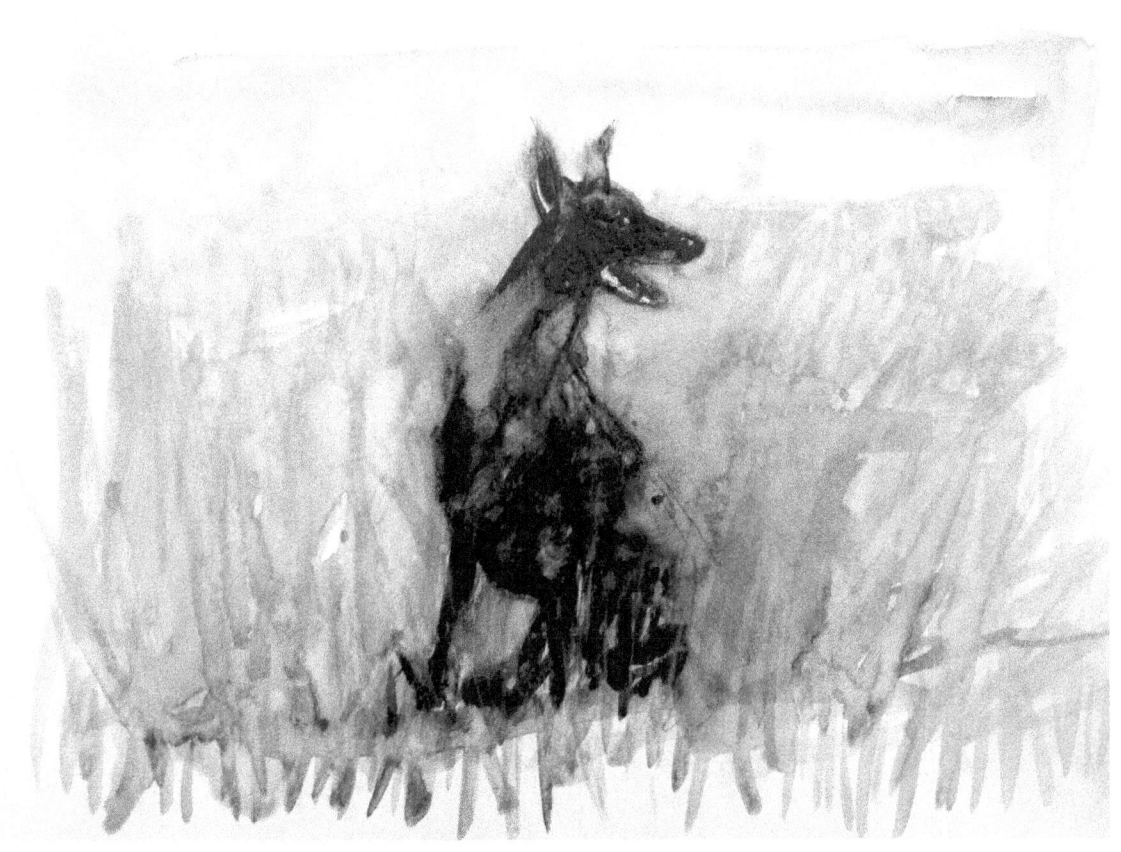

Chaka.

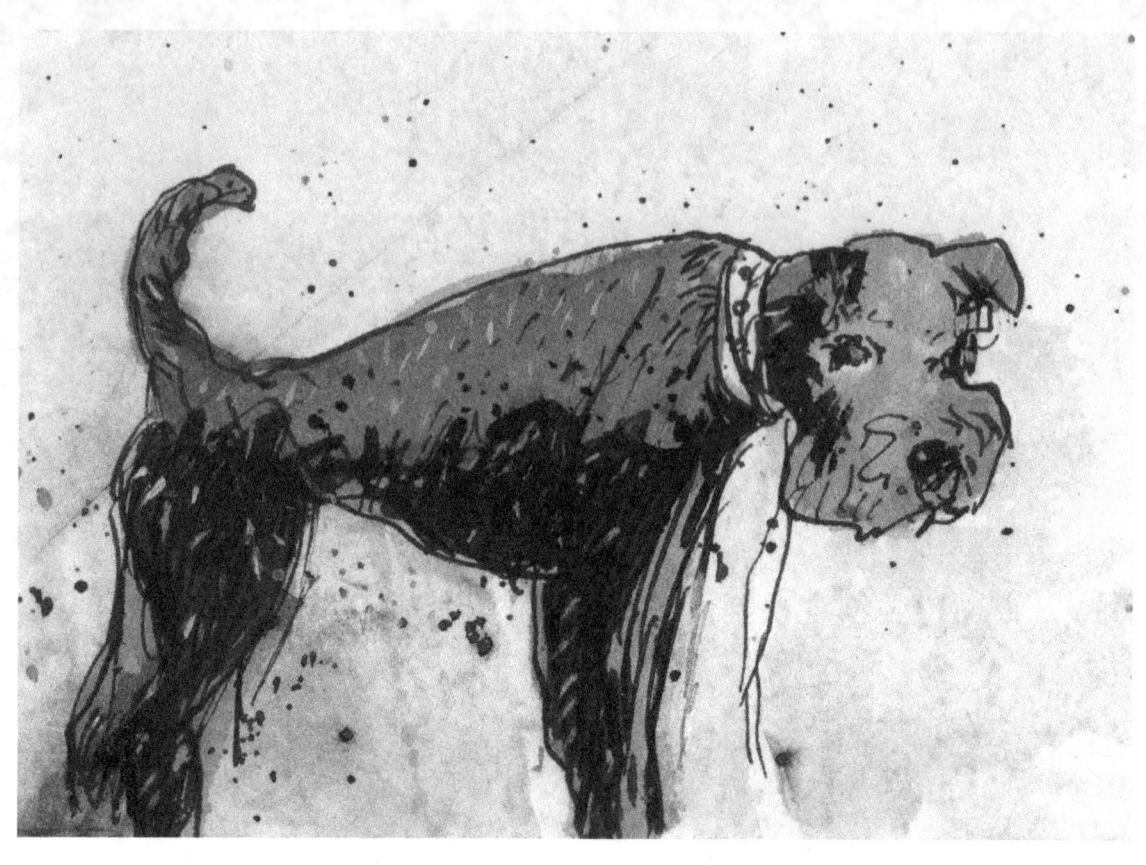

Slightly fed-up dog, needs a break from the hum - drum.

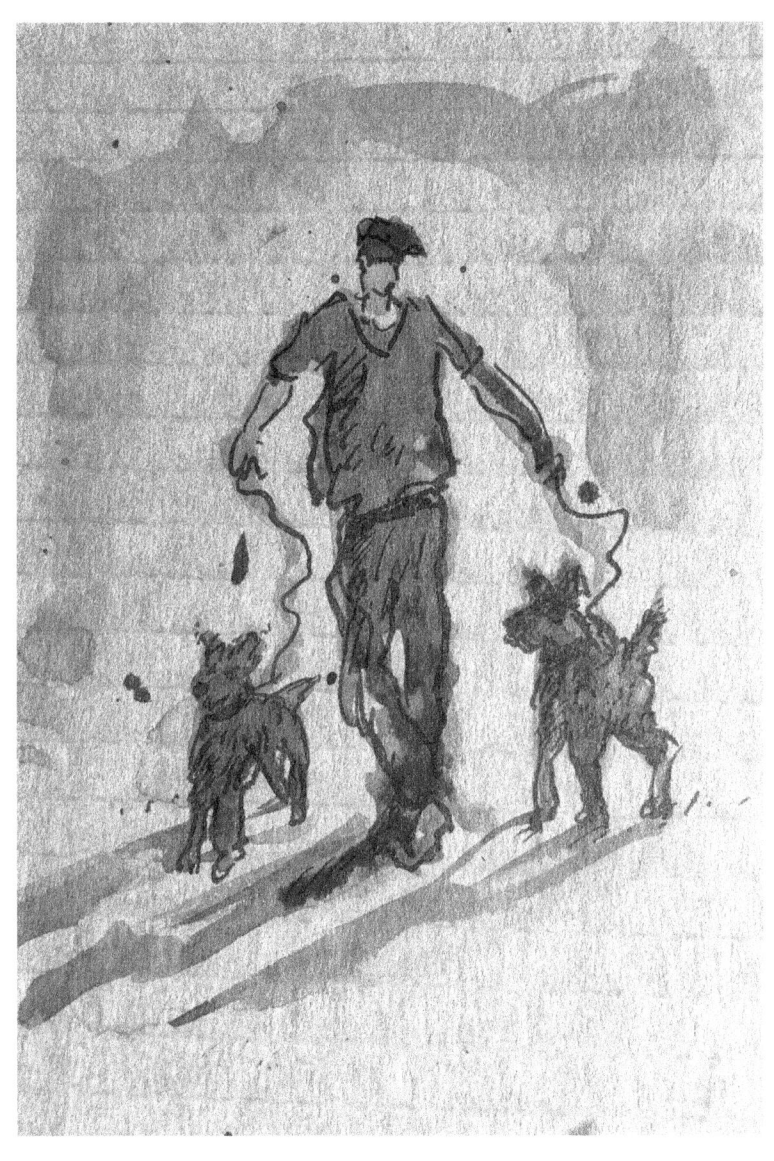

*The more we walk,
the less we bark.*

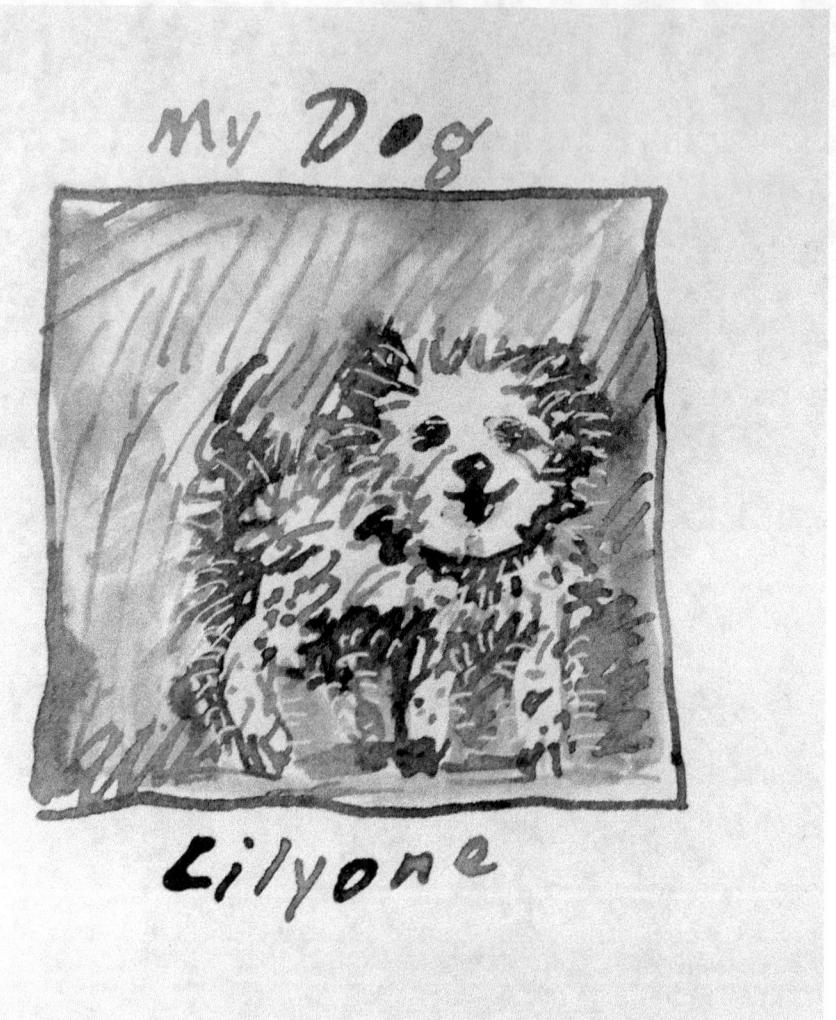

Lilyone.

The smallest and the smartest.
She was born legs first.

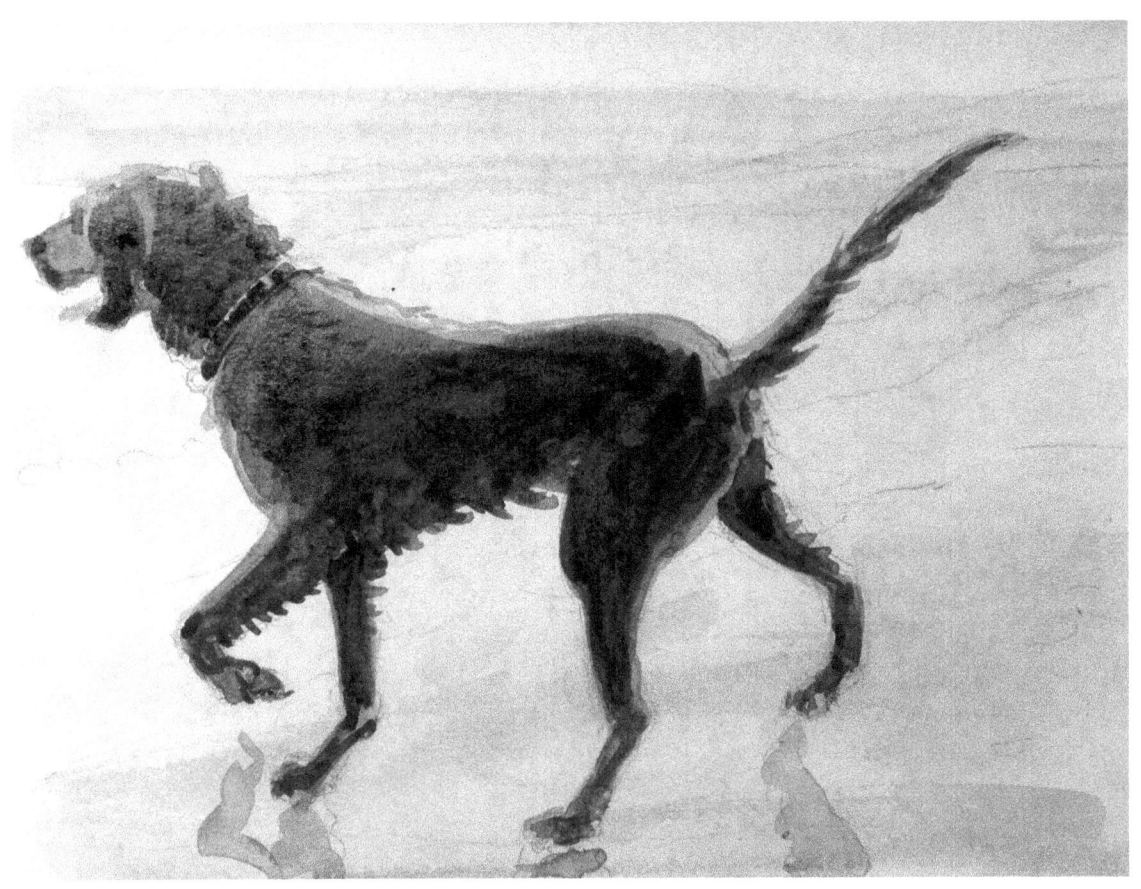

Rough 'n ready Rosie on the beach.

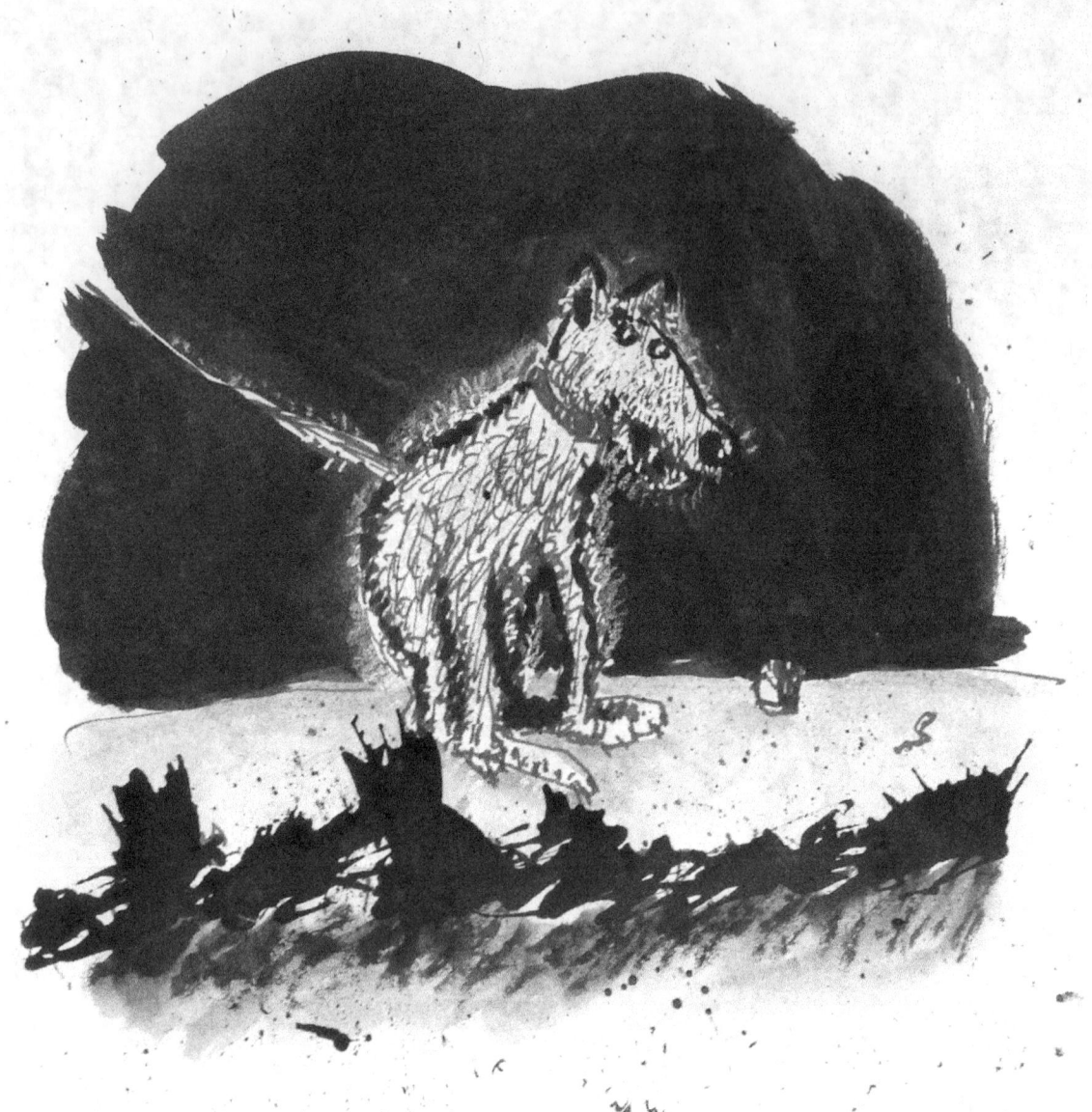

Extremely ugly dog but extremely lovable.

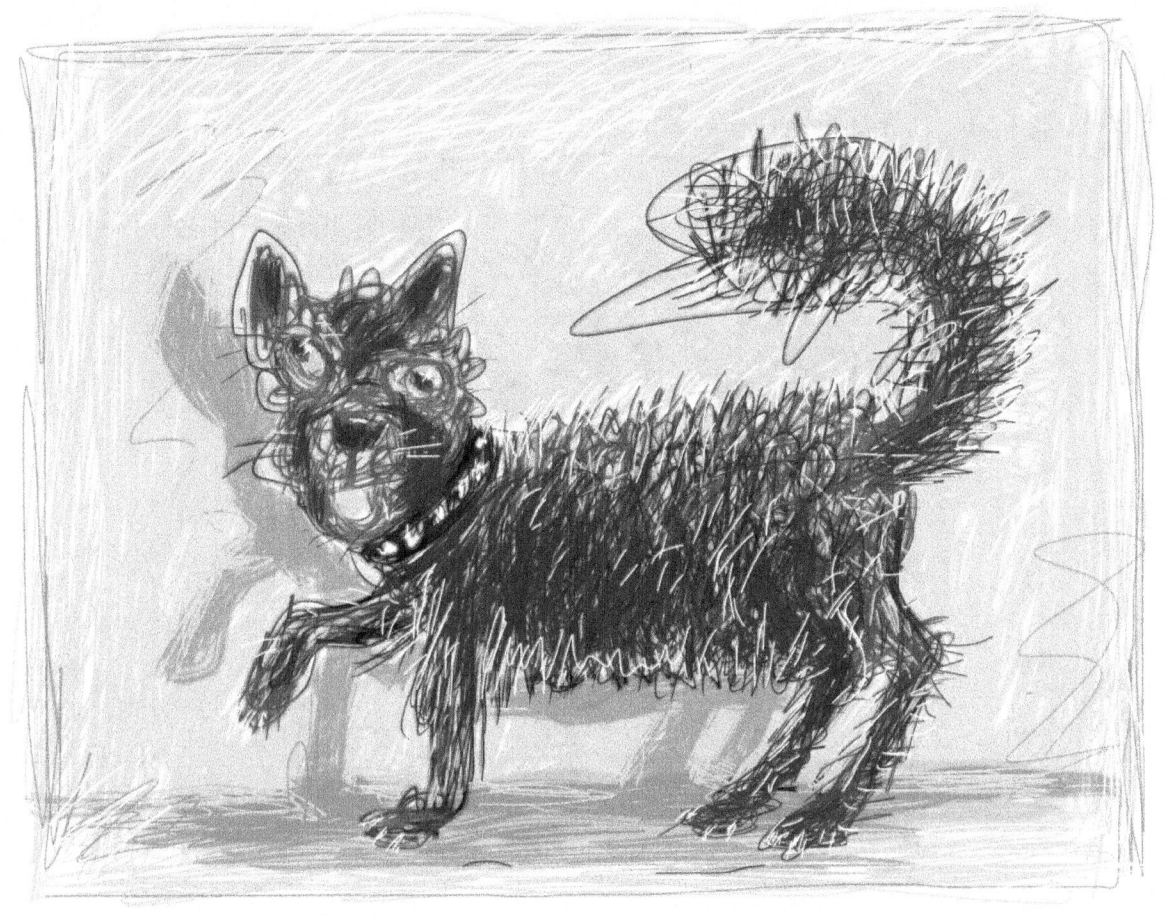

Lazy-eyed dog.

Yes, she has a lazy eye,
but she's not a lazy dog.
Just look at her body language.
Is that a lazy dog? No.

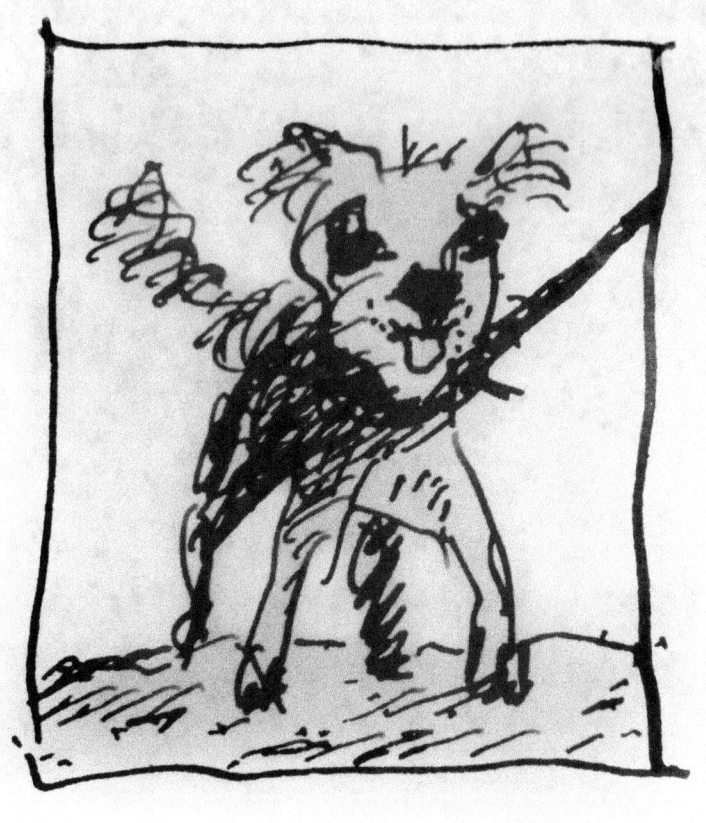

"It's not the size of the dog in the fight, it's the size of the fight in the dog."

— Mark Twain

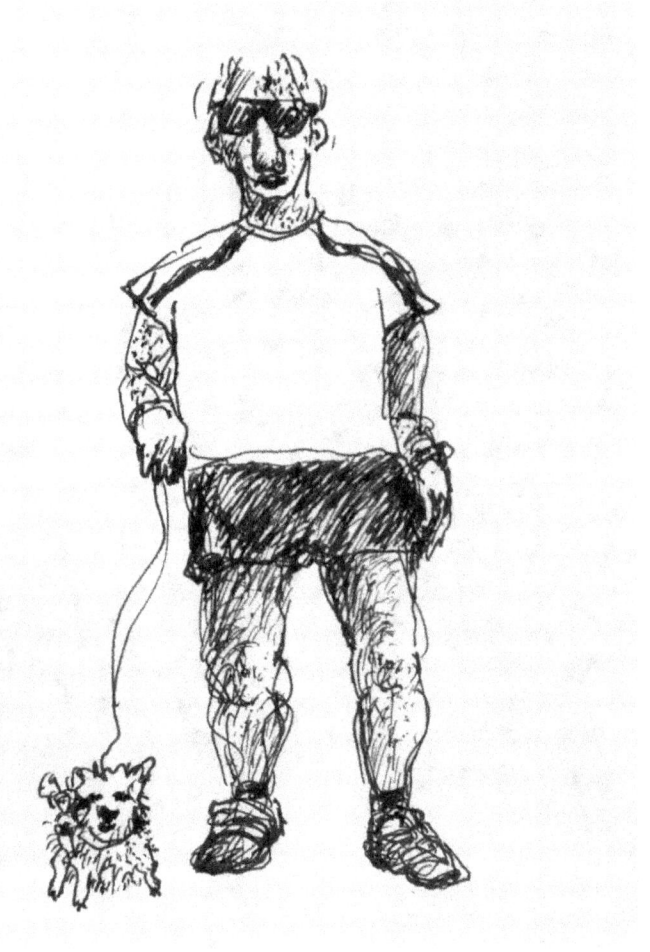

Tasteless tourist with companion.

Wondering if they should have stayed at home.

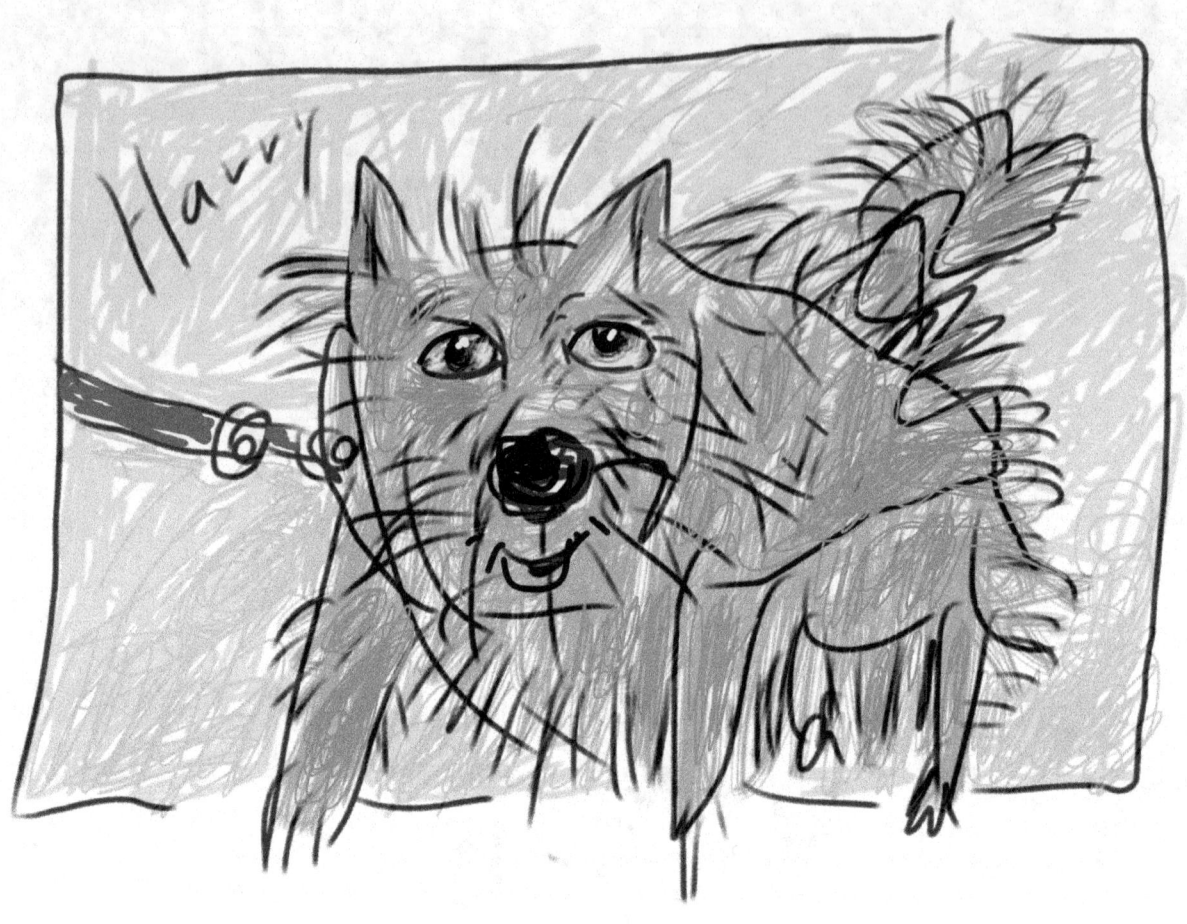

Harry.

Met him in France.
Doesn't speak a word of French
because he's British.

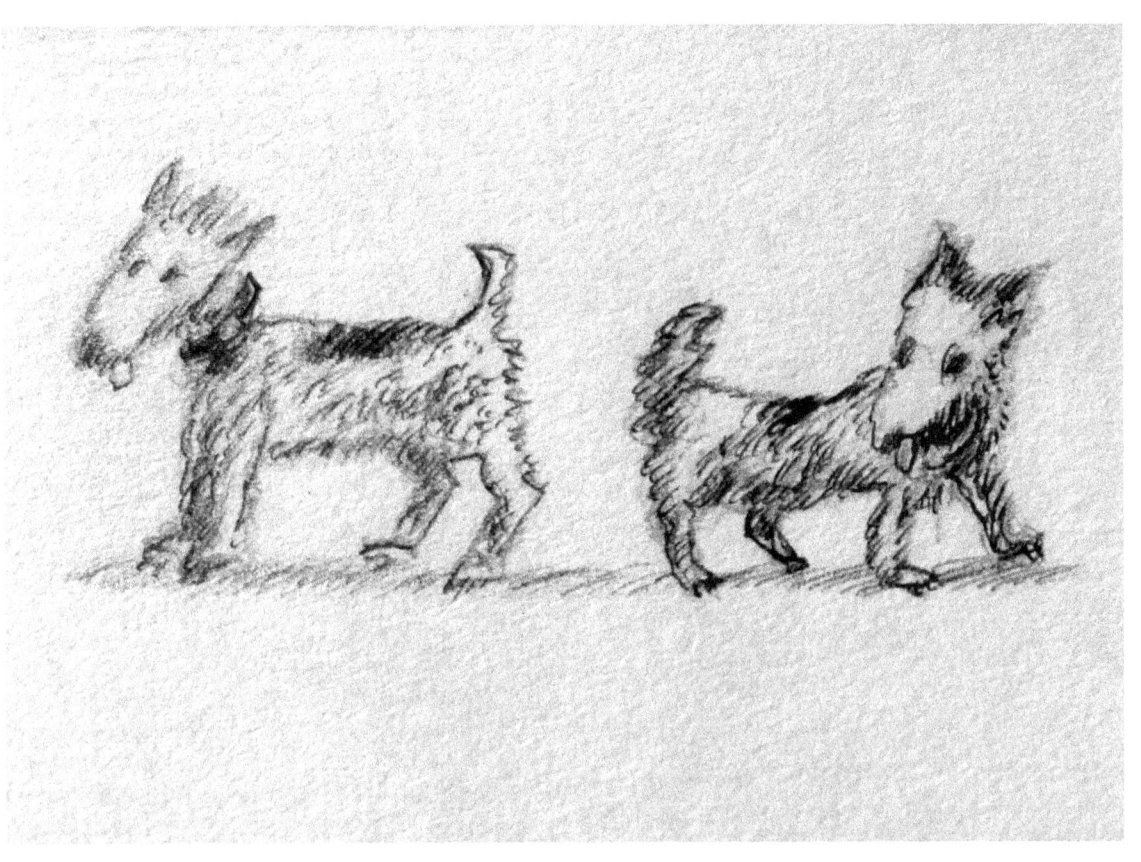

Matching French dogs

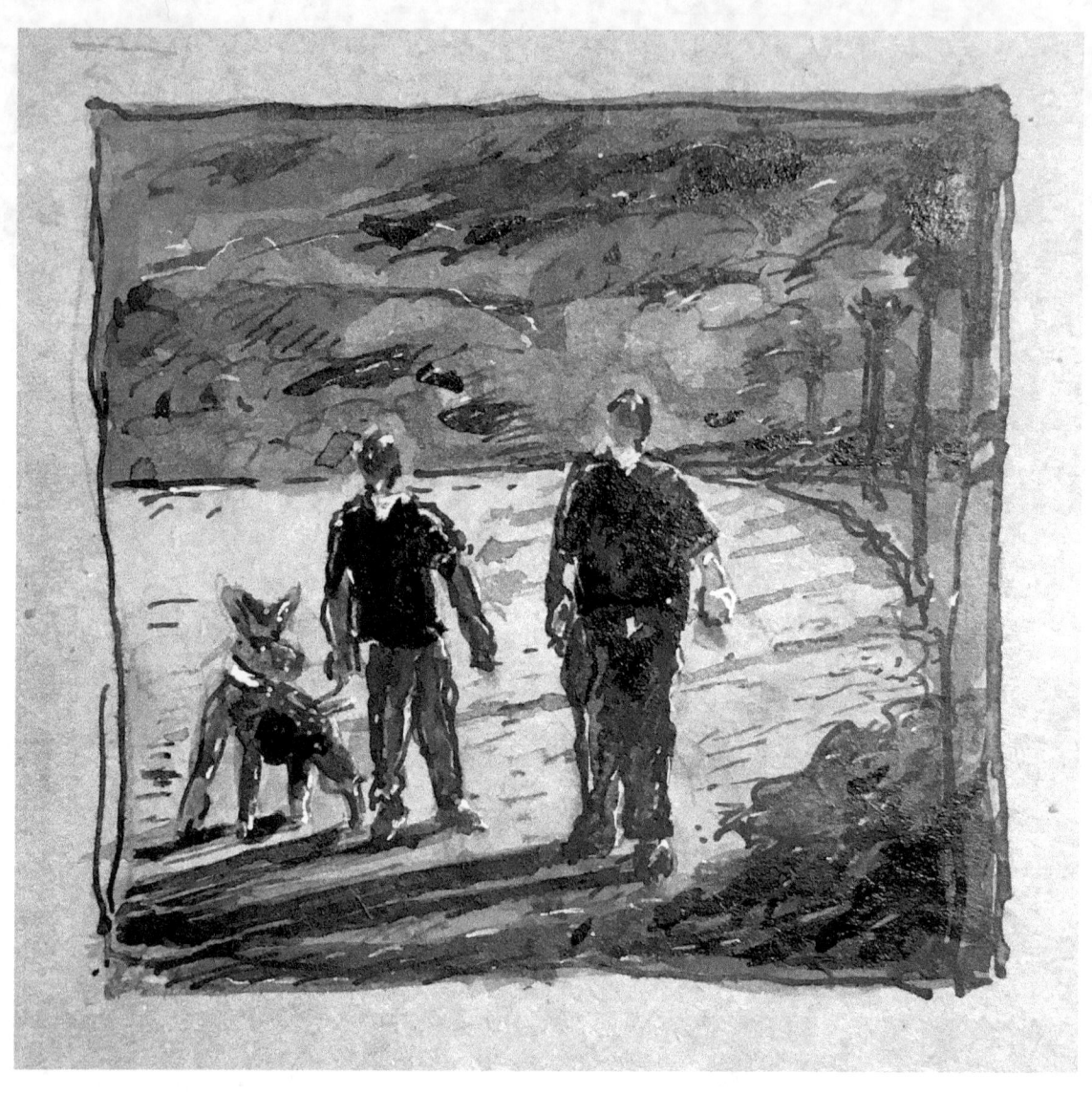

Taking some humans for a stroll.

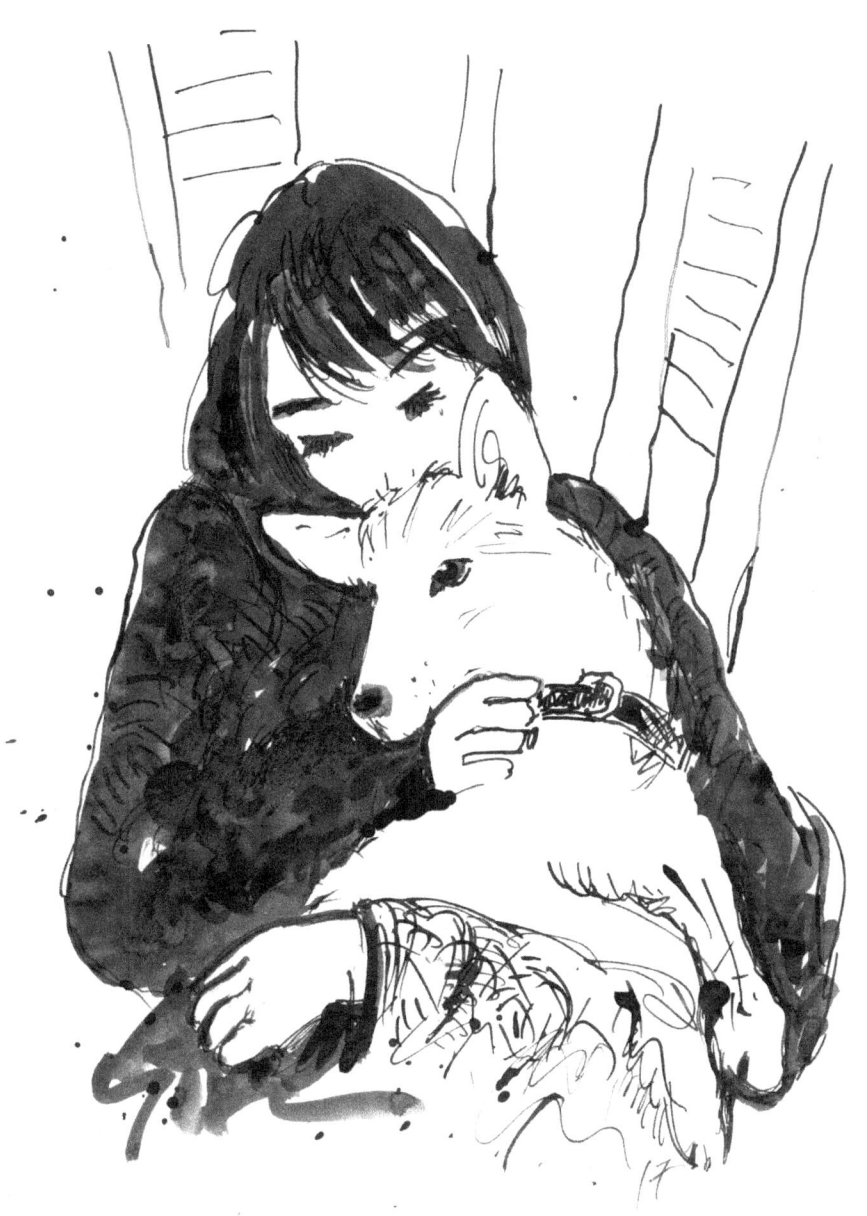

Tender moment with Mojave.

Portnifoy.

He's a little embarrassed by his size, so we won't mention it.

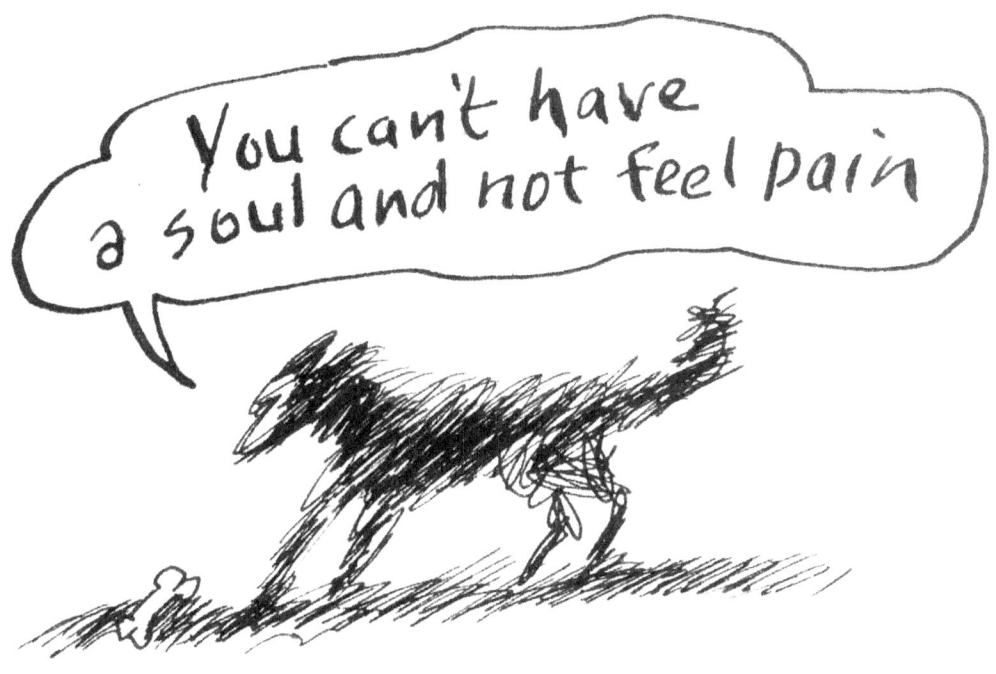

Profound hound.

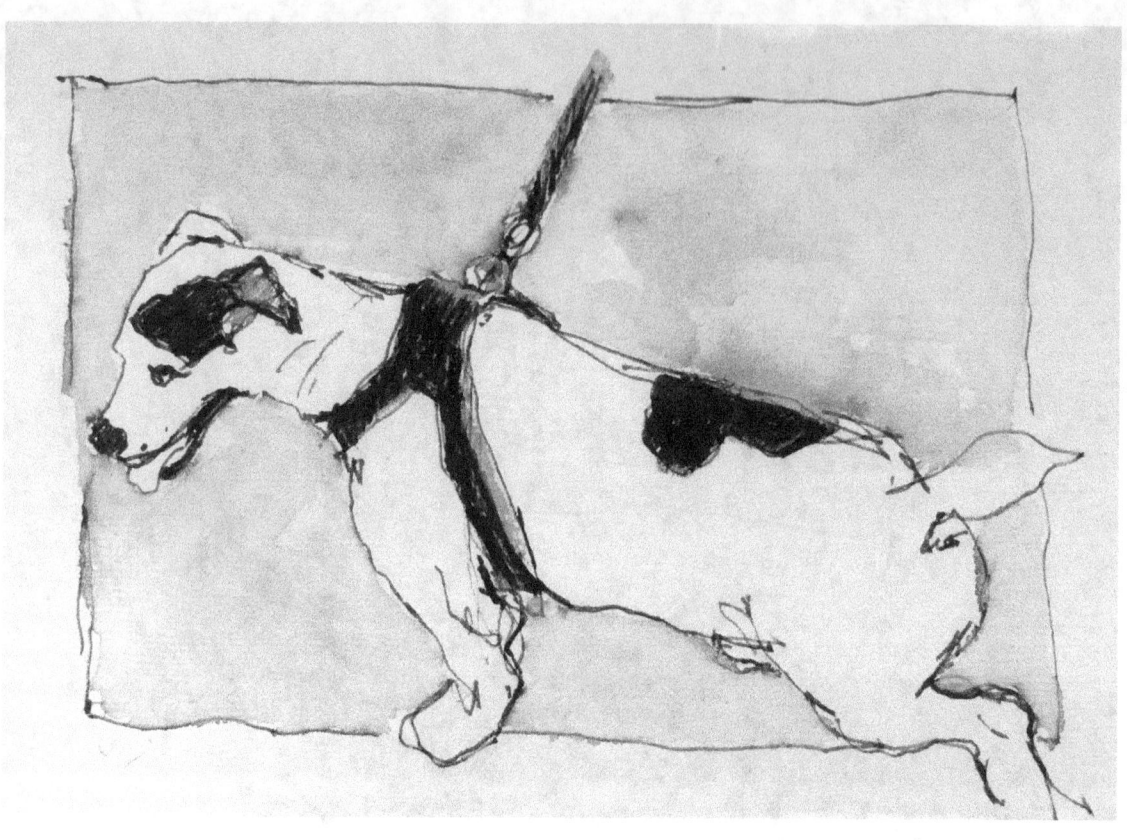

Bull Terrier.

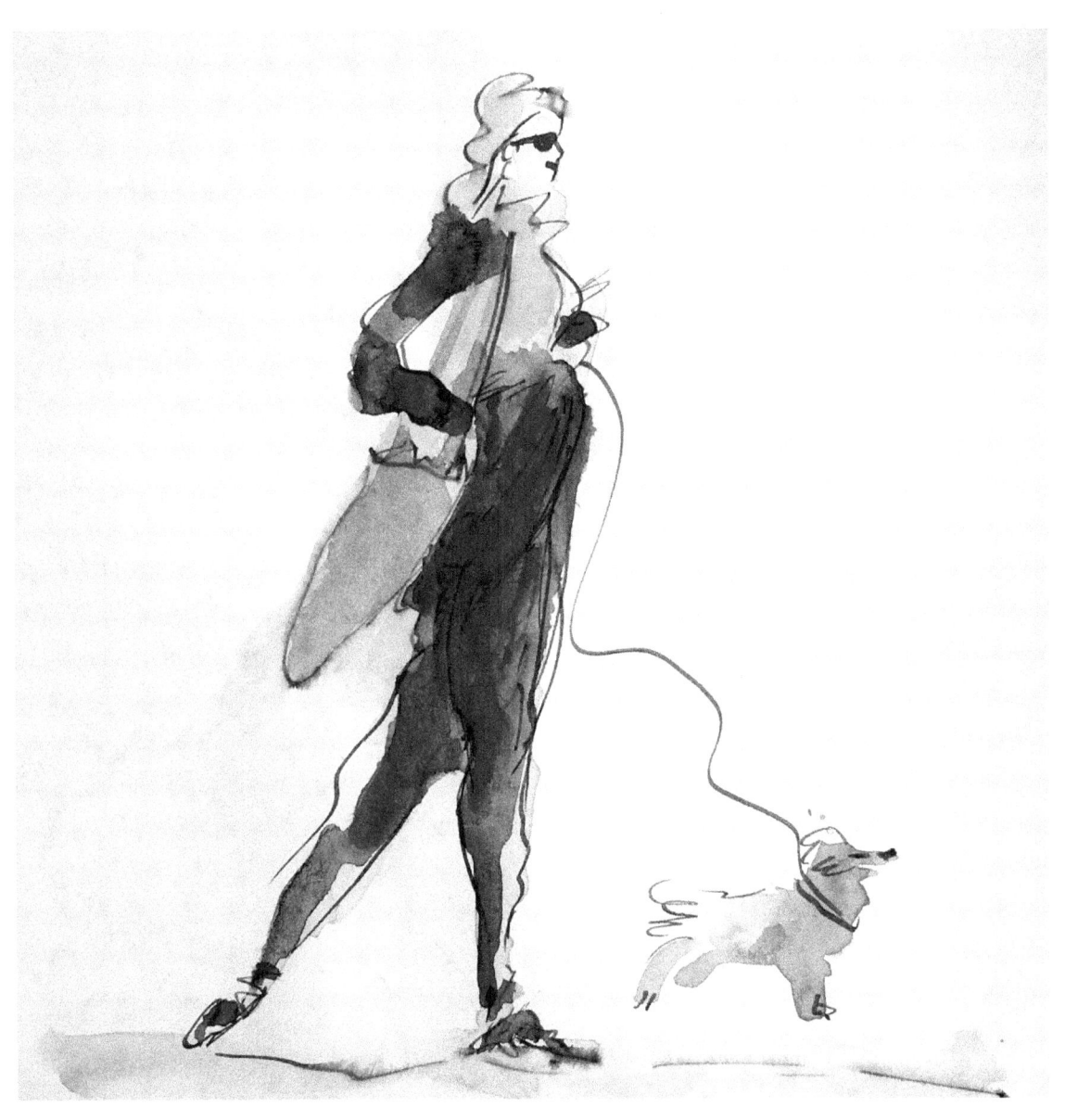

Will he be allowed into Starbucks? That is the question.

Mister Facky.

Father of the family.
(But not really a family man.)

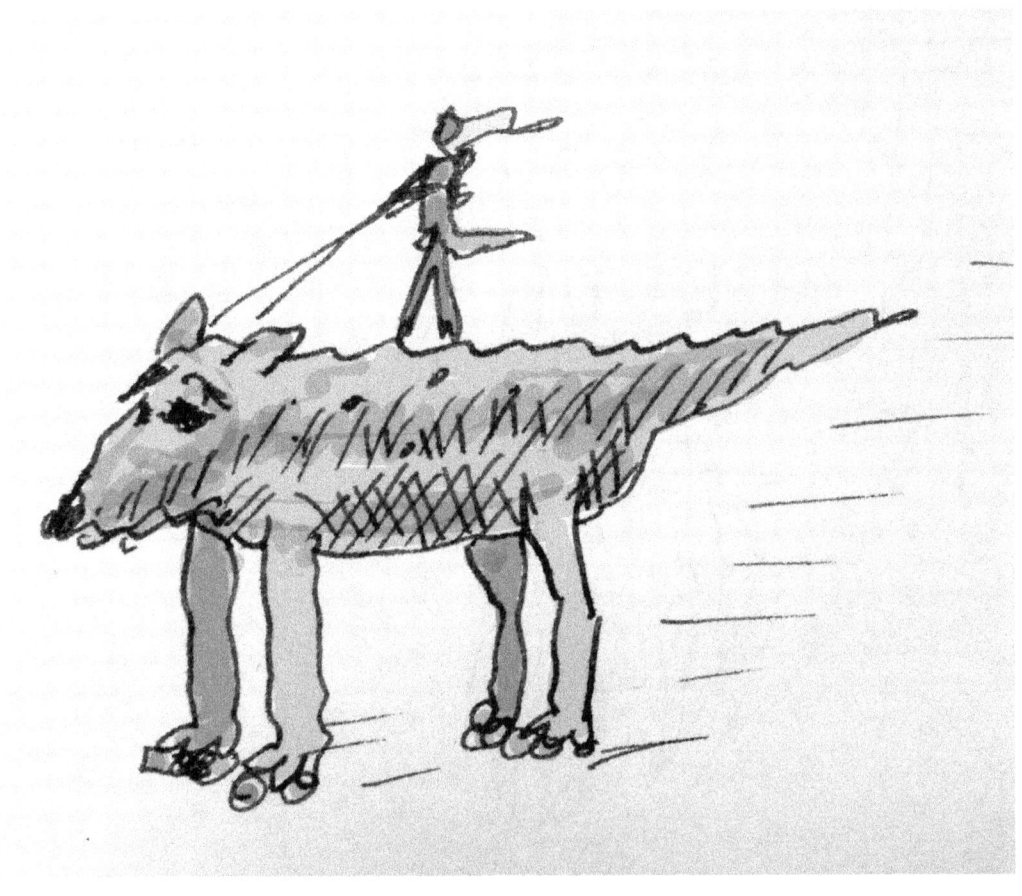

Roller-skating dog.

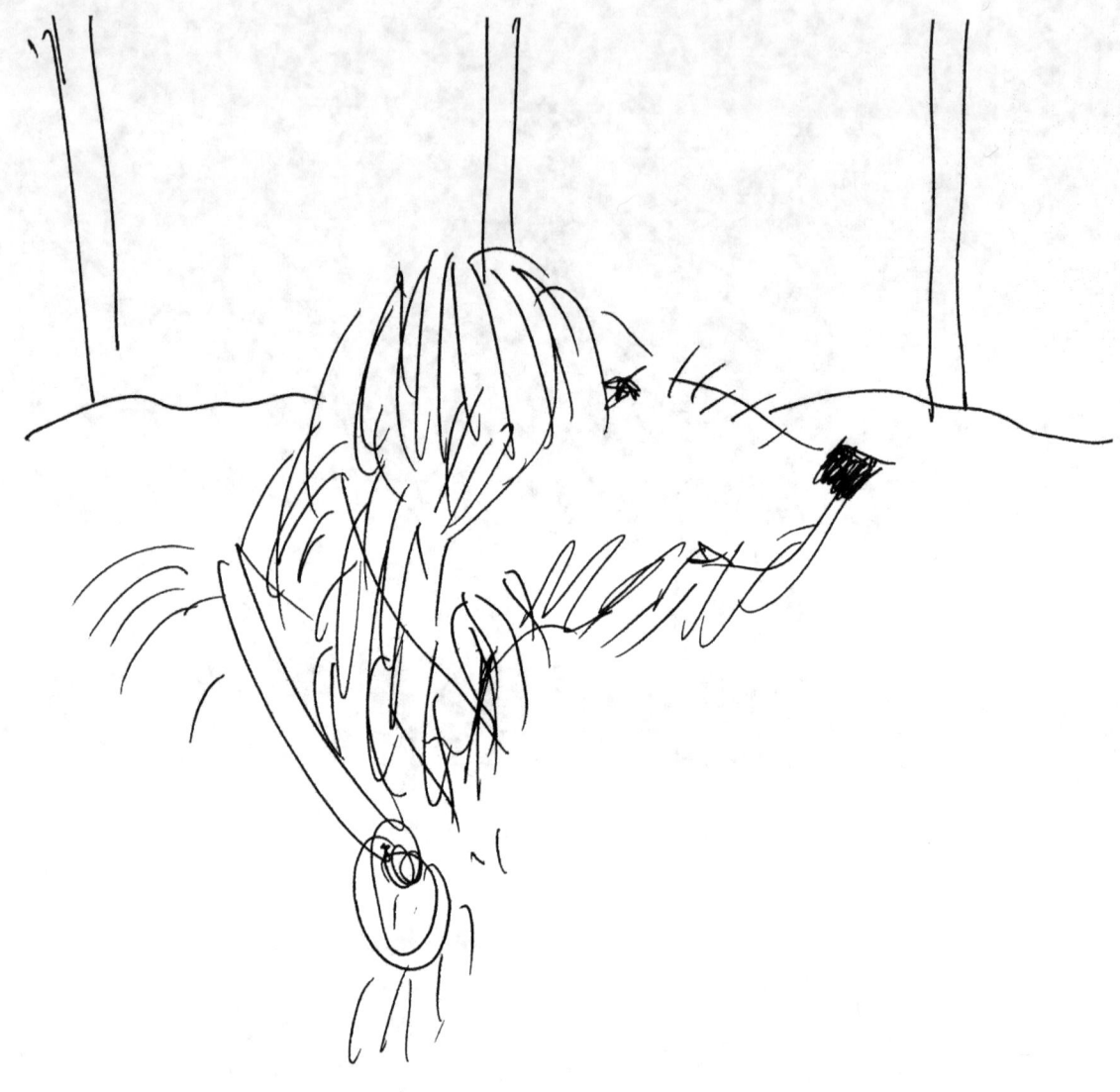

Mamelodie.
She cleans all of our faces
in the morning.

Gumdrop eyes and nose.

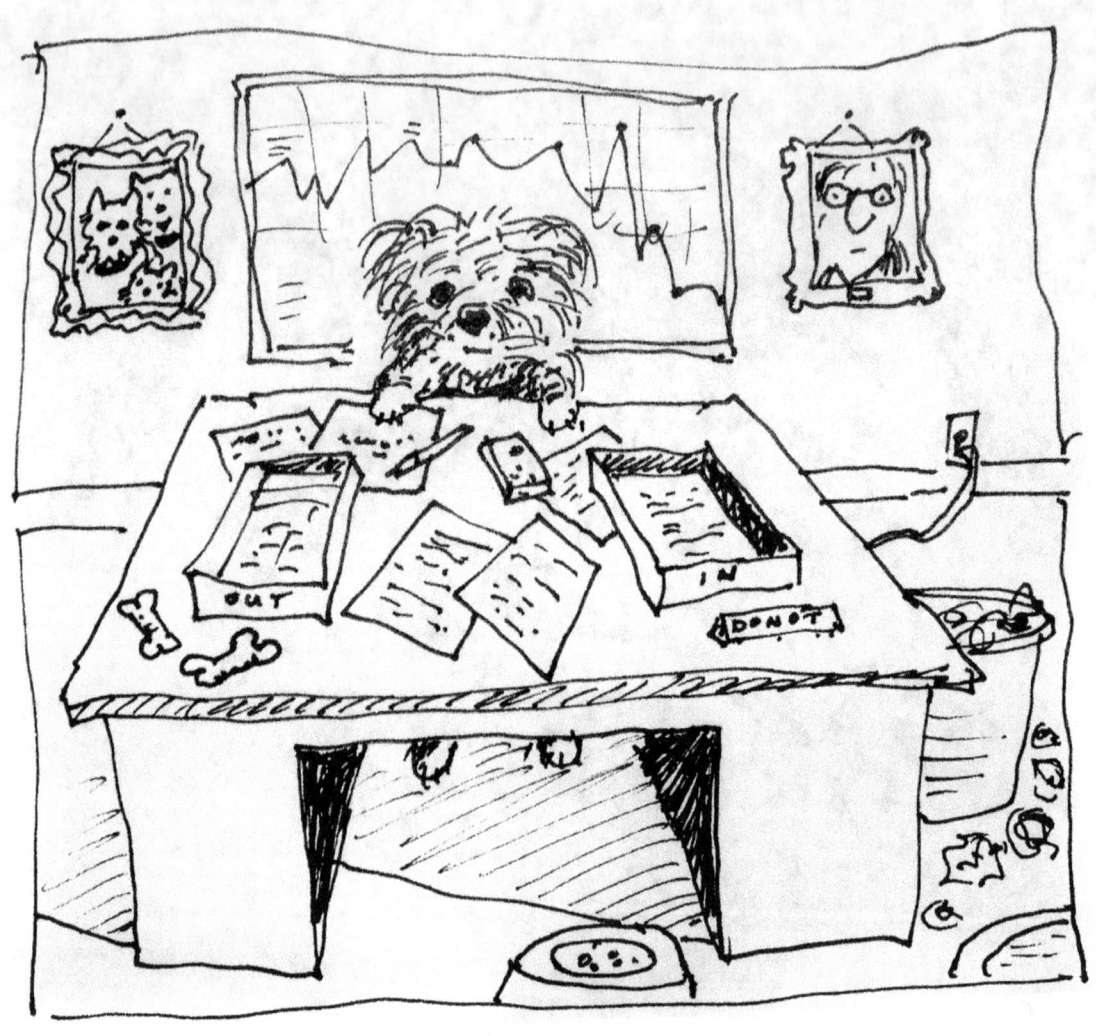

Working dog.

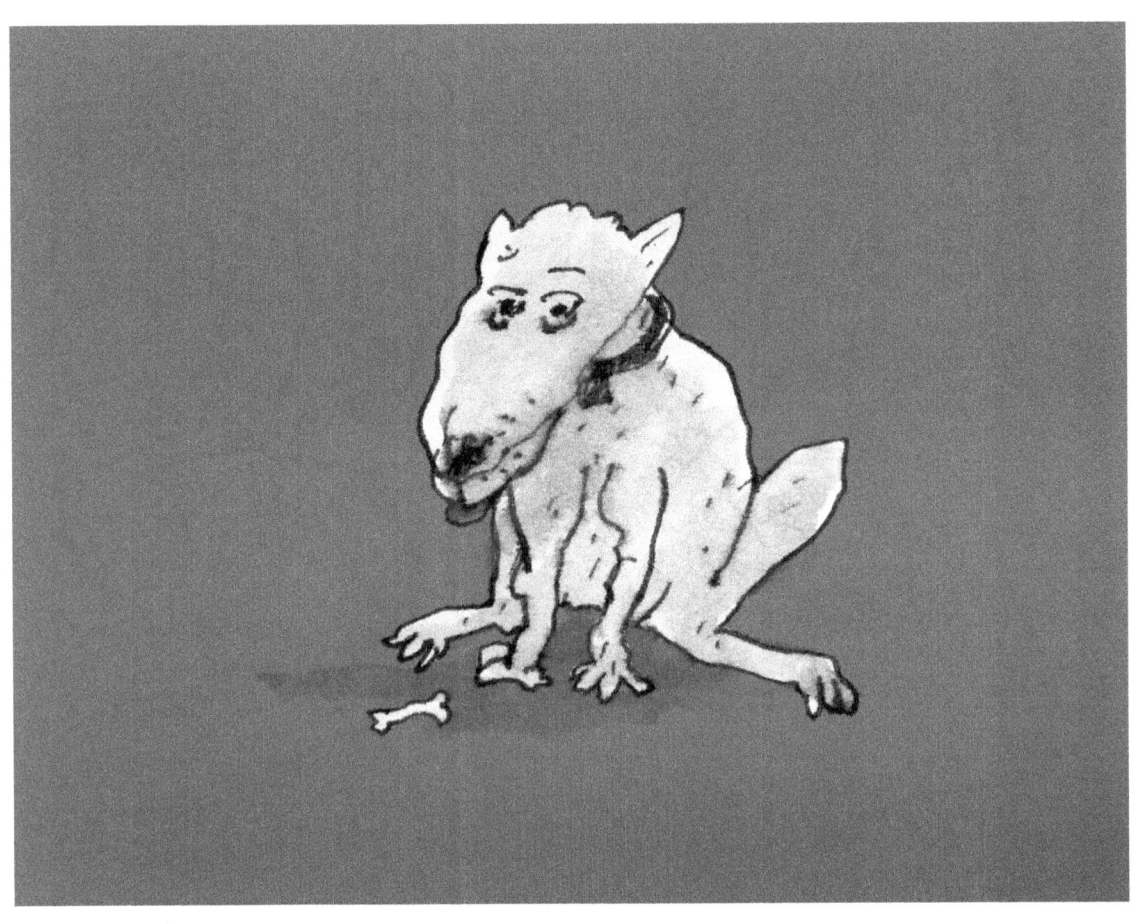

Enjoying the little
things in life.

Bedbug.

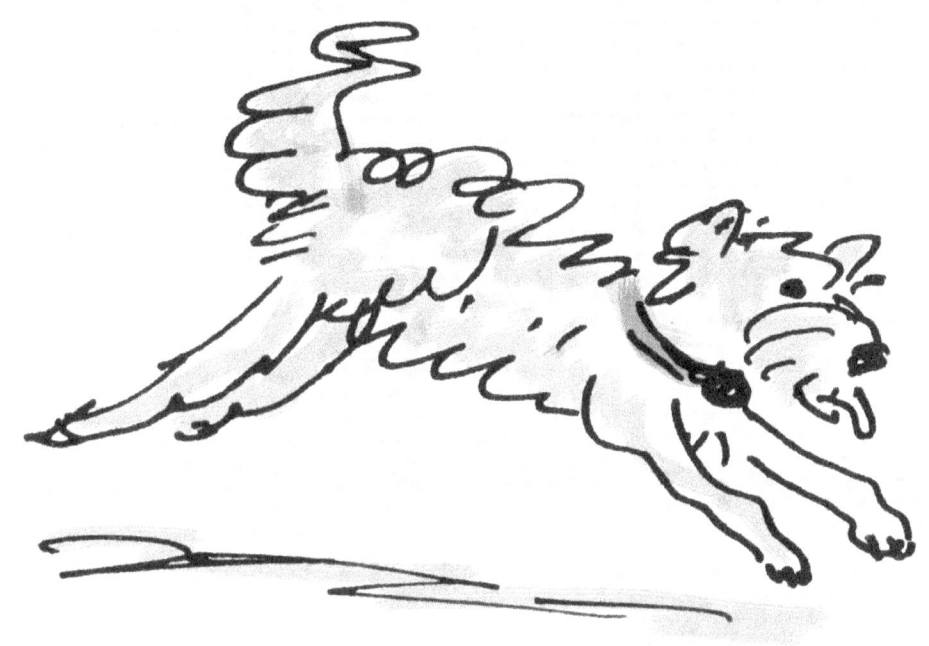

Decathlon Don.

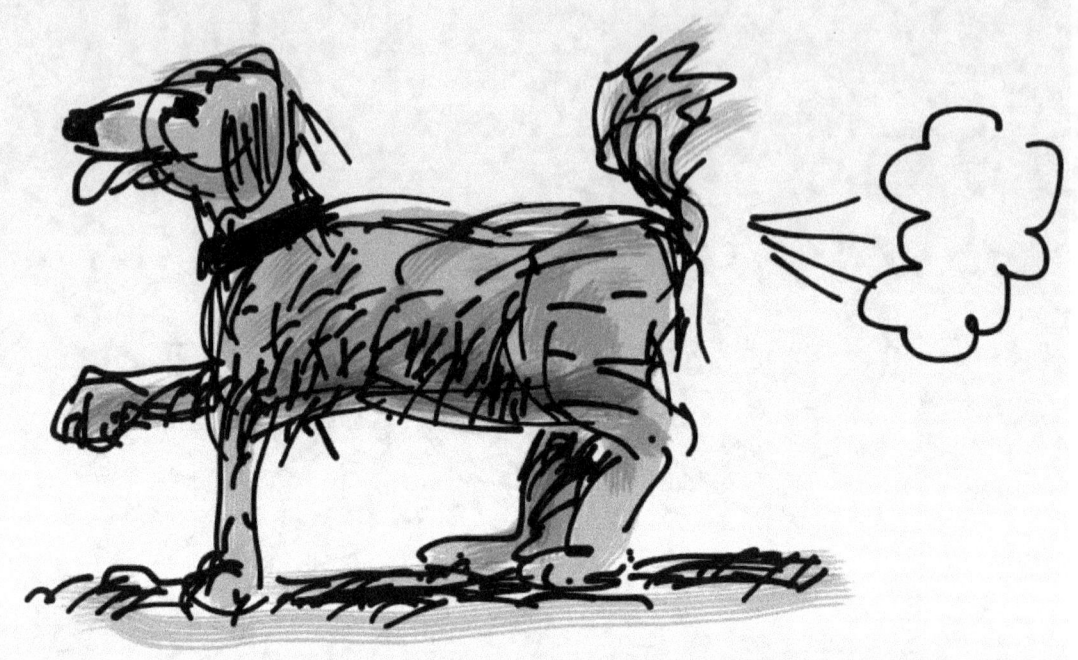

Smelly Bennie.

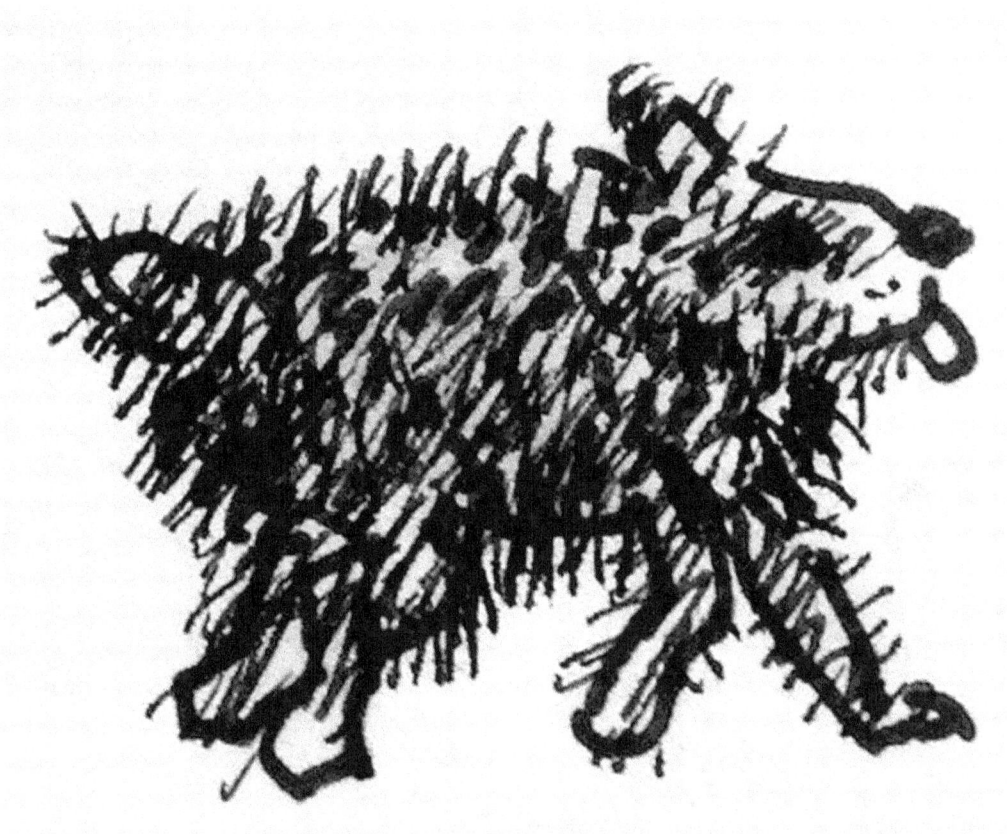

Quite a hairy dog
and he does shed.

Downhill facing dog.

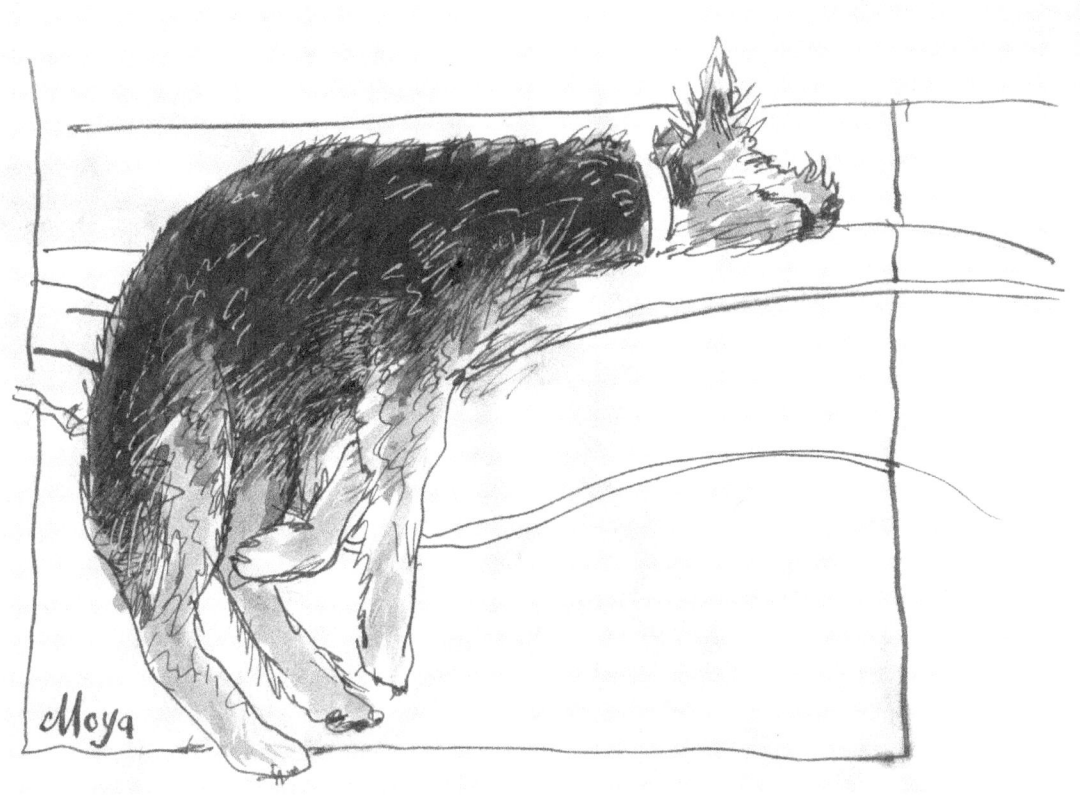

Restless leg syndrome.

Three Dogs and two humans on a phone bill.

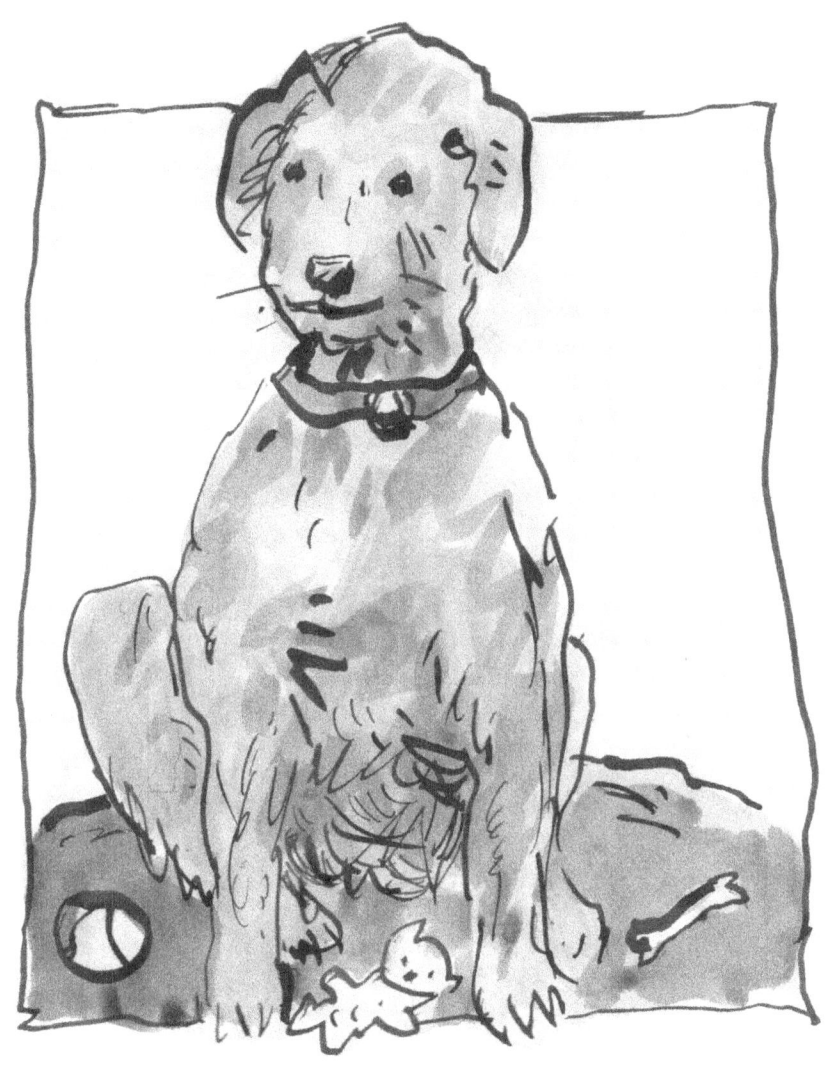

When Hector was a pup, he had three toys.

*There's a dog
in there somewhere.*

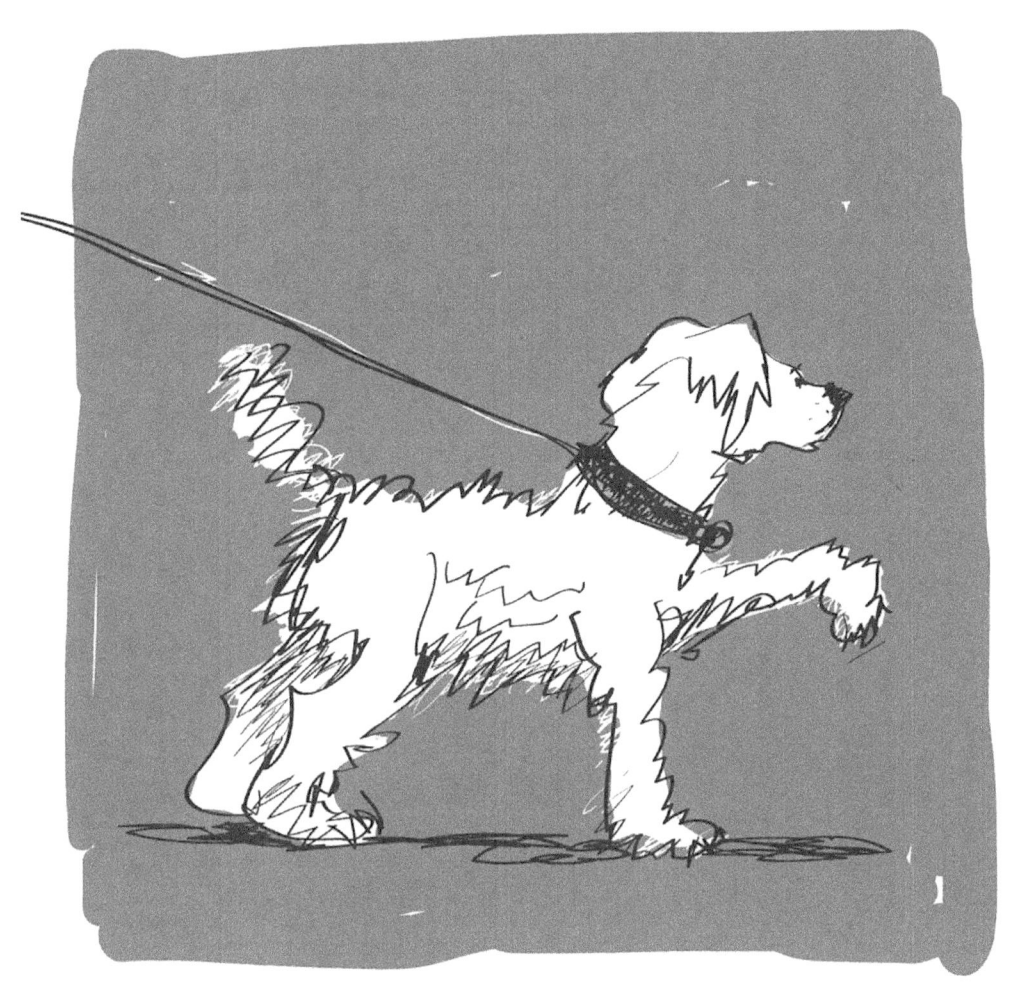

Dressage dog.

Nose to nose pose.

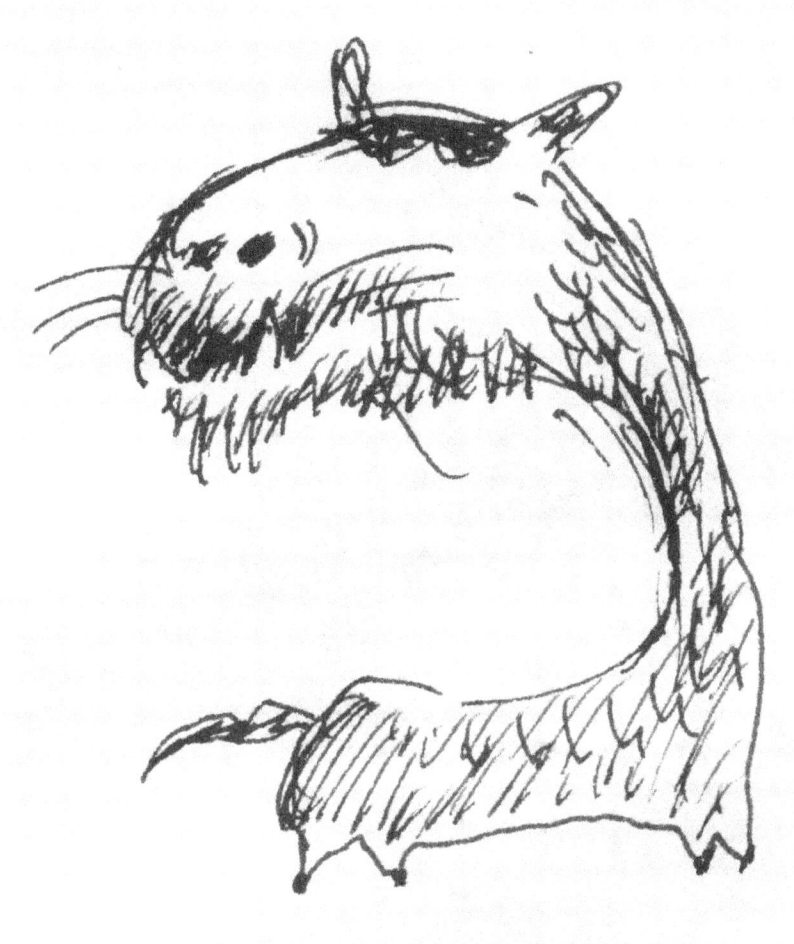

Dude with attitude.

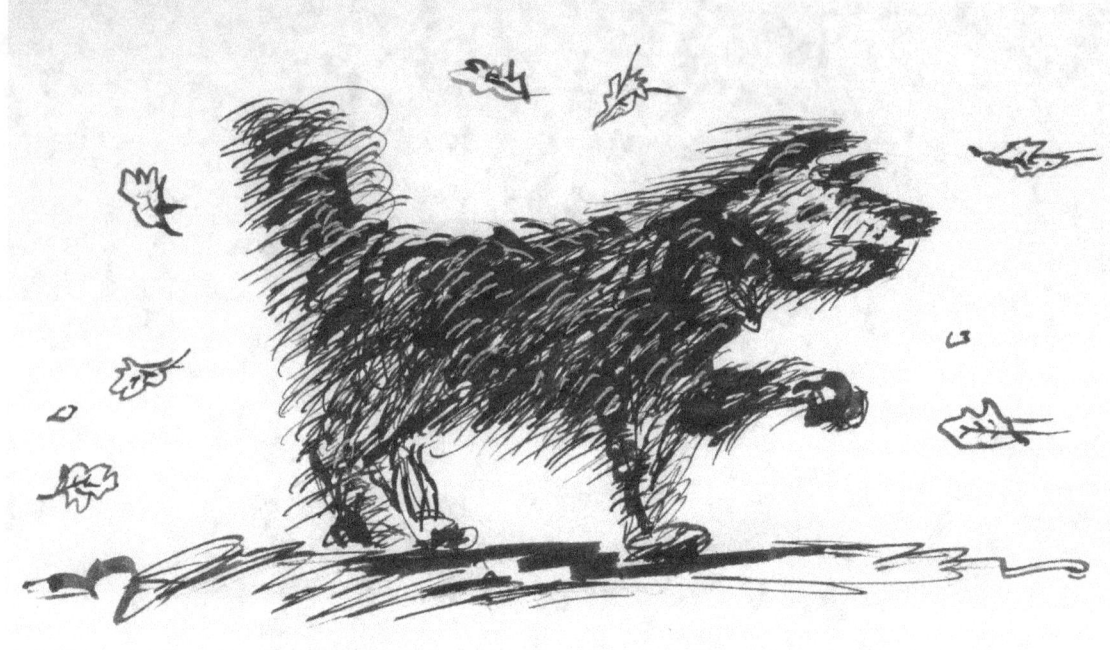

Windy.
Despite a thirty knot headwind,
she stayed on course.

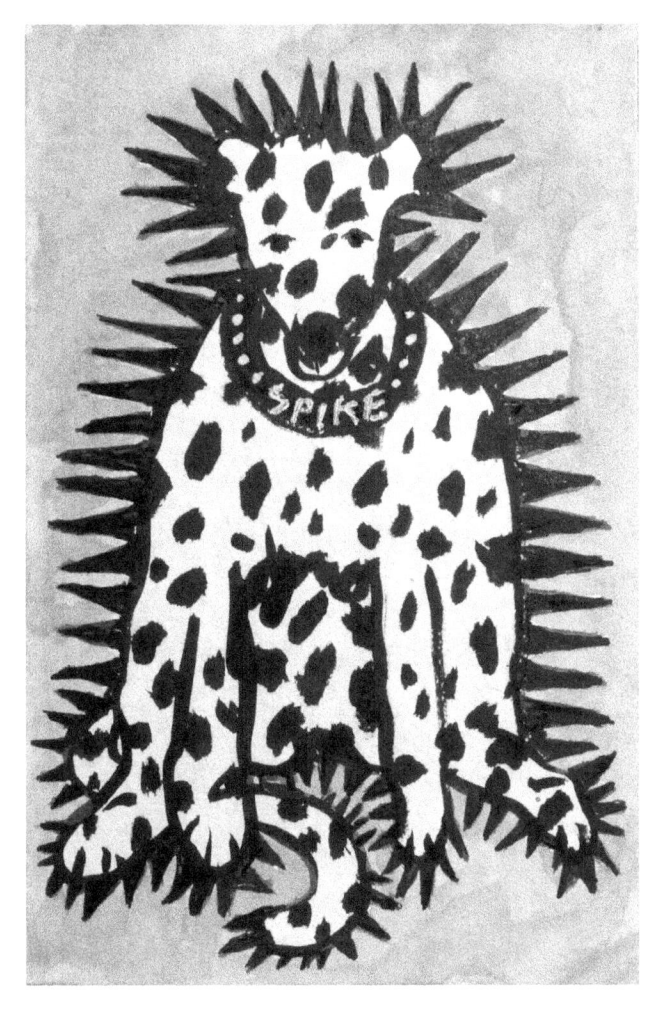

Dog named Spike.

He is named after our lizard who died from a back injury.

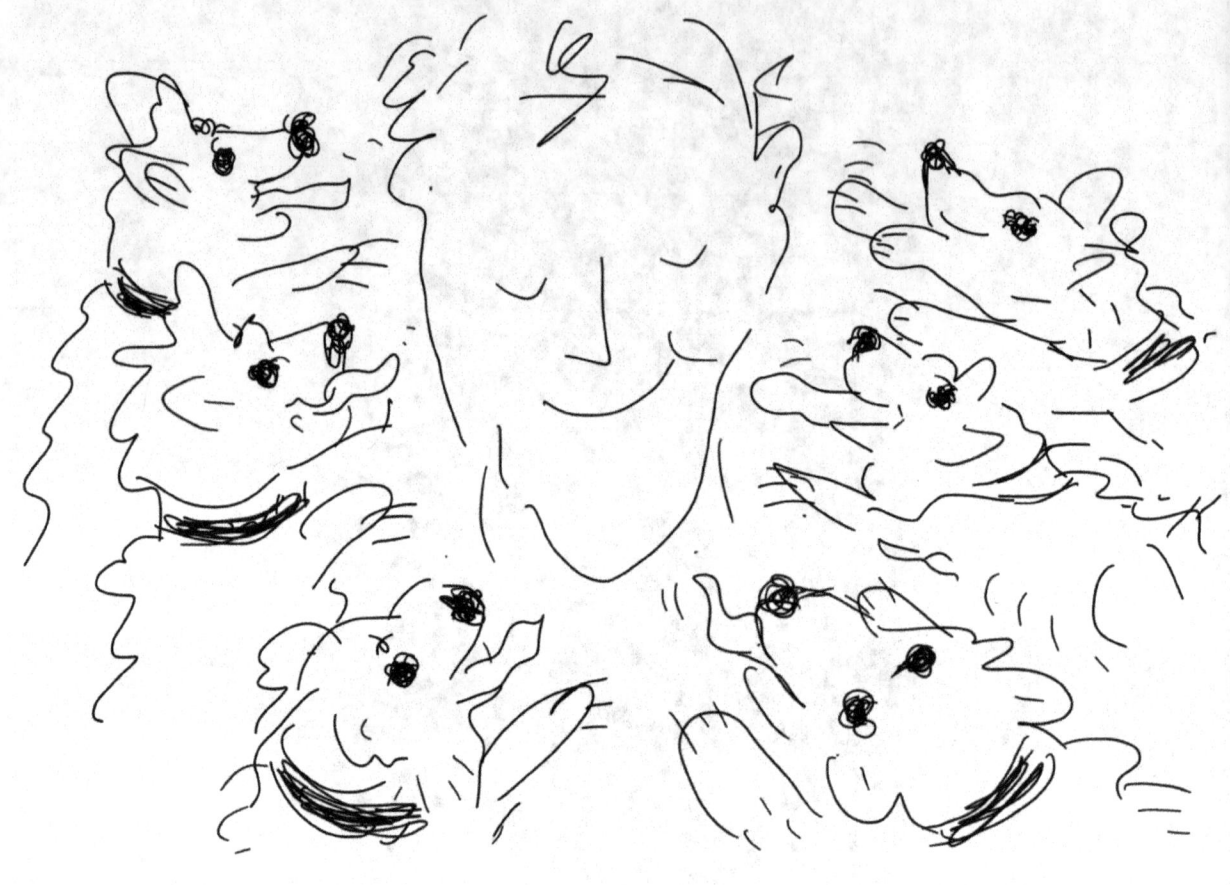

Welcoming committee.

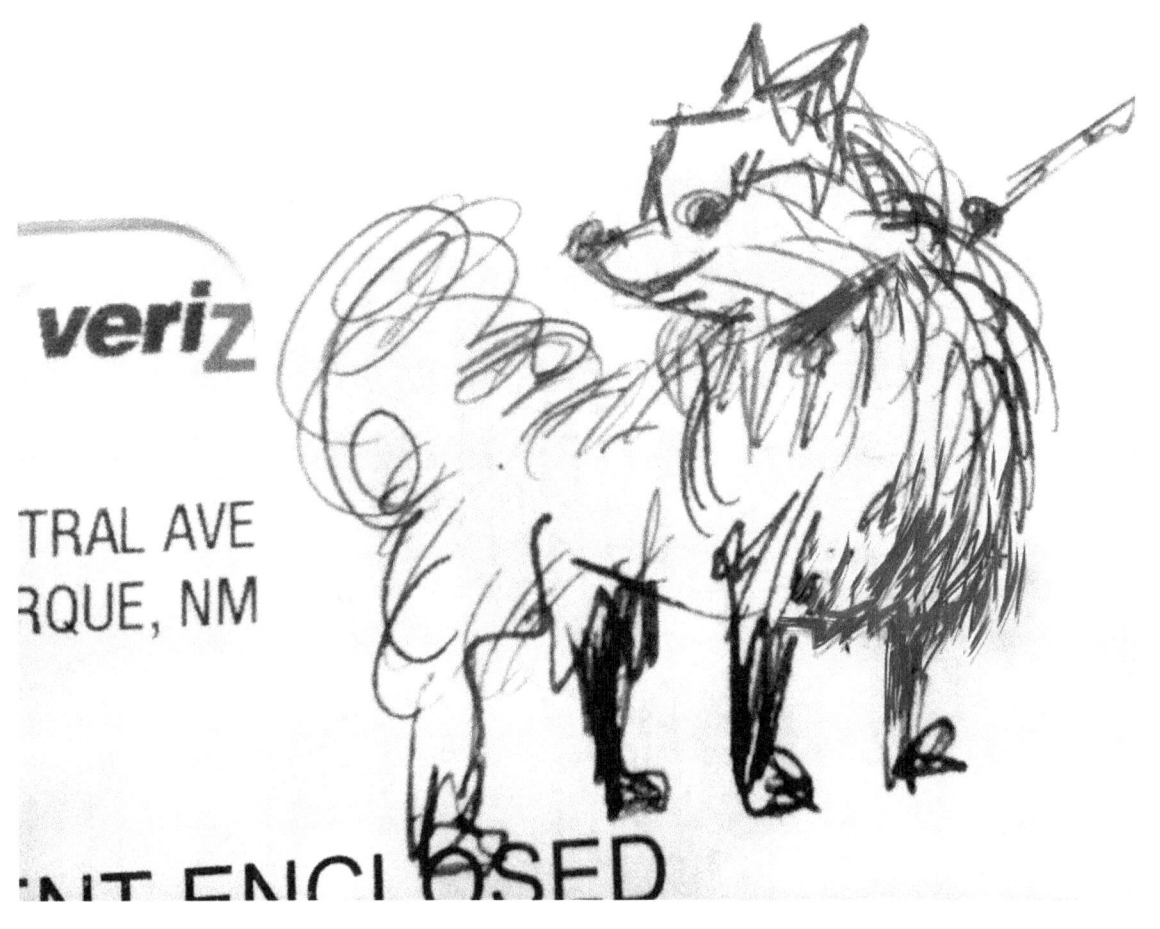

Phony dog.

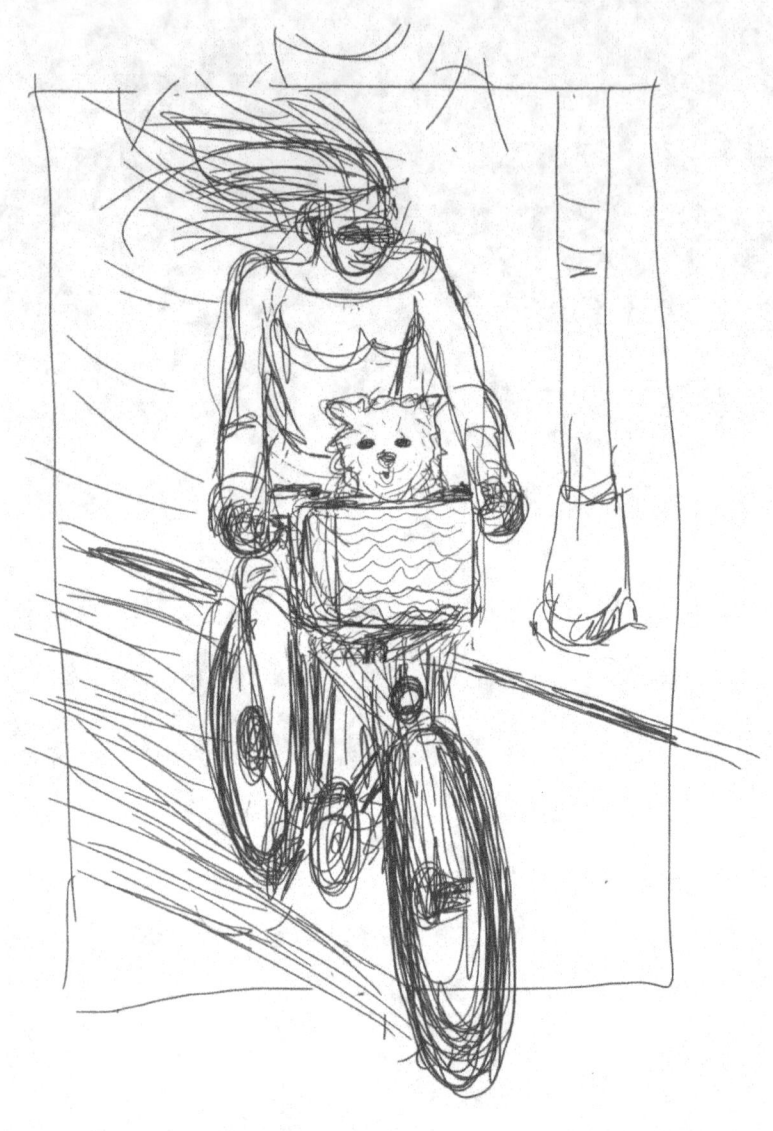

He looked me right in the eye
as he sped by.

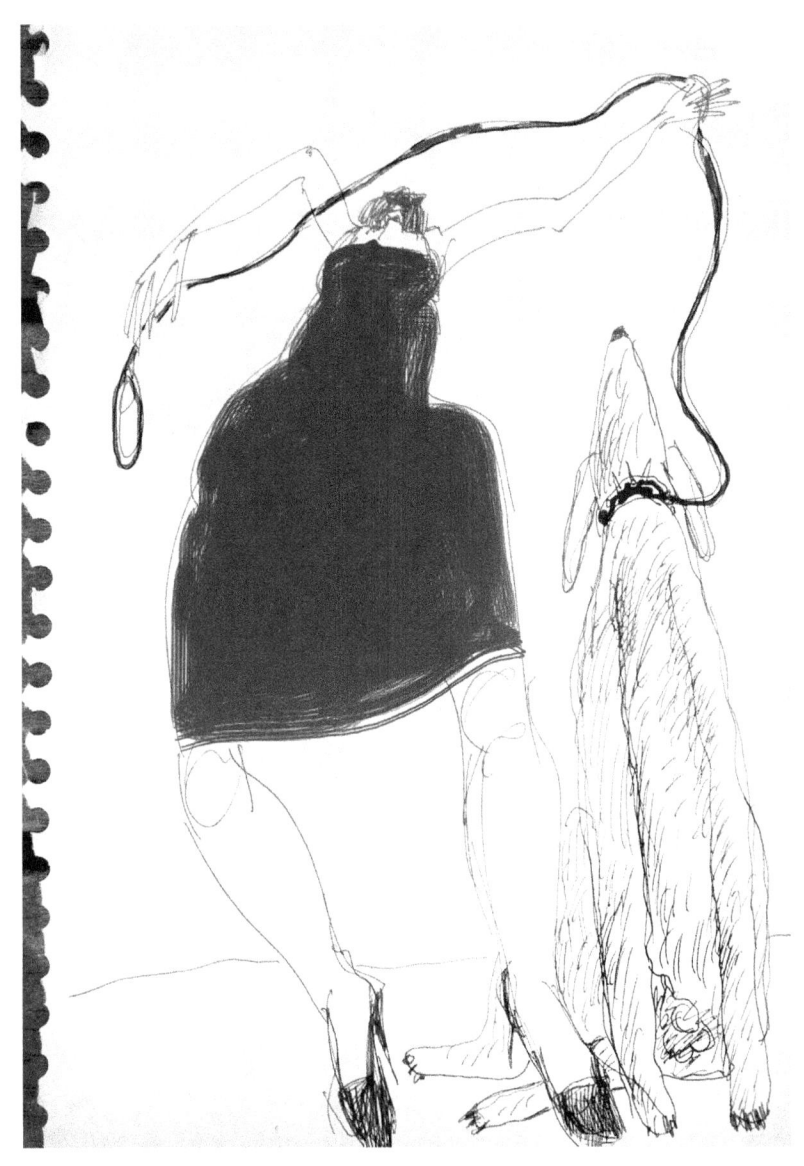

Calm and assertive dog trainer.

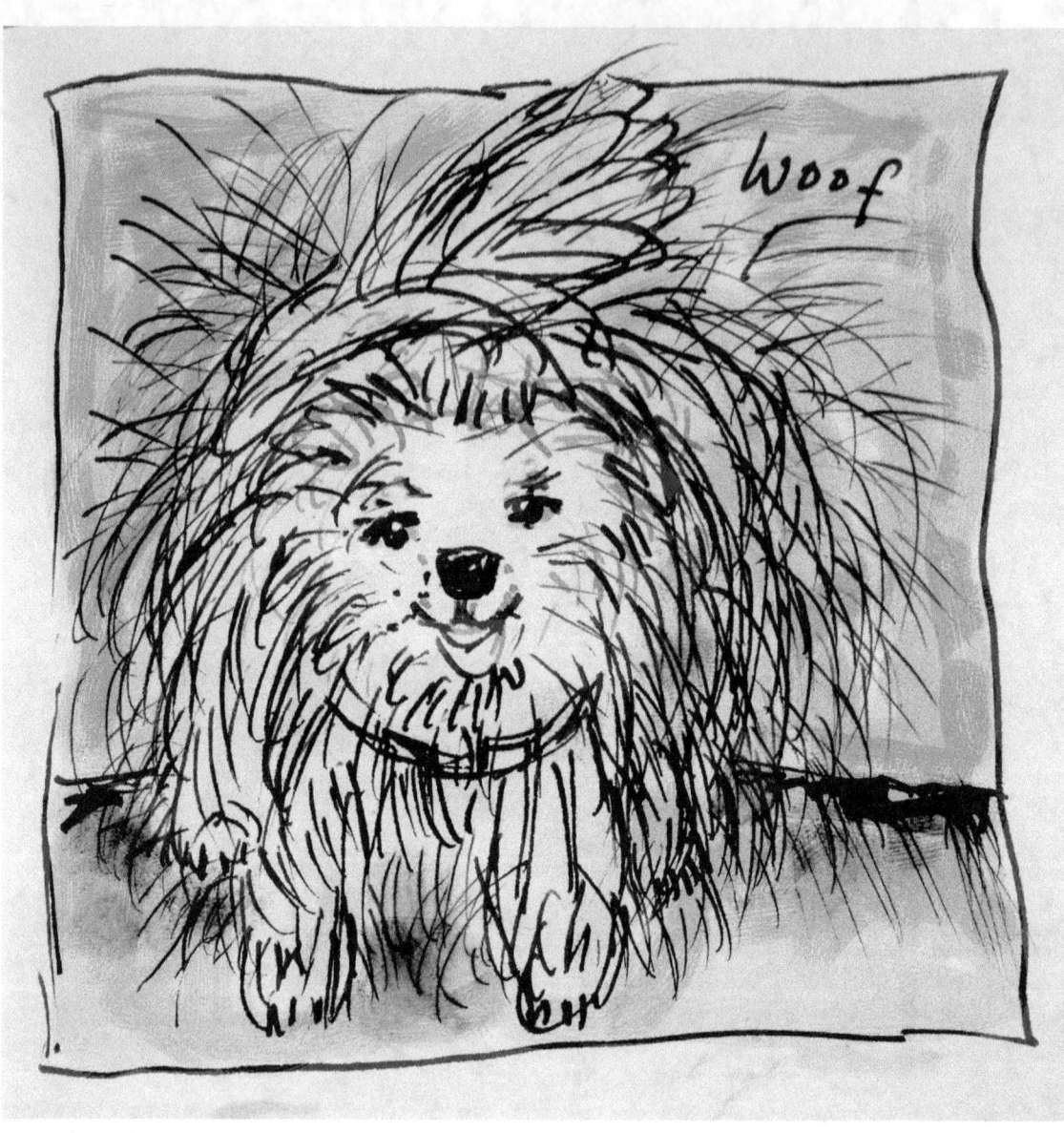

Sub woofer.

A pup in the hand is worth two in the bush. Or so I say.

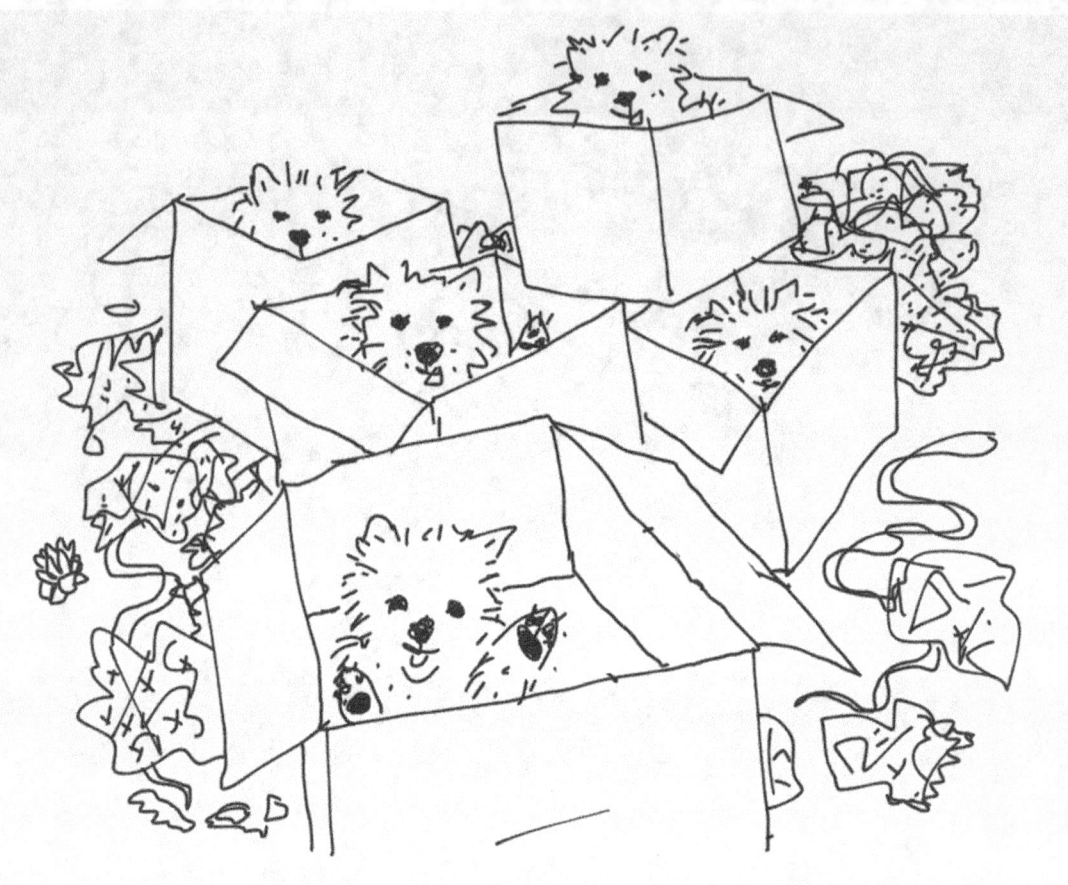

Dogs in the dog box.

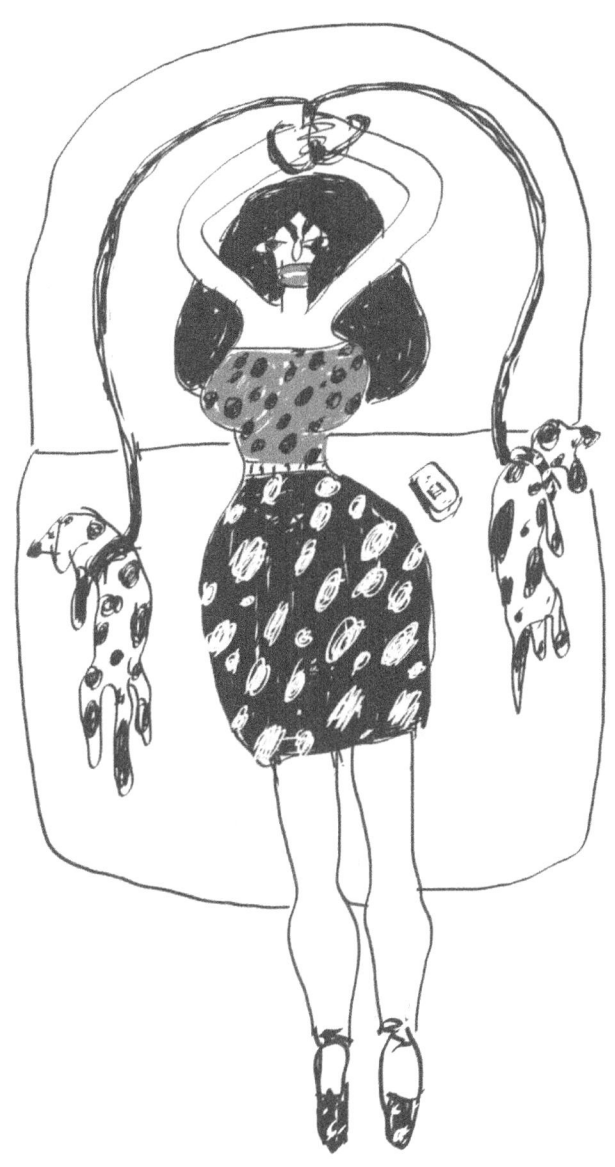

Cal Worthington's wife and her dogs with spots.

Good go potty dog.

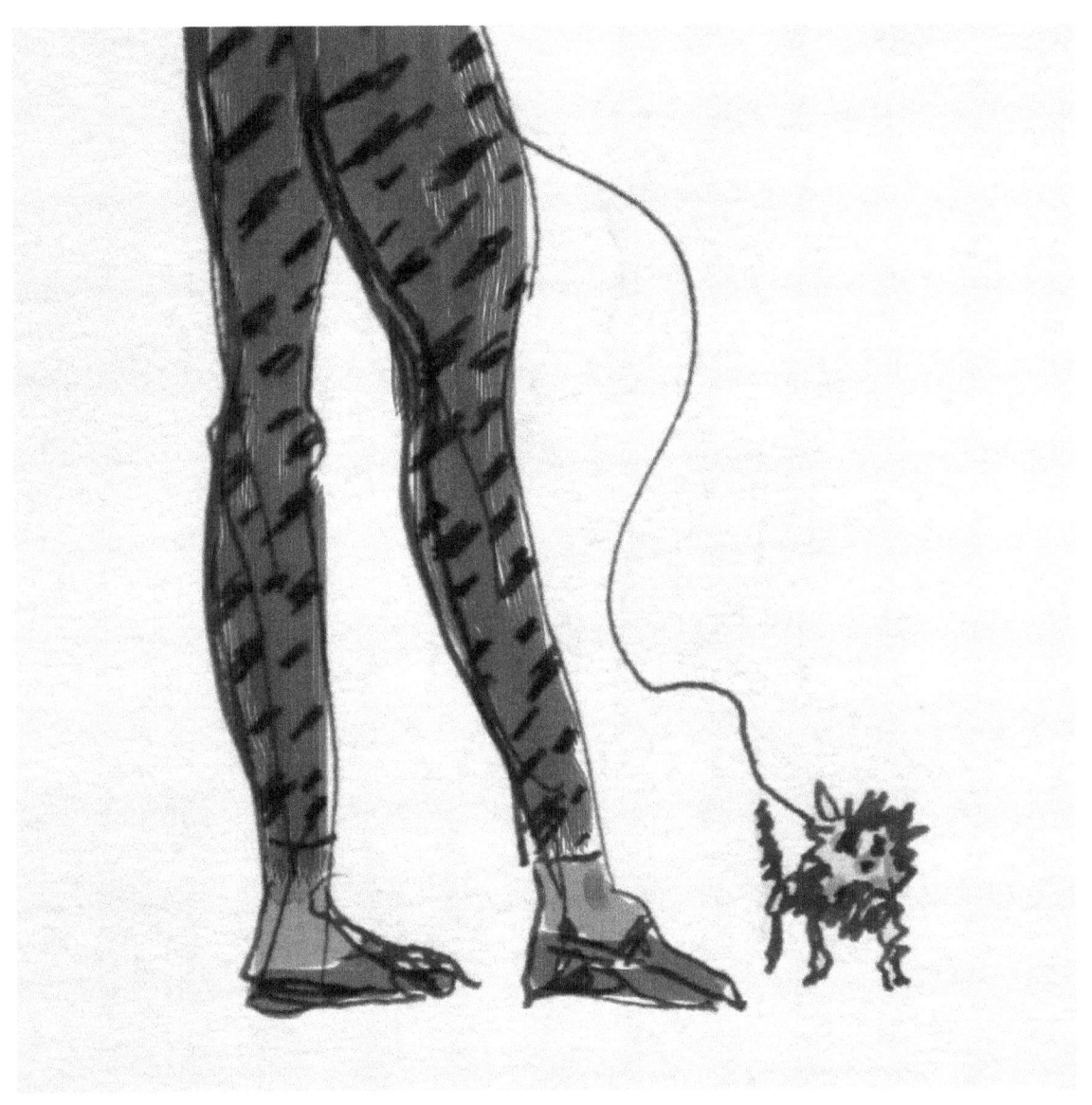

Flea on a leash.

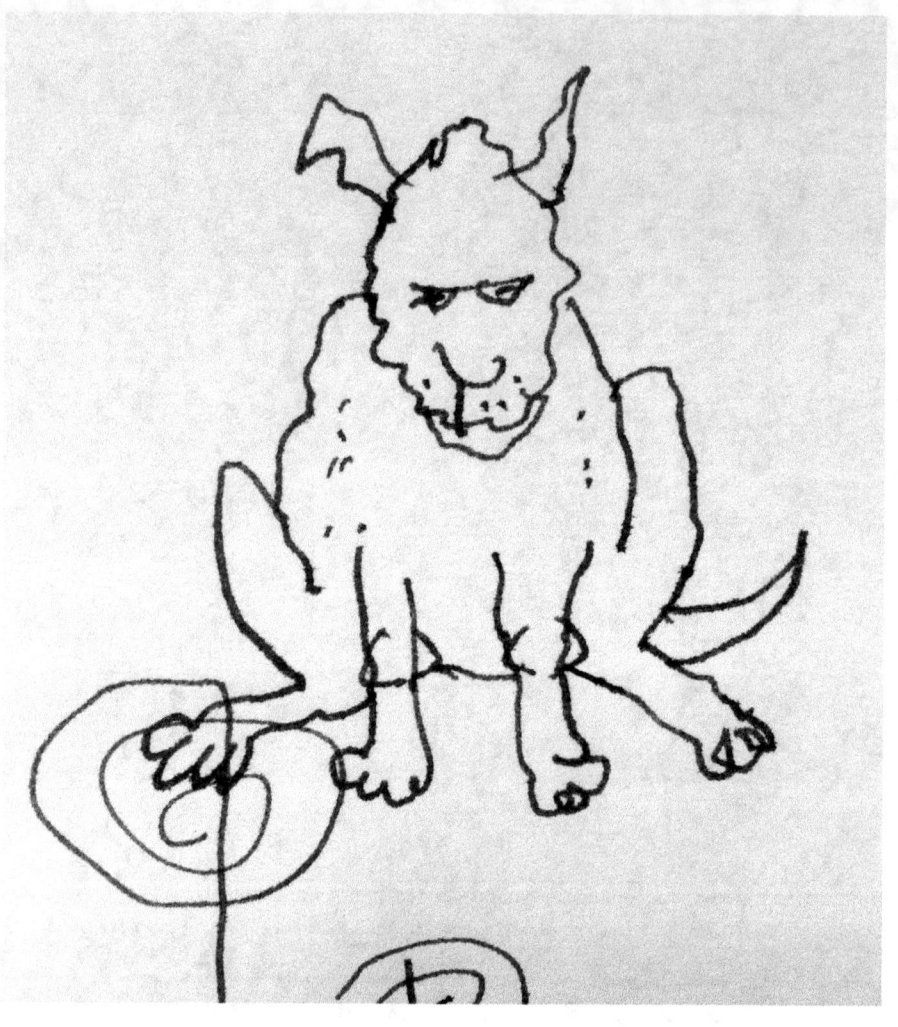

Pensive dog.

Reflecting on his shortcomings.

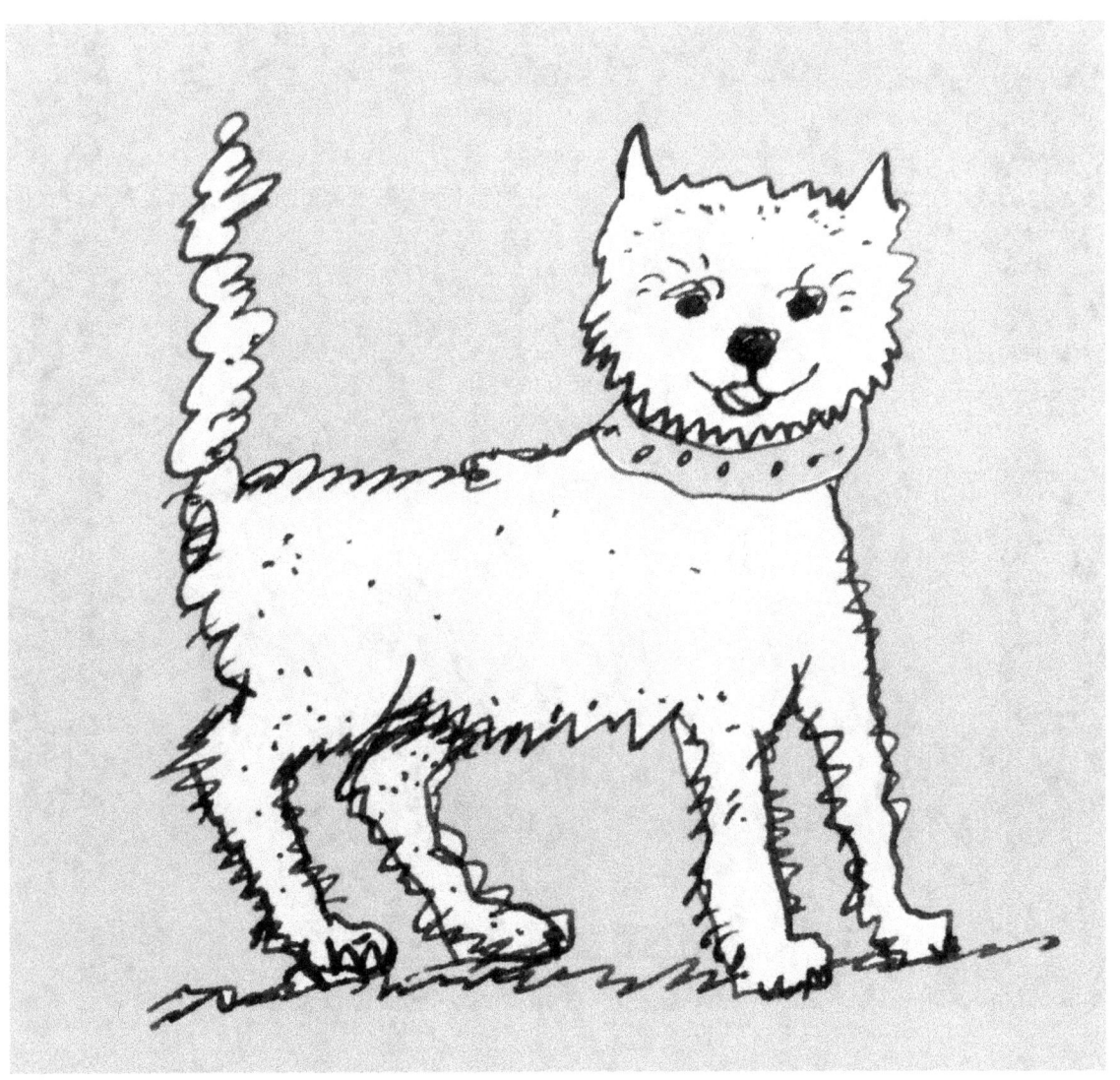

Ambassadog.

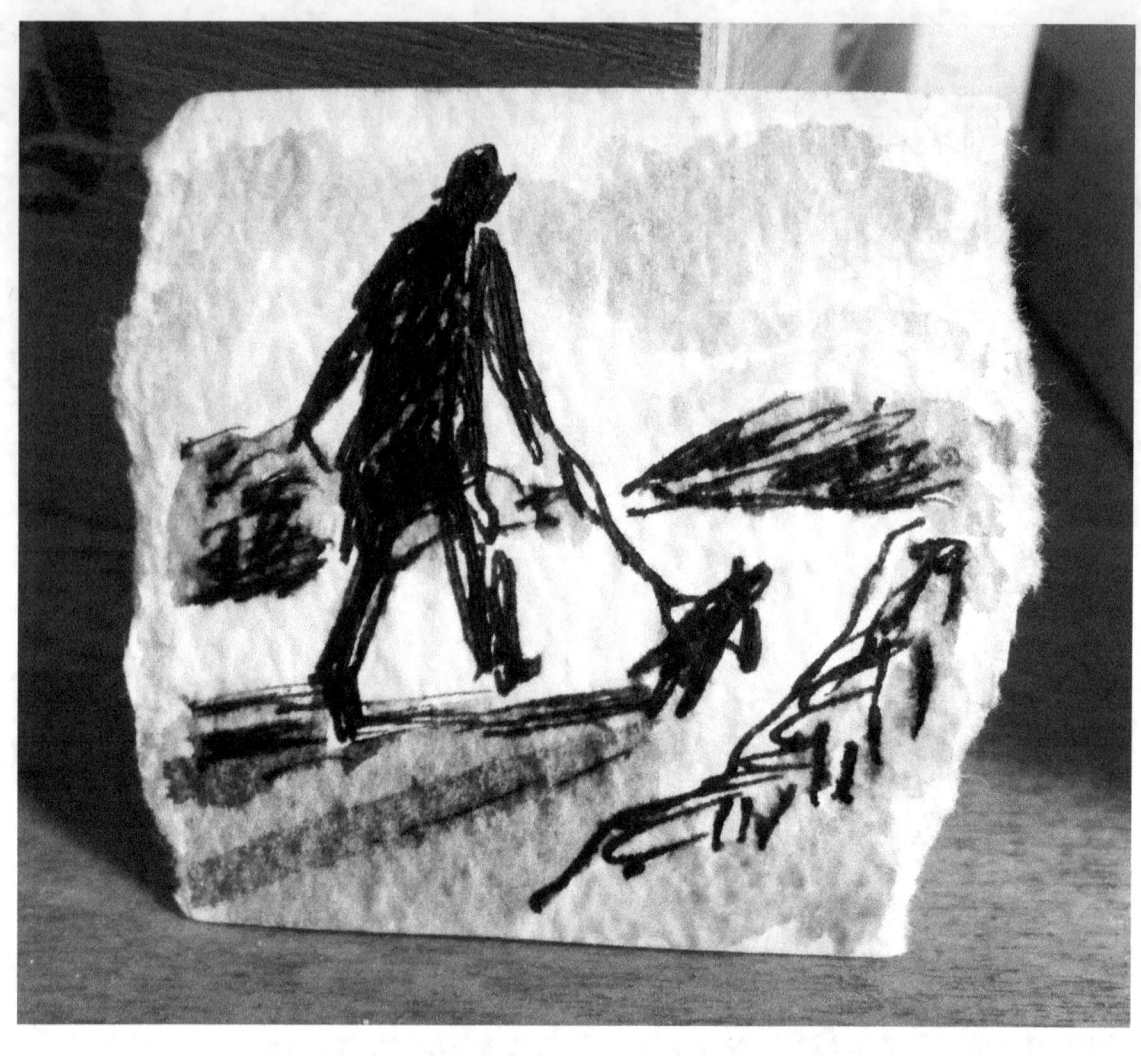

Homeless dog
with a friend.

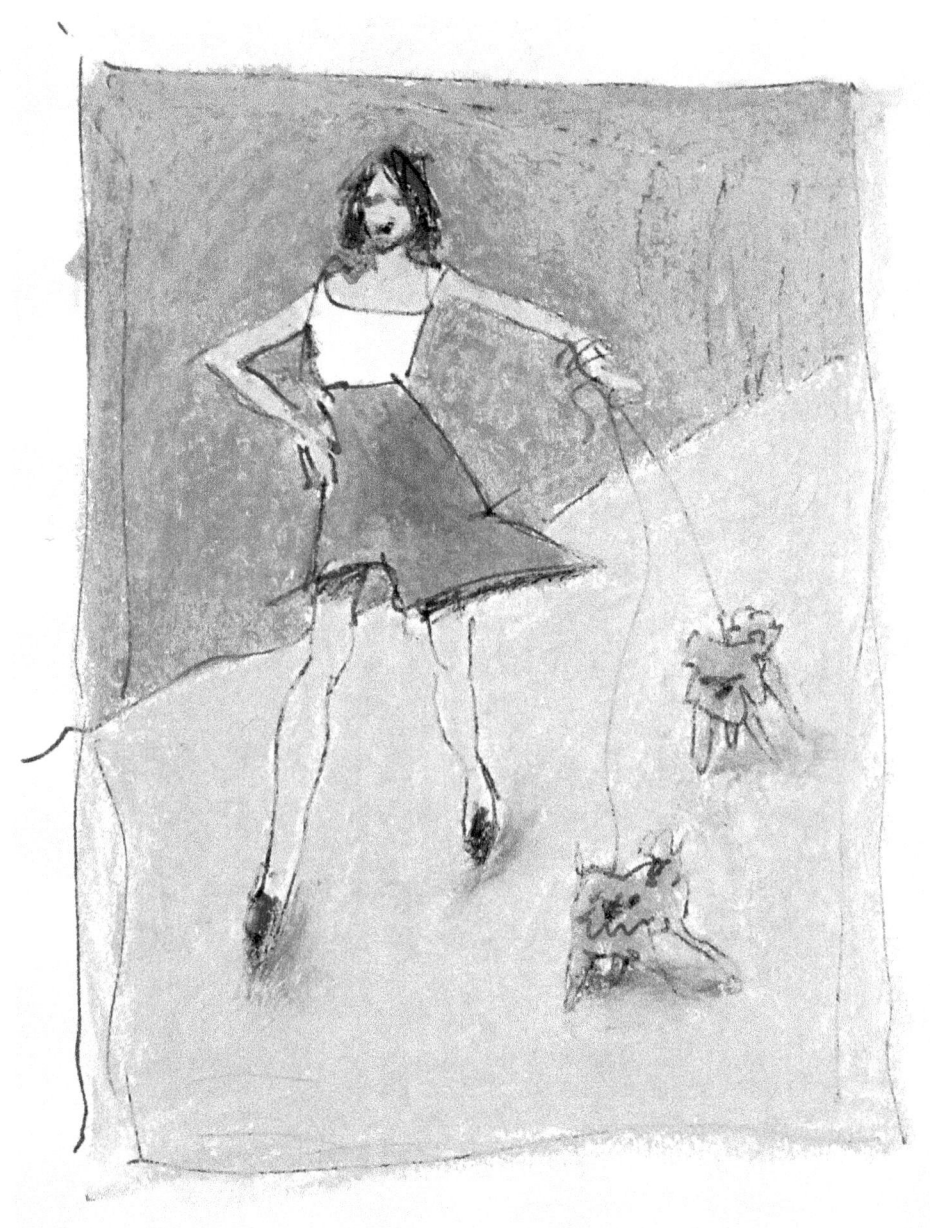

Who's in charge here?

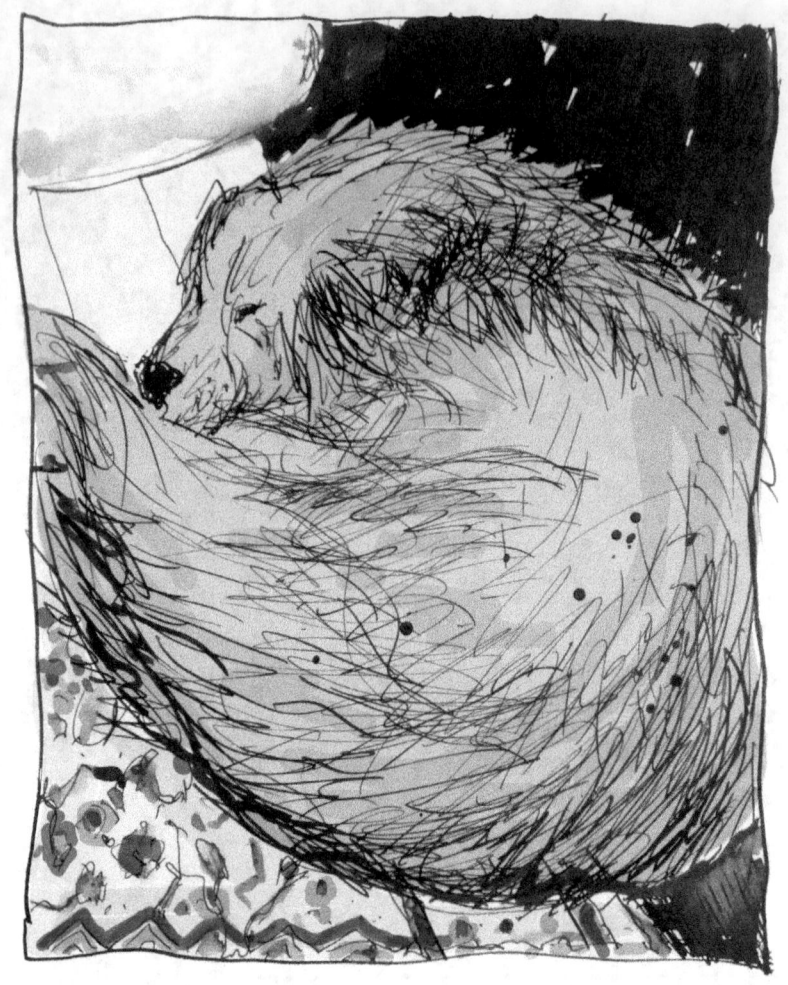

Lounge lizard Luther.

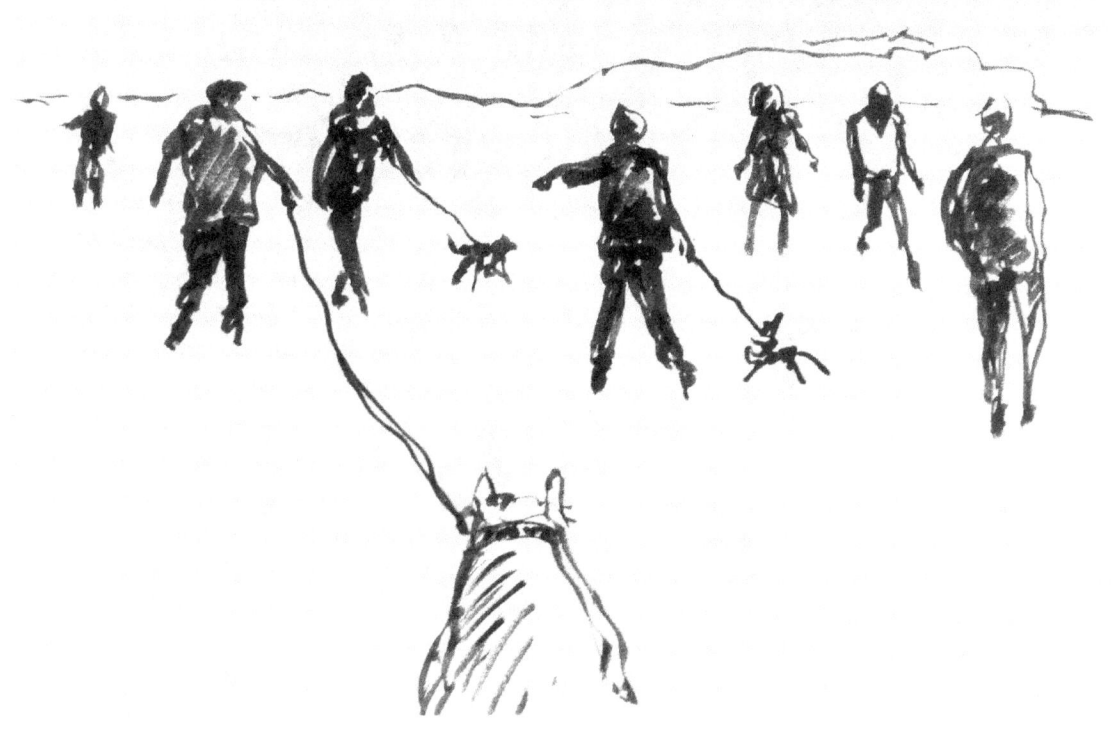

Leashes
on
beaches.

Mister Facky.

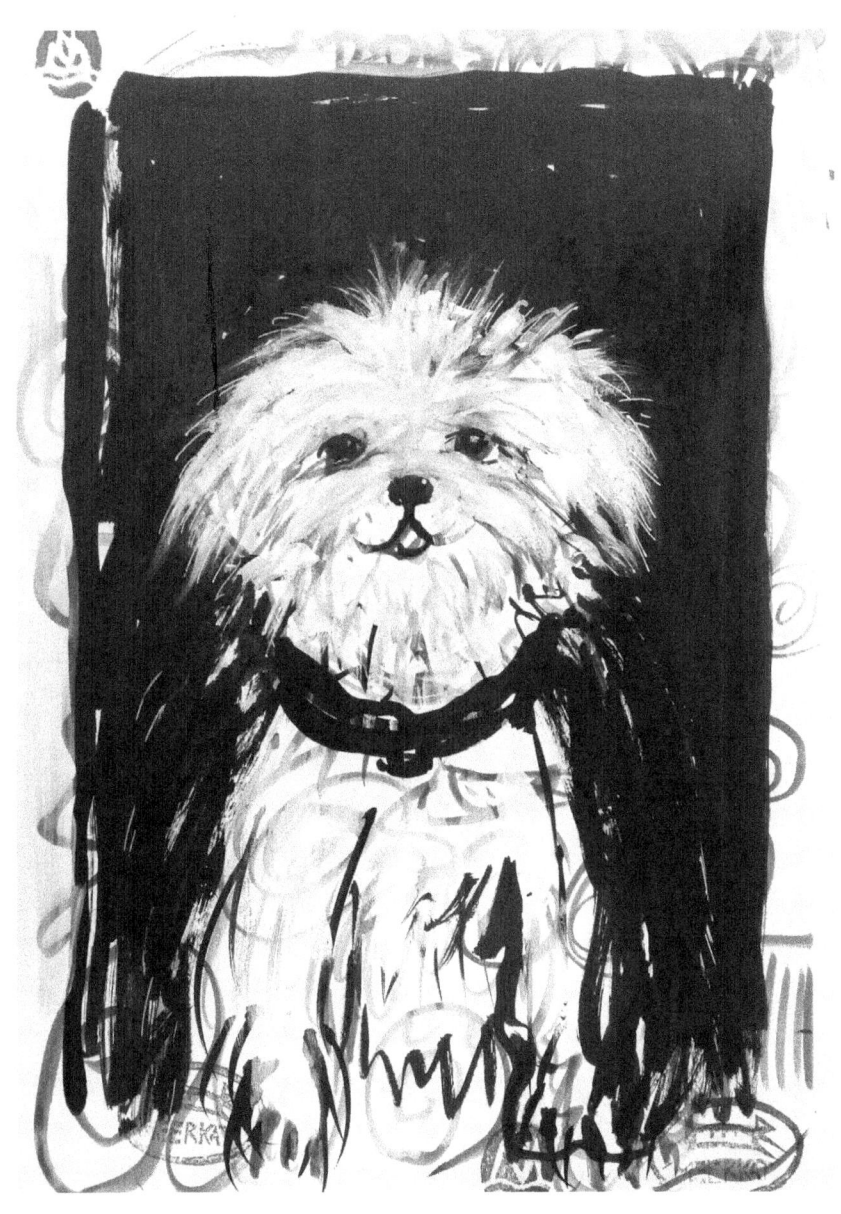

Mister Facky's wife
Mamelodie.

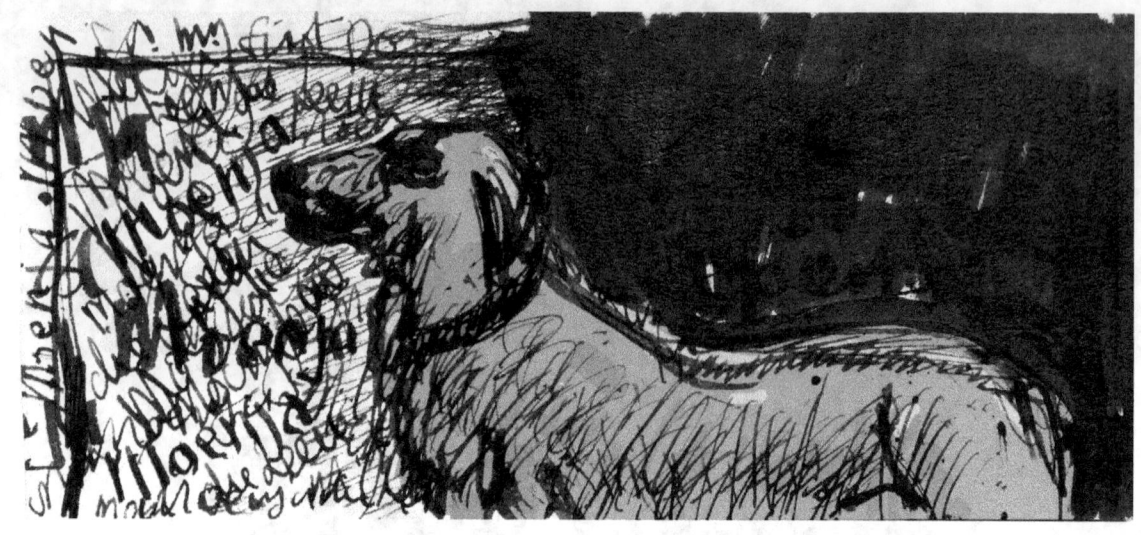

Moenja, my
African queen.

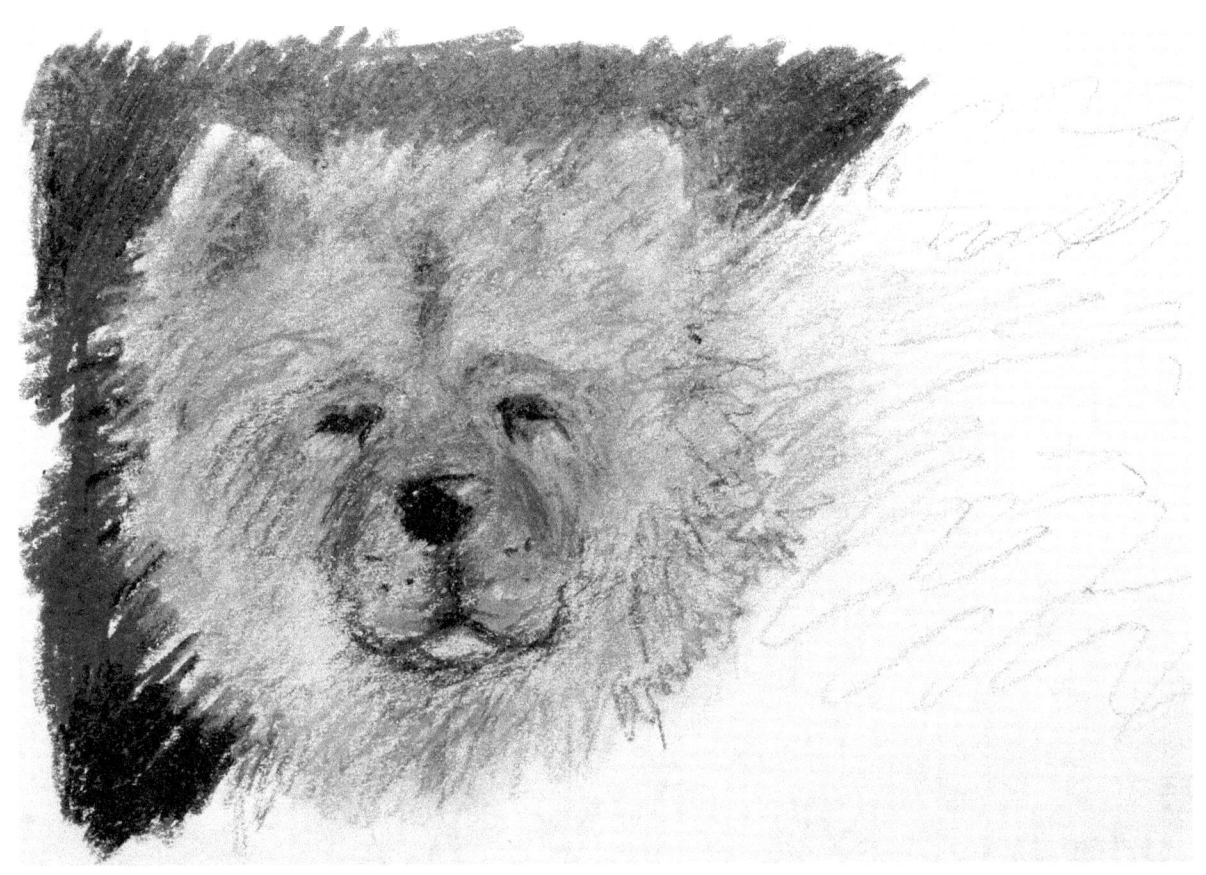

Cubbie,
the ginger bear.

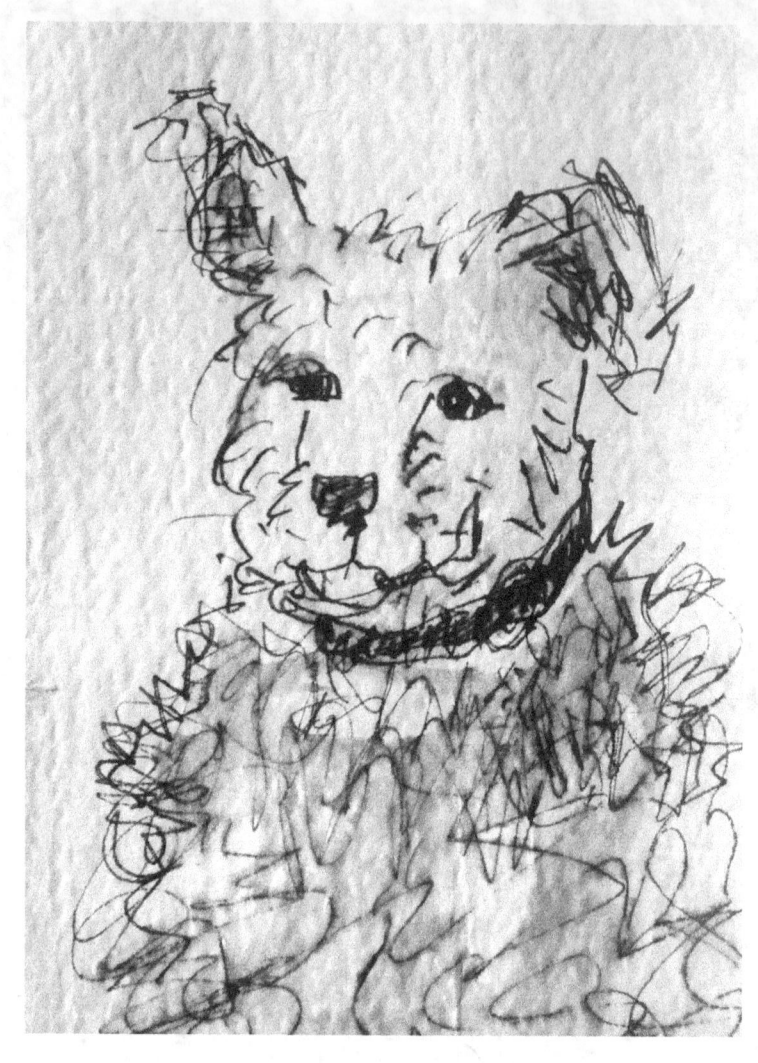

A good listener.

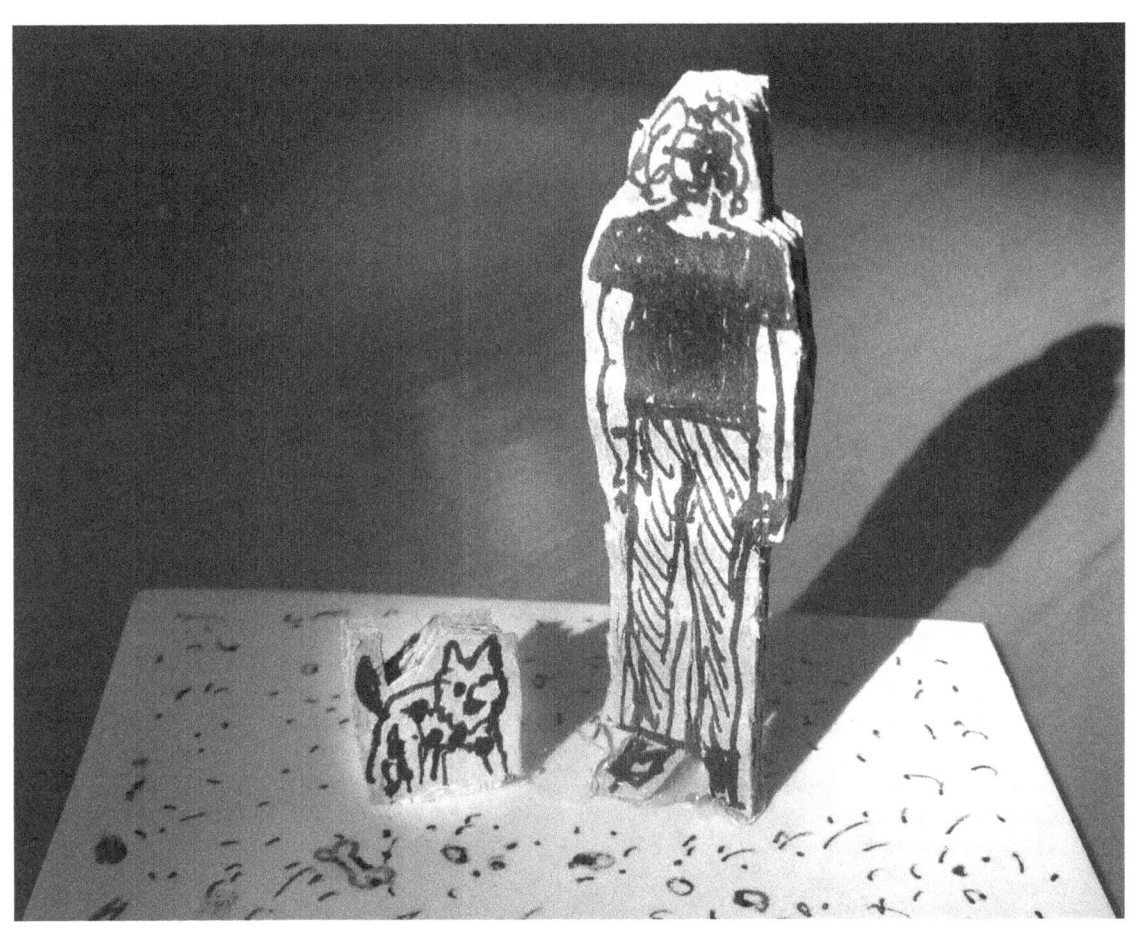

Are they house trained?

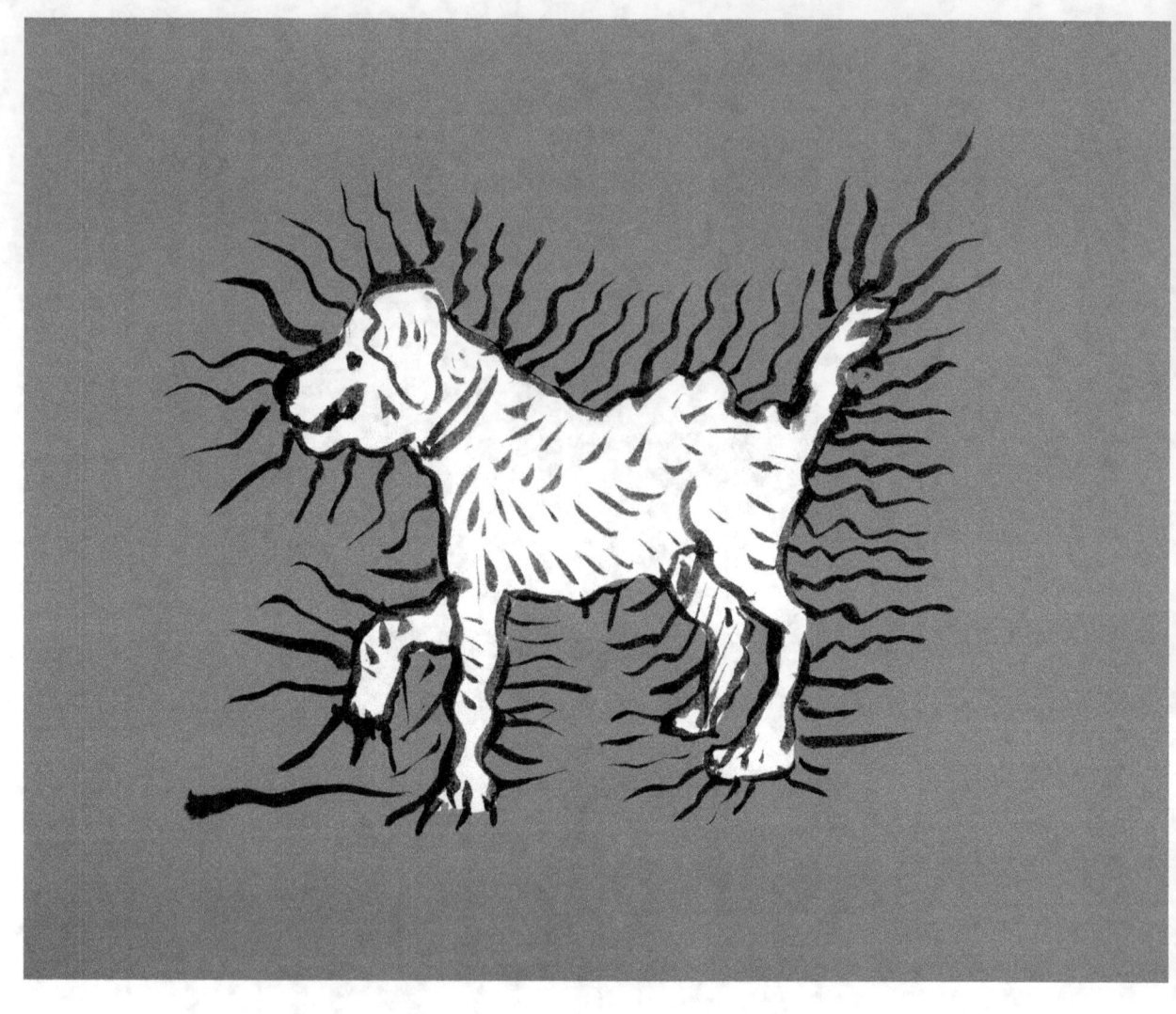

Slighty nervous dog.

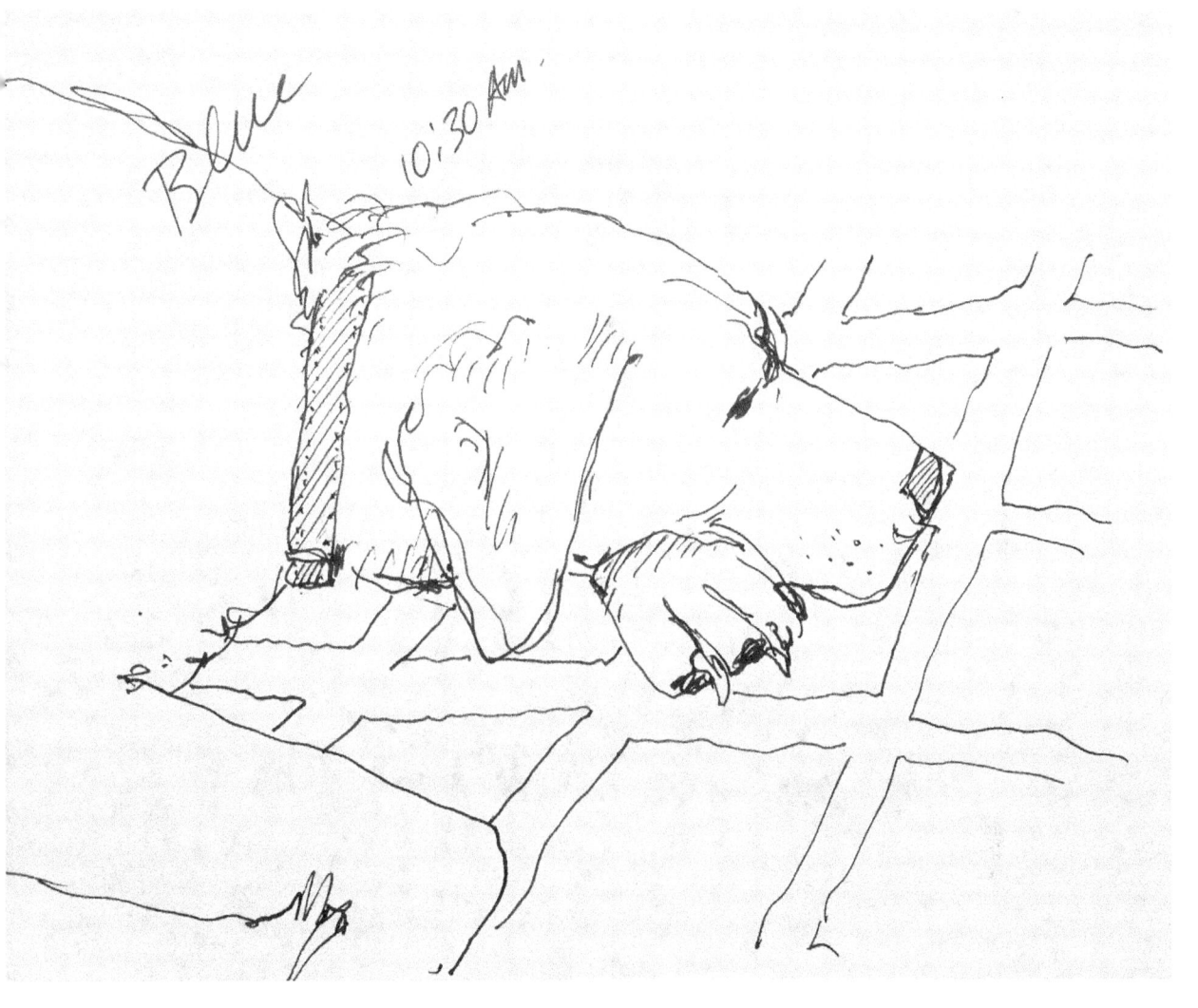

Bleu in the morning, golden all day.

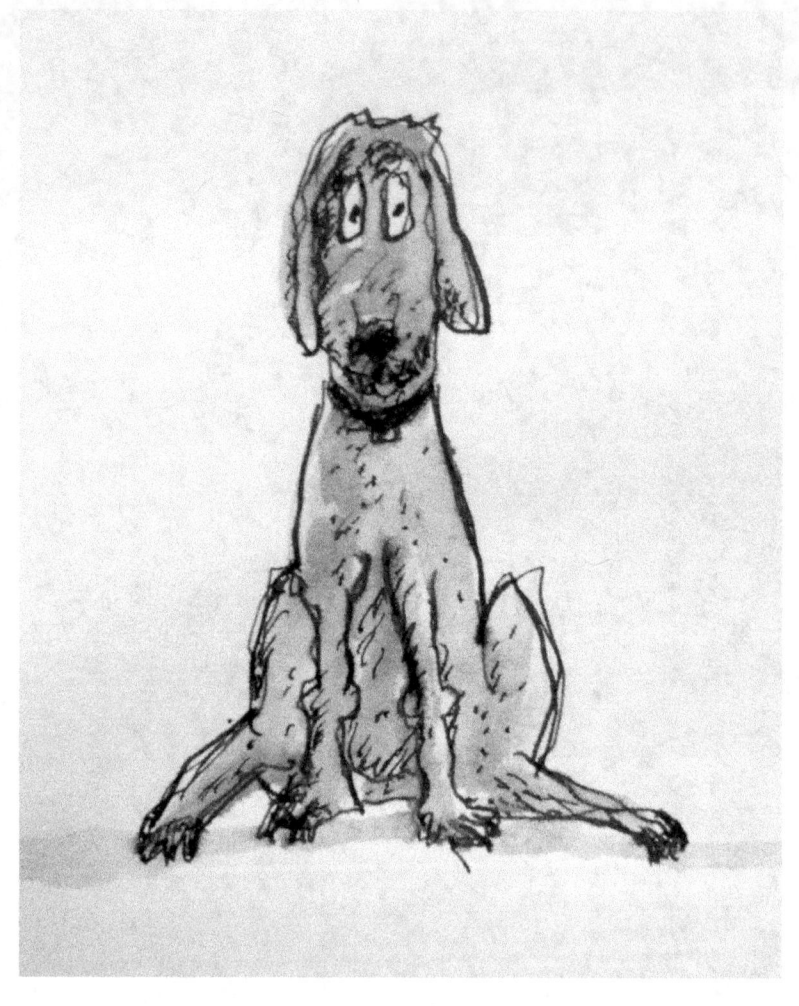

Making dinner plans.

Thinking it would be good to eat early and then take a short nap before bedtime.

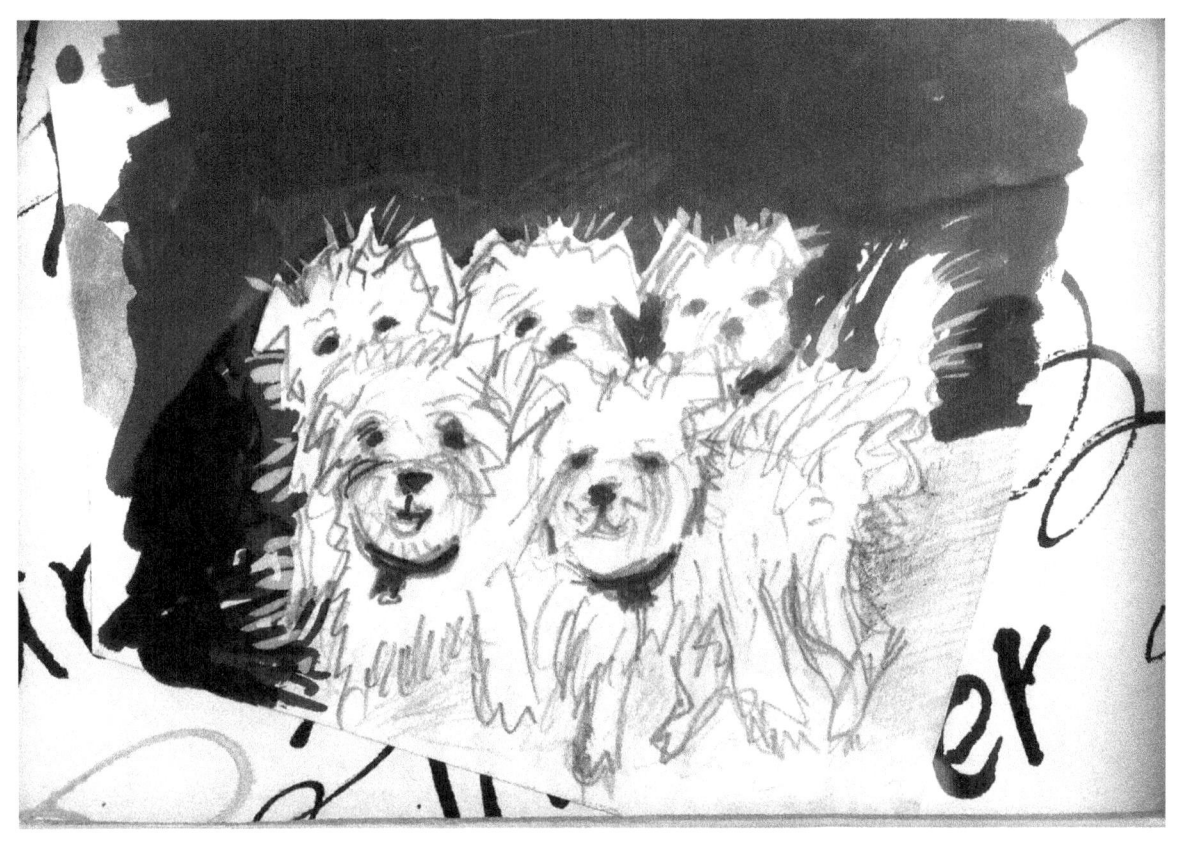

Maltese bundle.

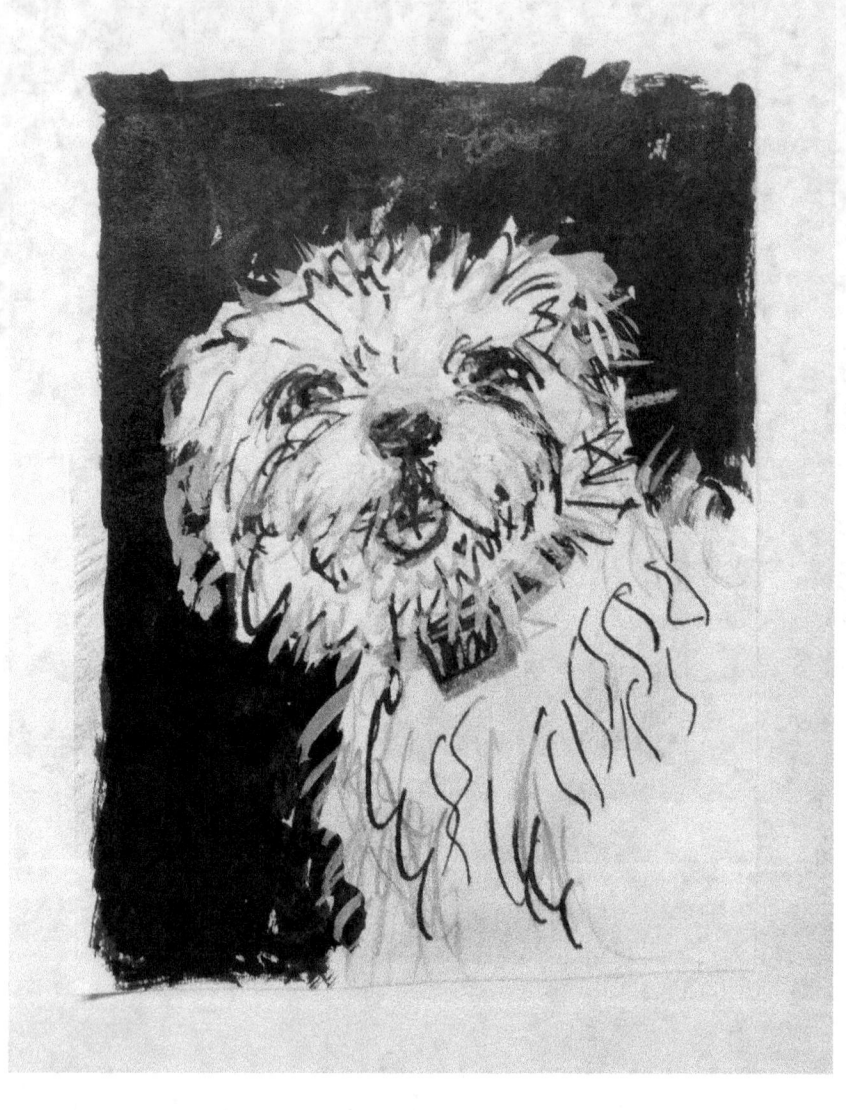

Mister Facky.

Canine Clark Gable.

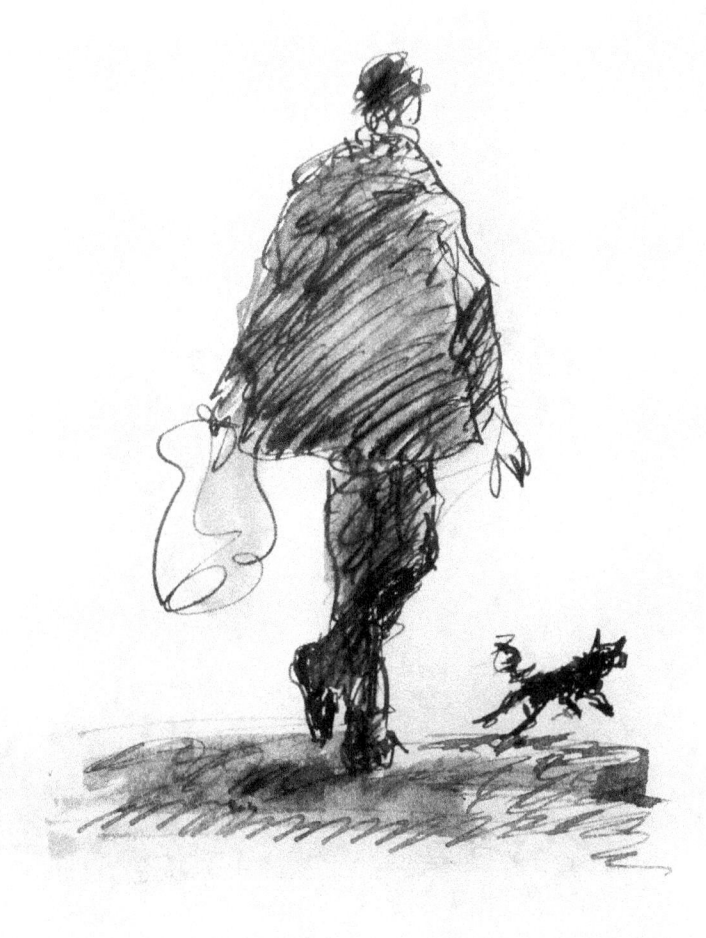

Let's get out of here.

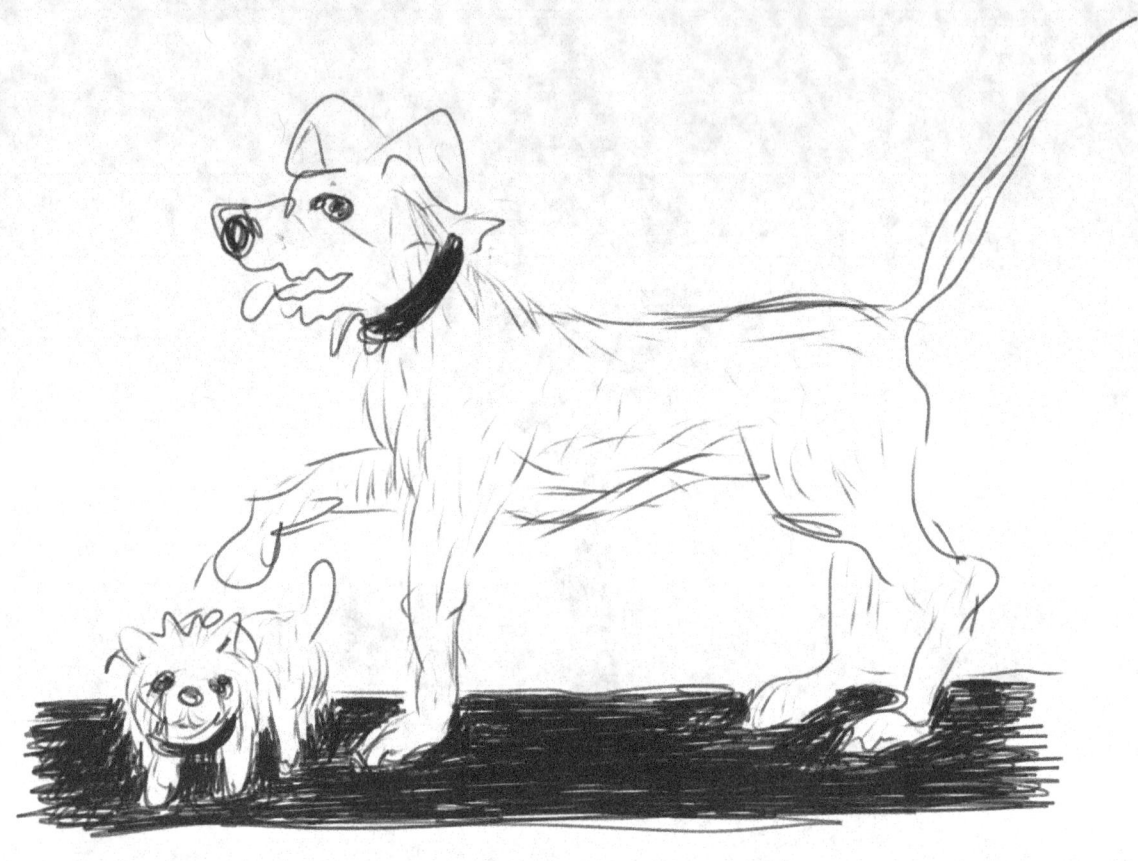

Heavy petting.

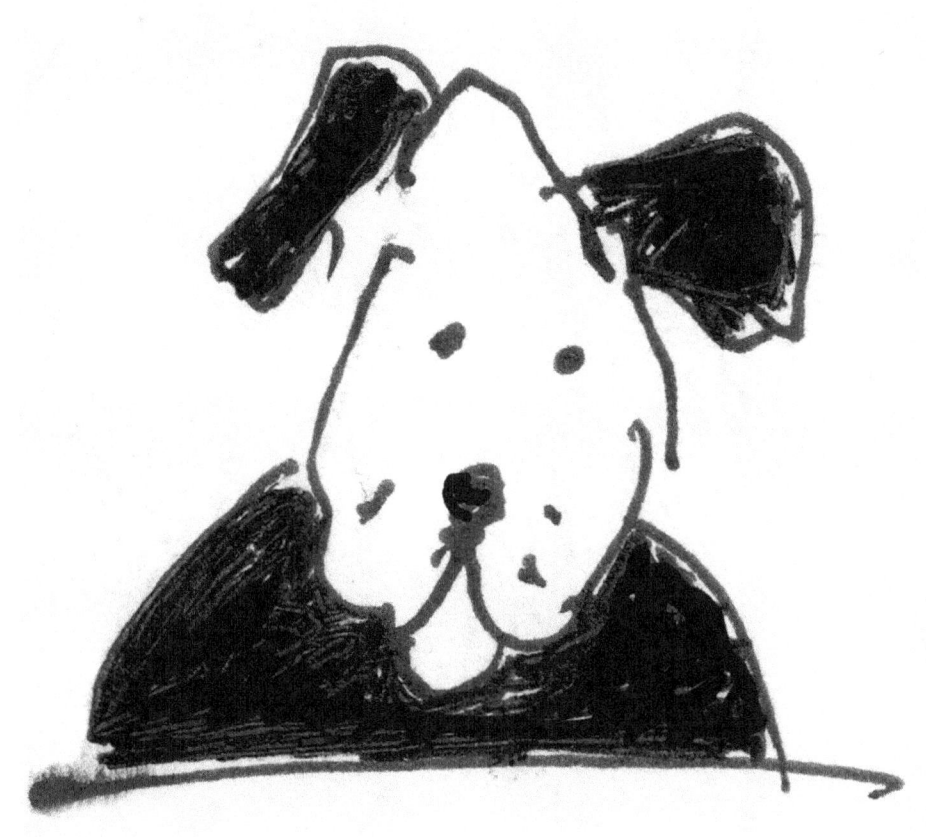

Local representative.

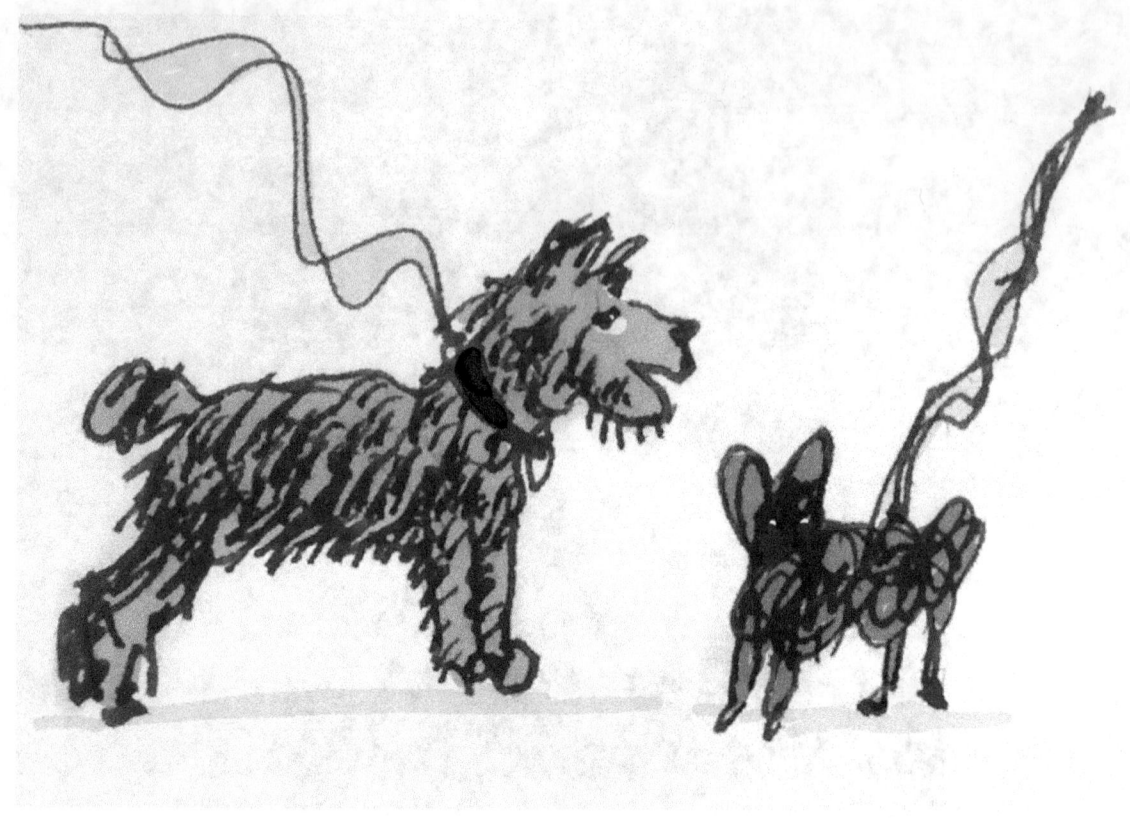

Meeting online.

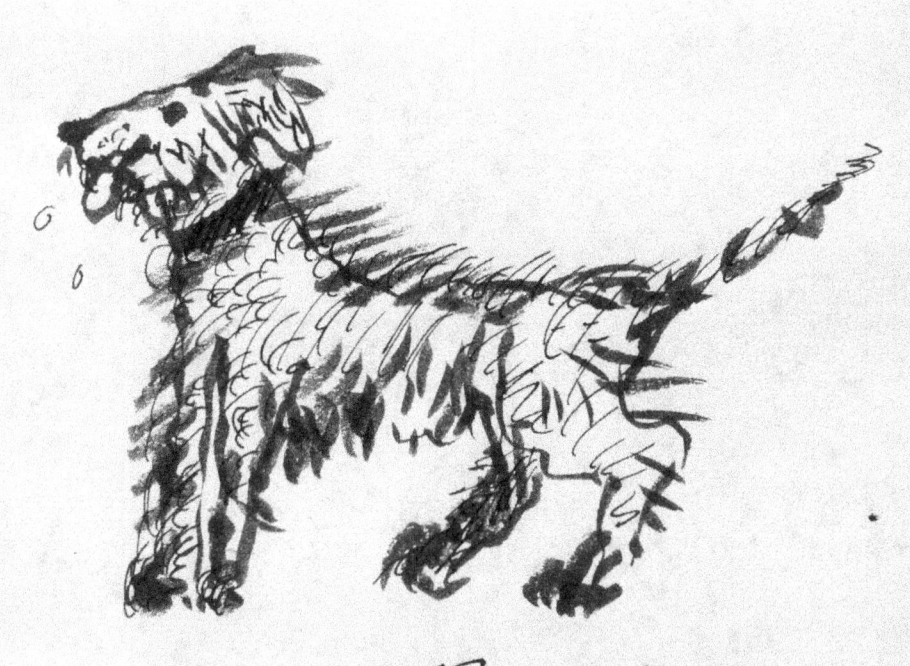

Ready Freddie

Sitting on go.

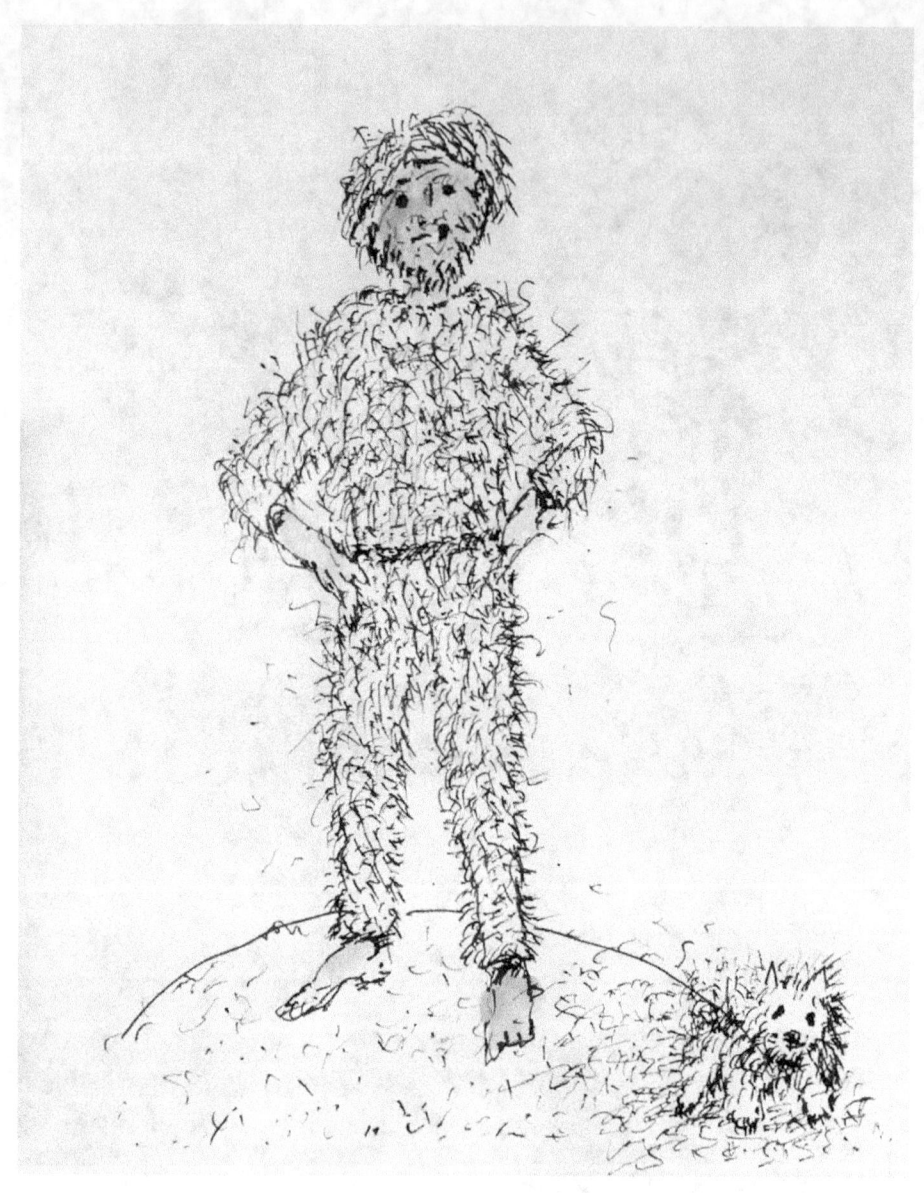

Shedding season.

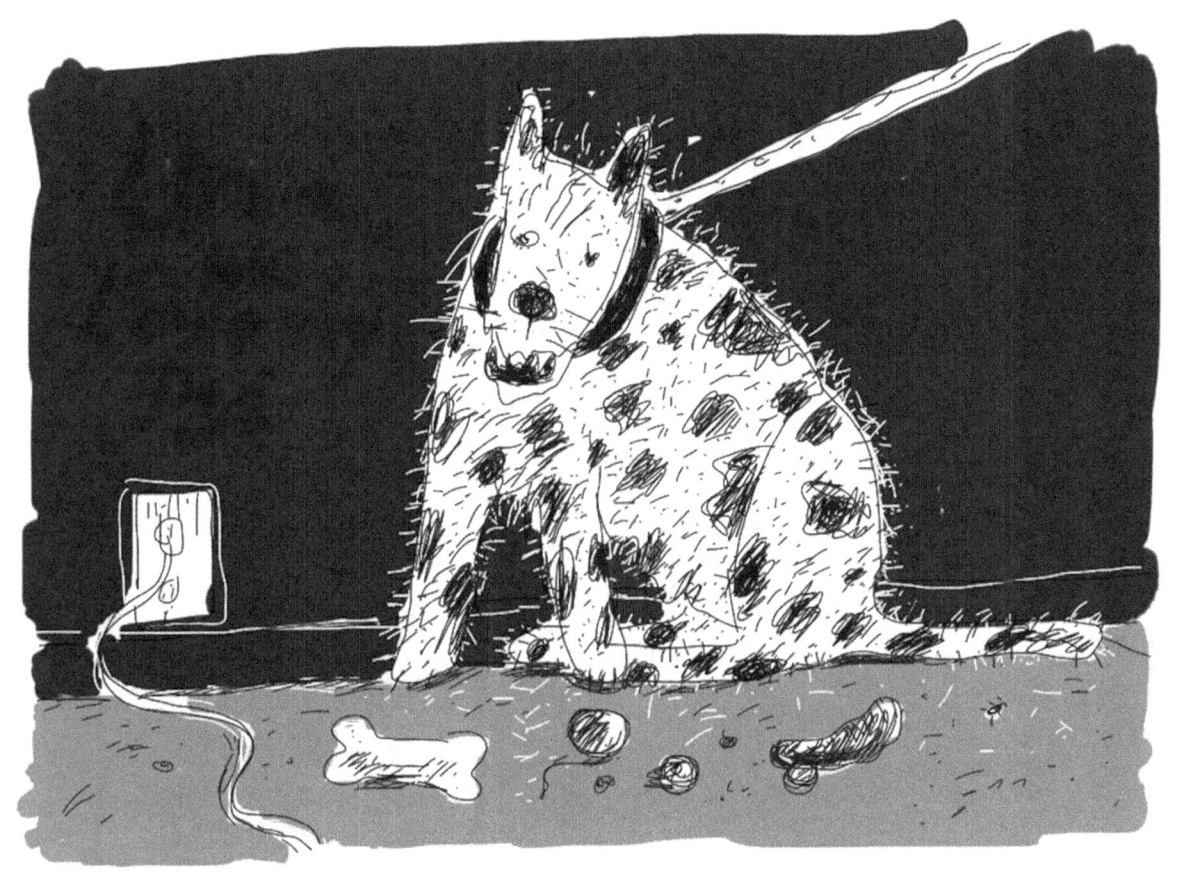

"Don't bother me.
I'm all tied up."

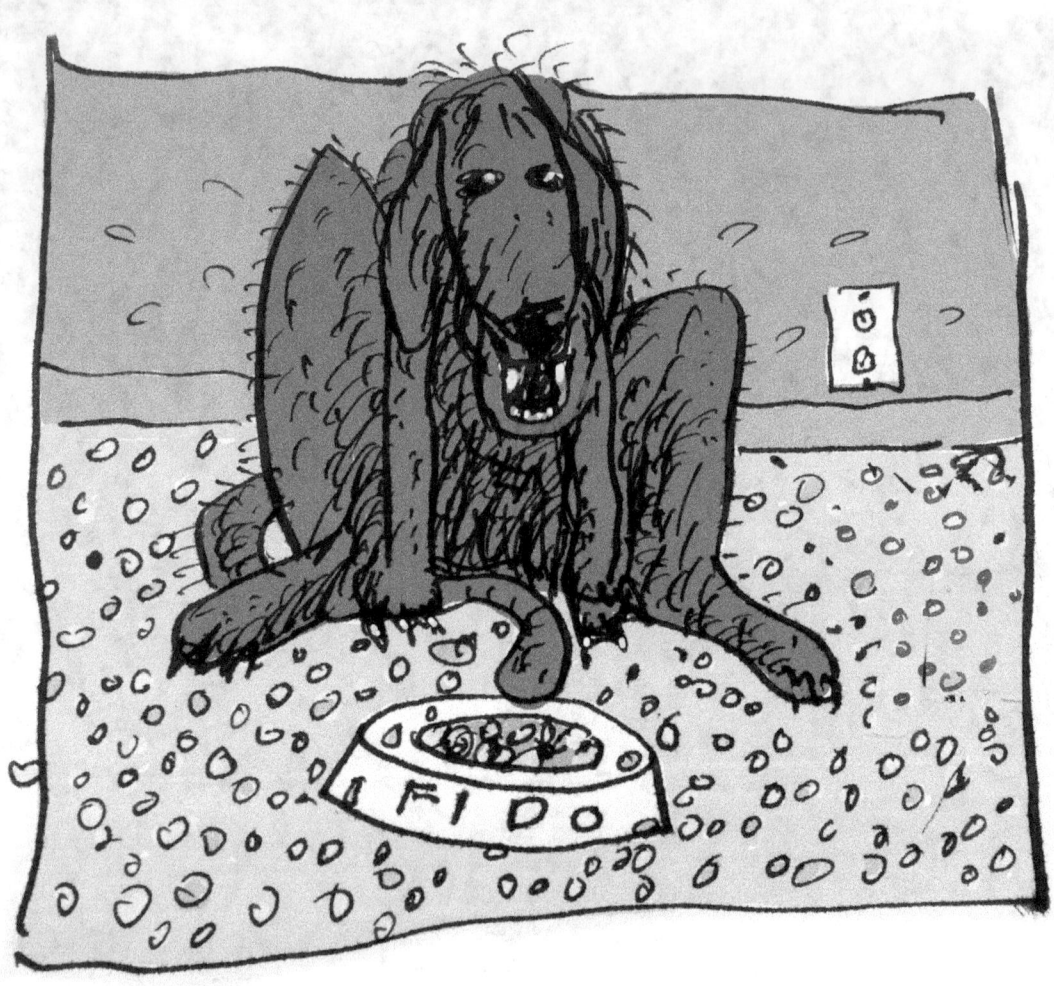

Messy eater.

Rescued dog.

Organized dog.

"I'll go on a diet if you fix your nose."

Wag the dog.

Creme de la chiene.

Bouvier des Flanders
in Toronto.

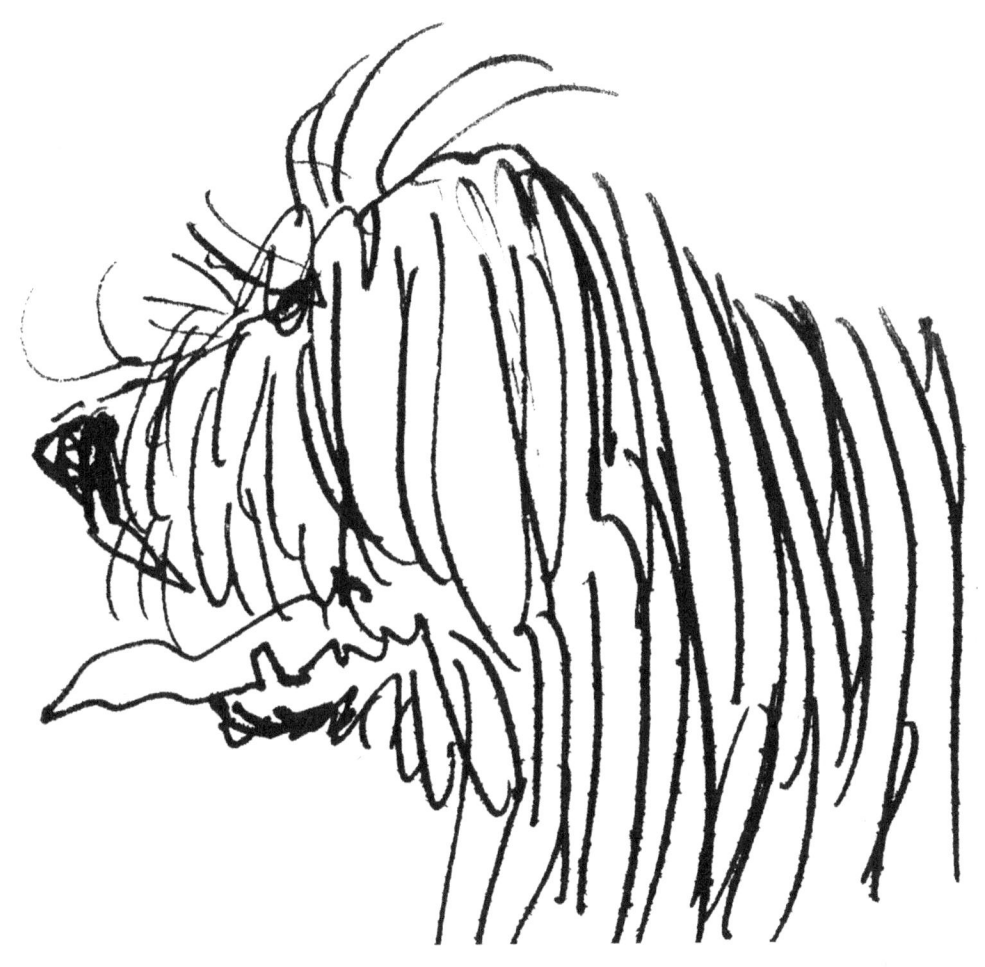

Long in the tongue.

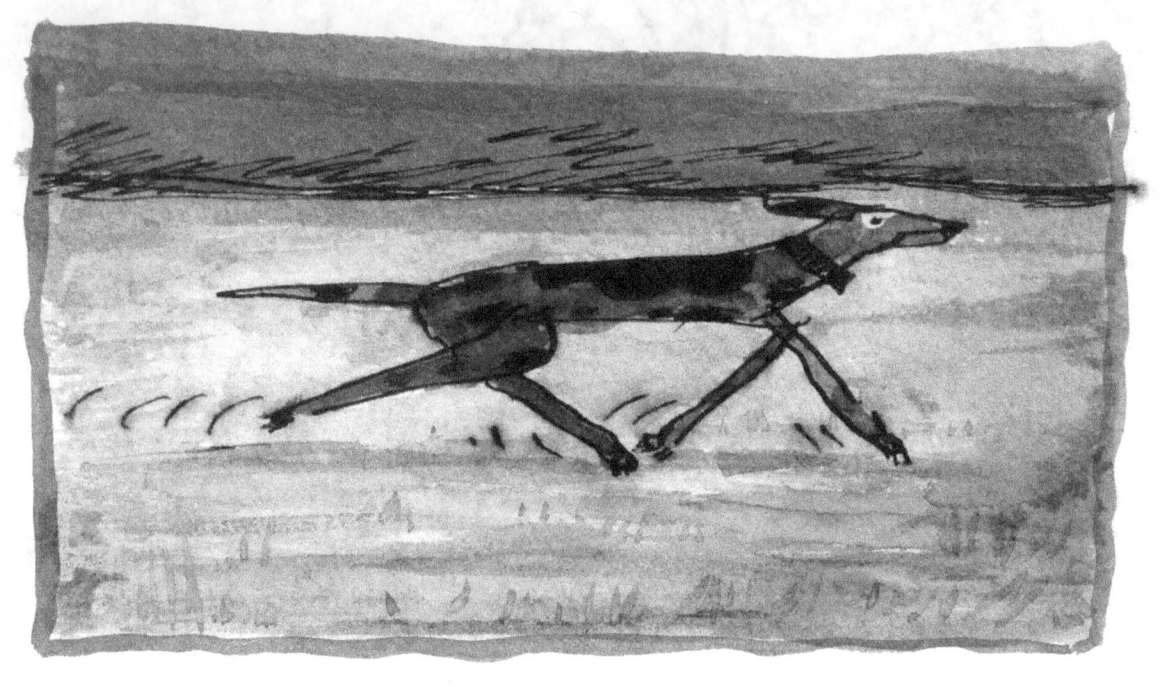

Fight or flight?

He decided on flight.

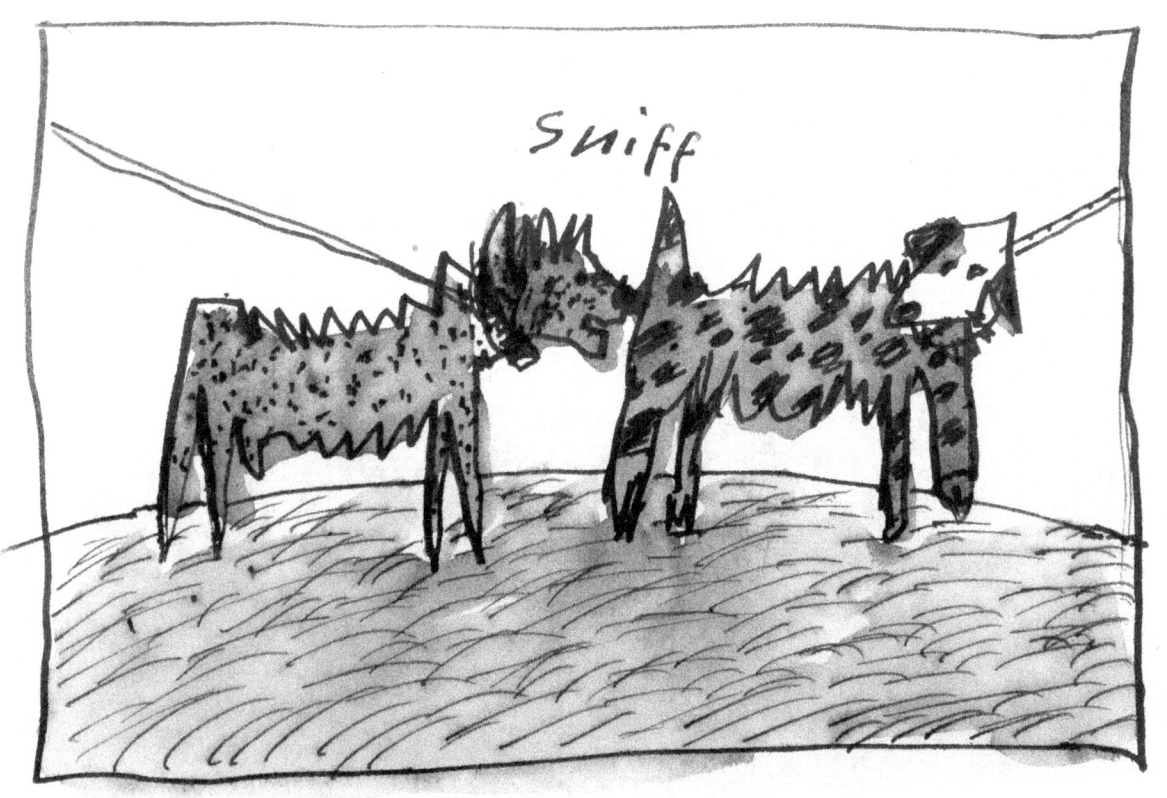

Sniffers.

First impressions are the most important.

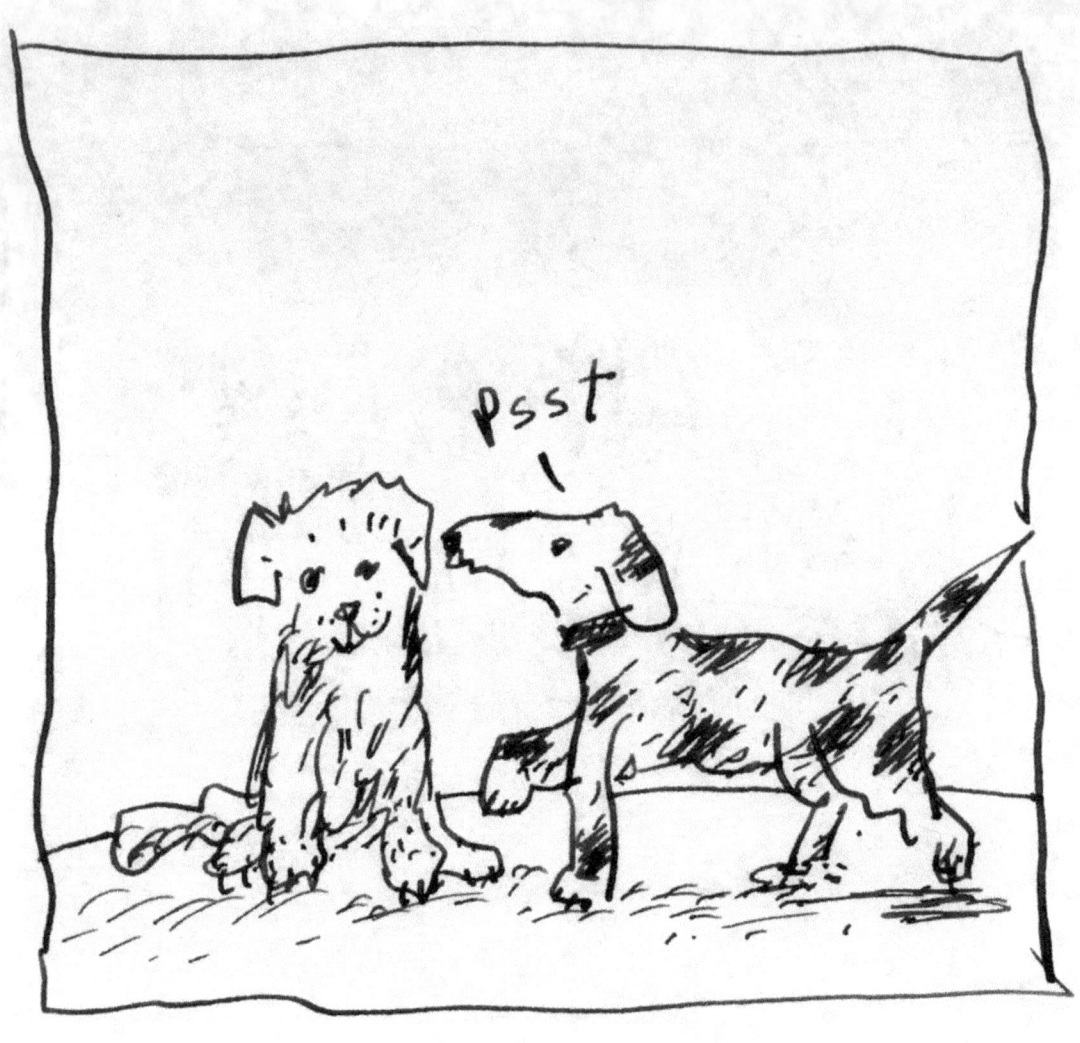

Dog whisperer.

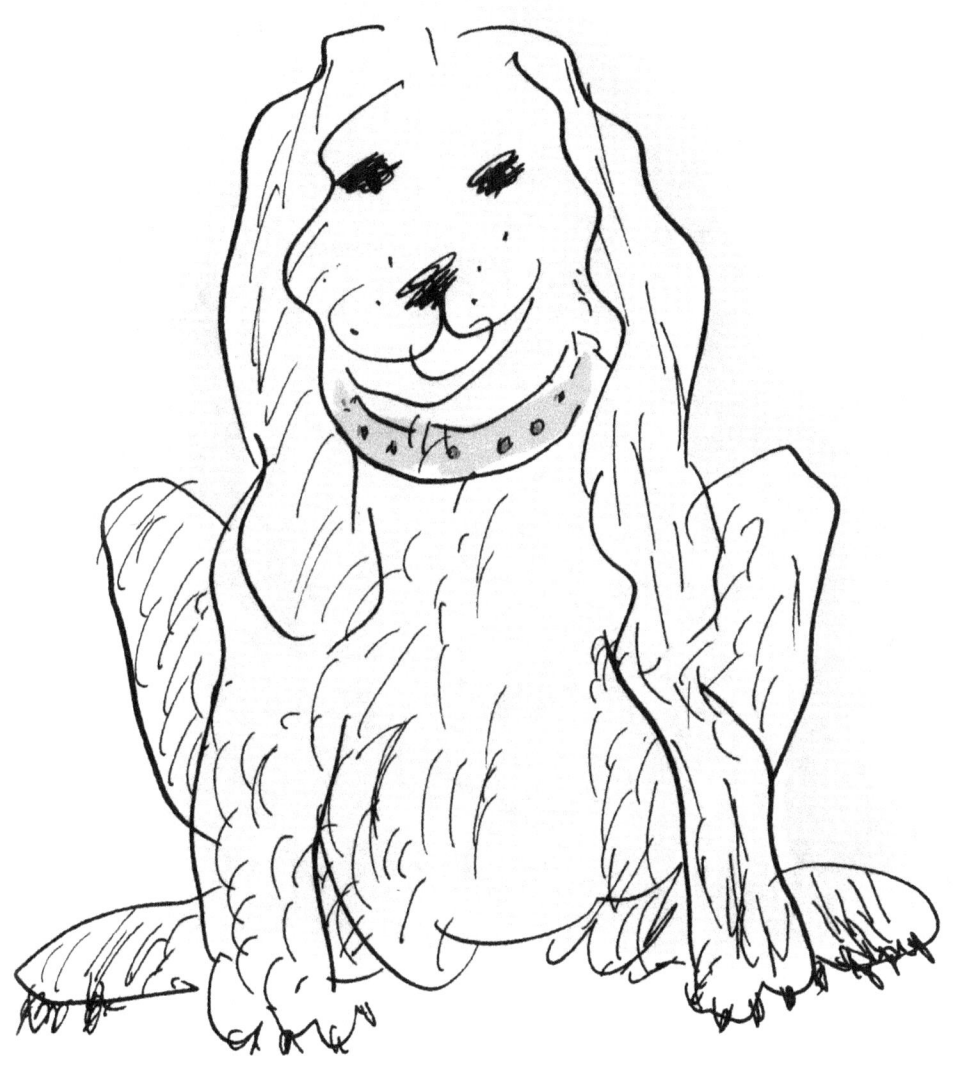

"I'm going to force
Happyness on you today"

Faraway dogs.

Much too far away to see.
But you can hear them bark.

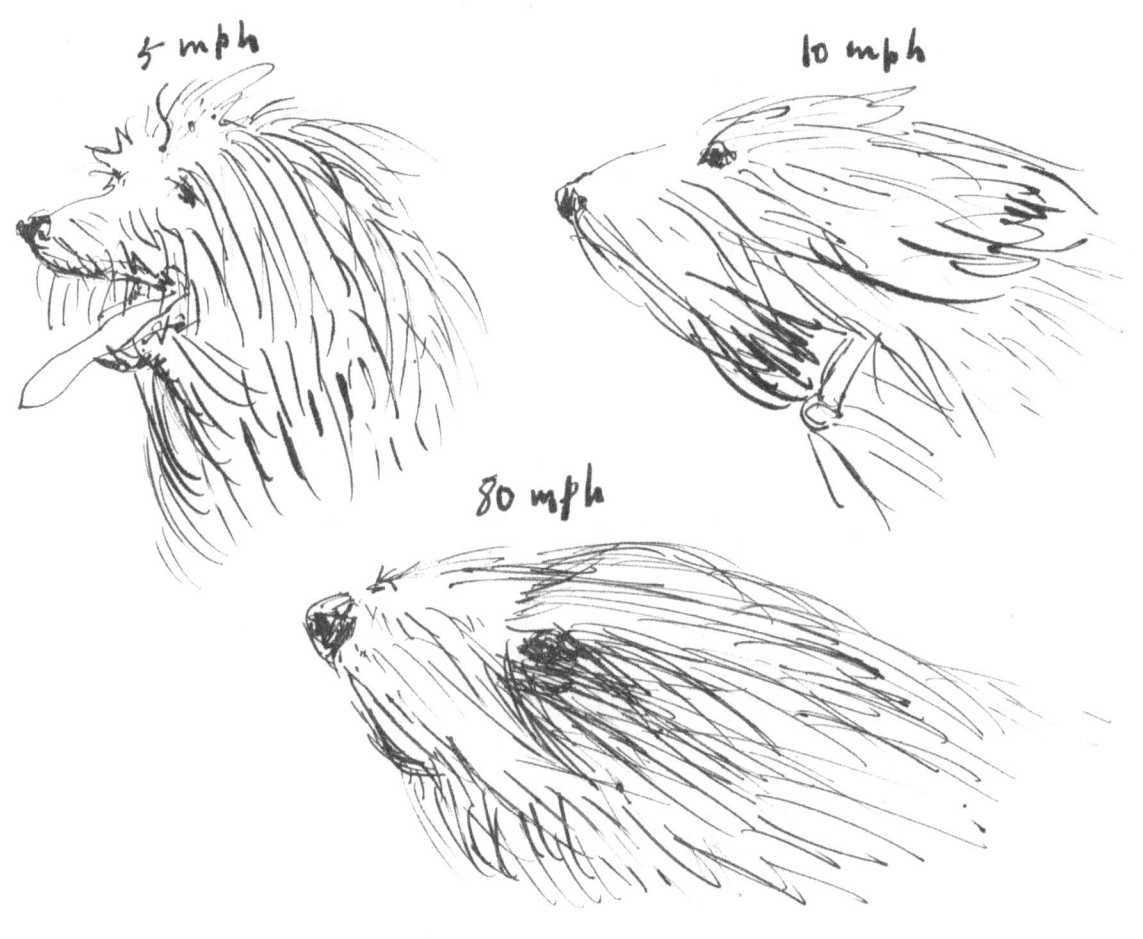

Dog speedometer.

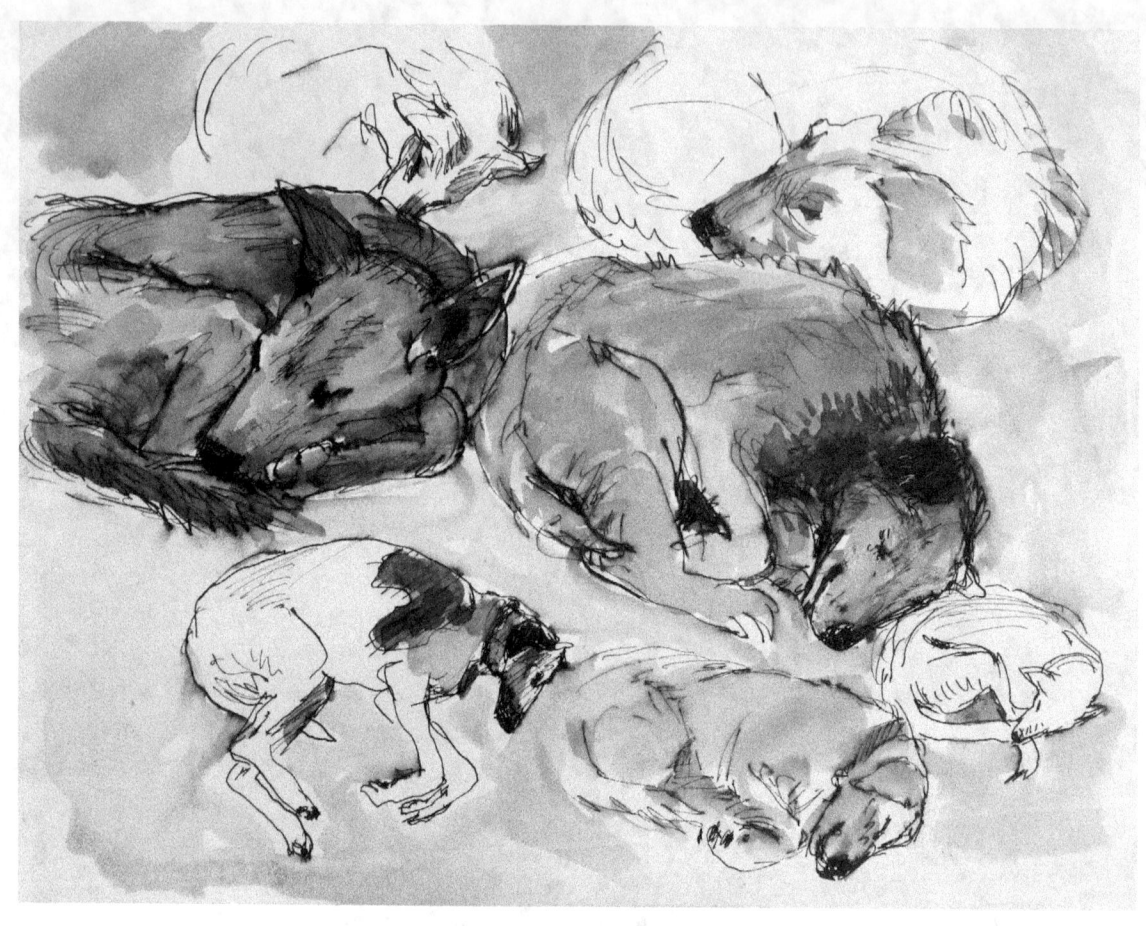

Osocozy dogs.

Alfred

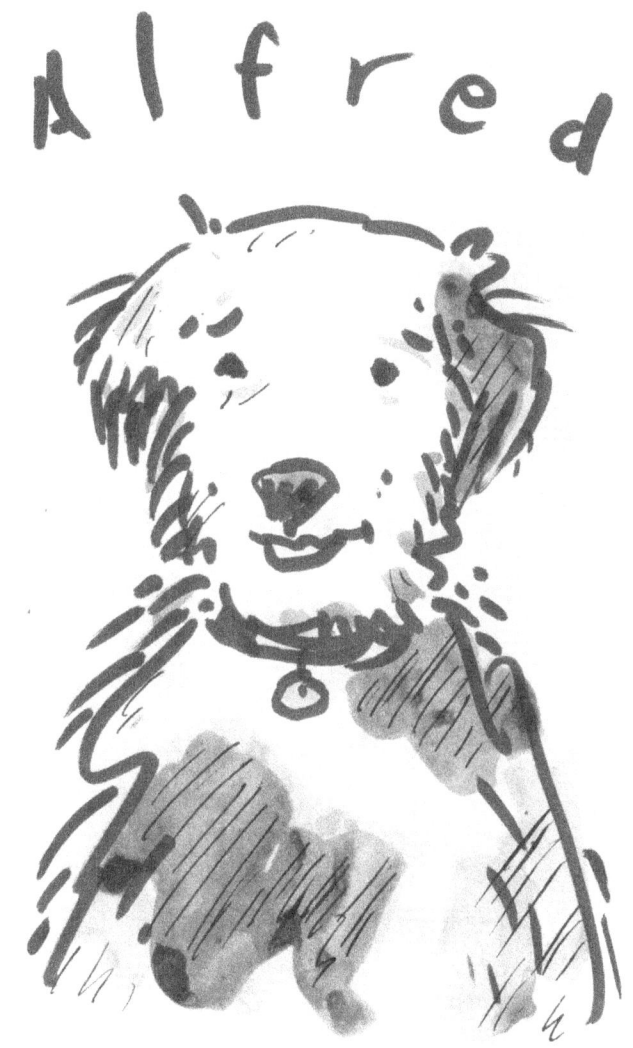

What's it all about, Alfie?

Many a dog has been asked this very question.

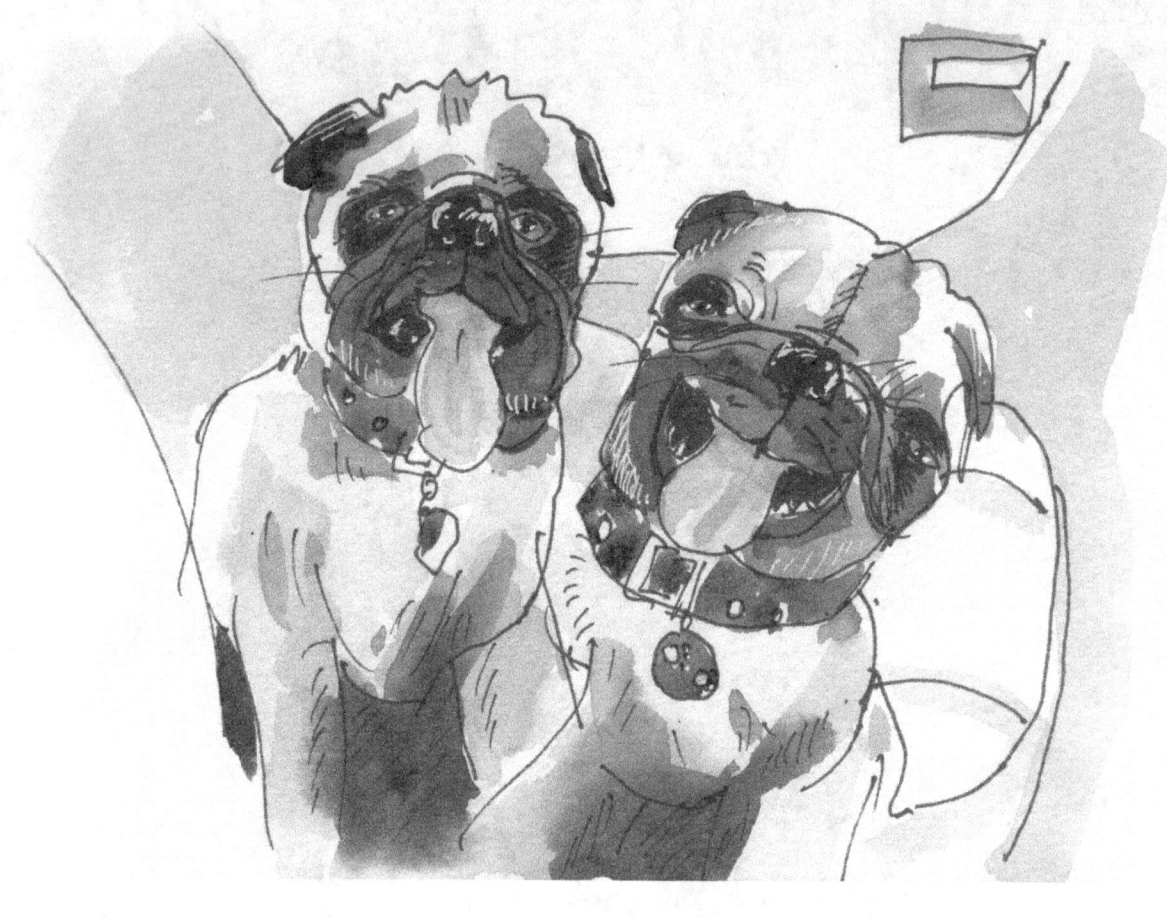

Pugs in a bucket seat.

Their names are Zeus and Pennie.

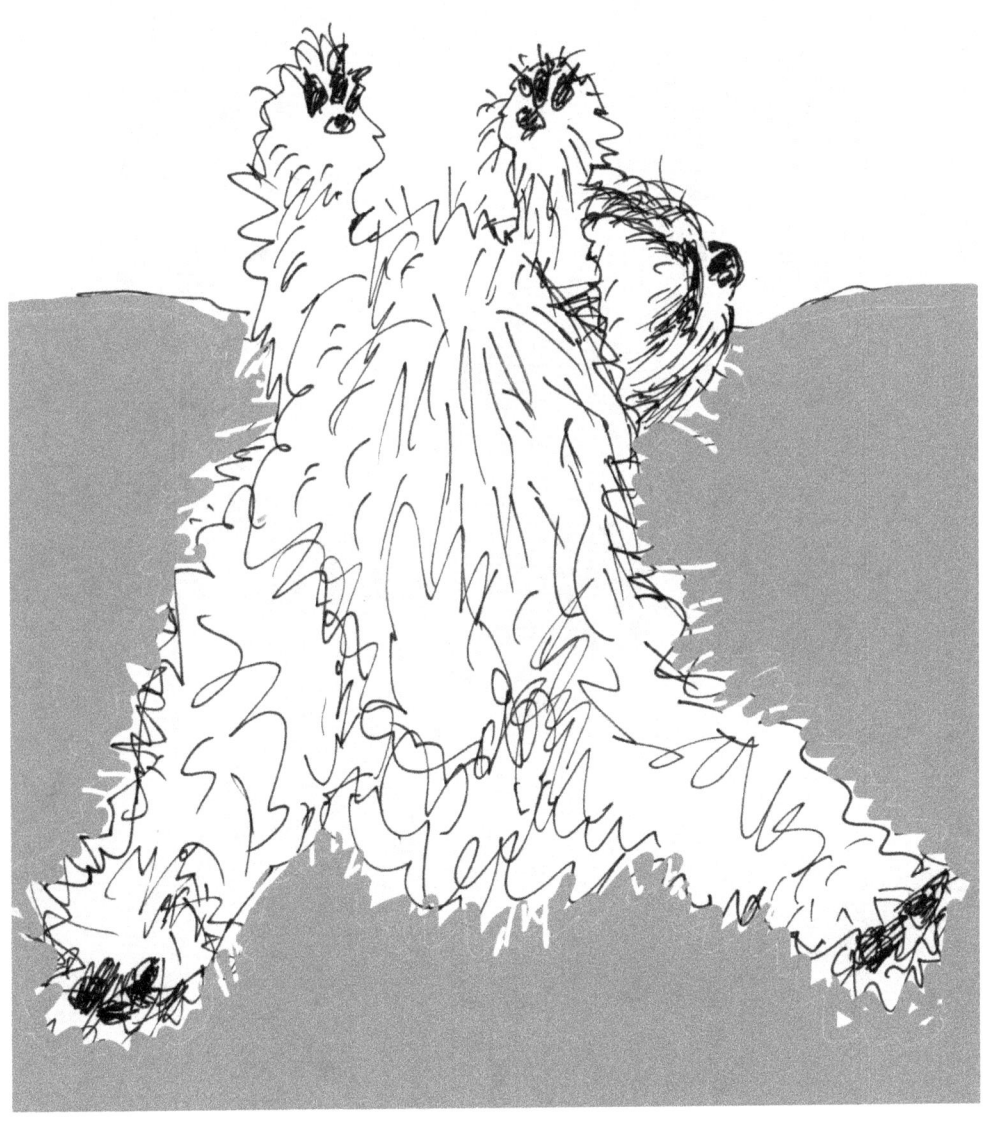

Barkalounger.

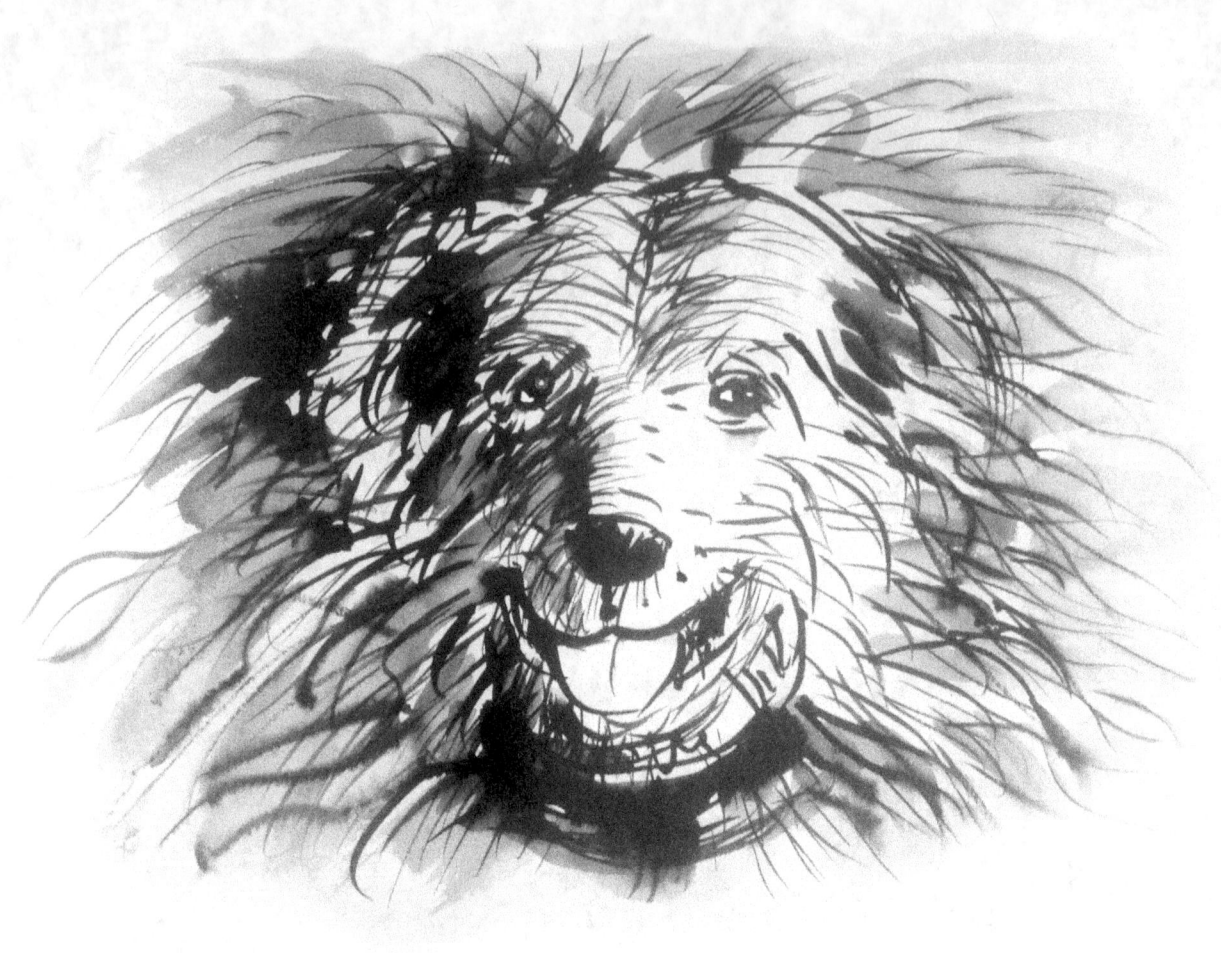

"All this hair will soon be in your car."

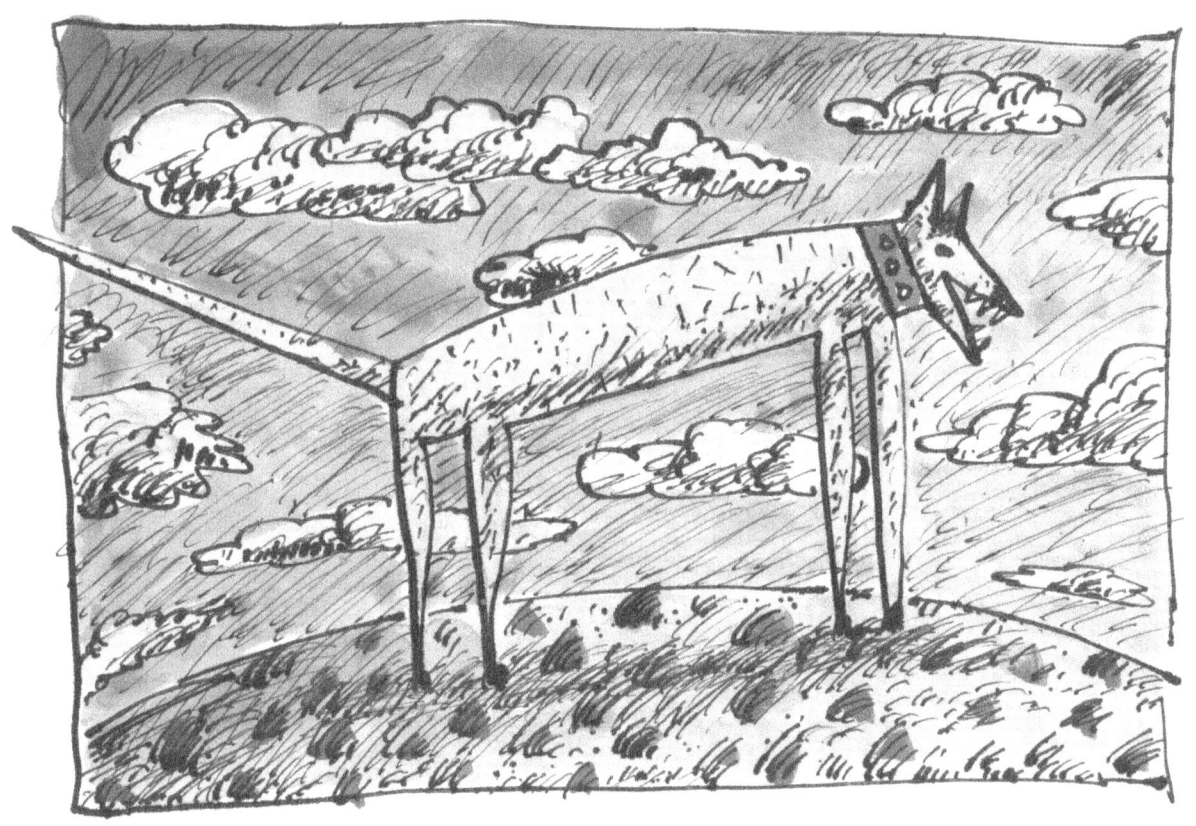

Sticky Rick.

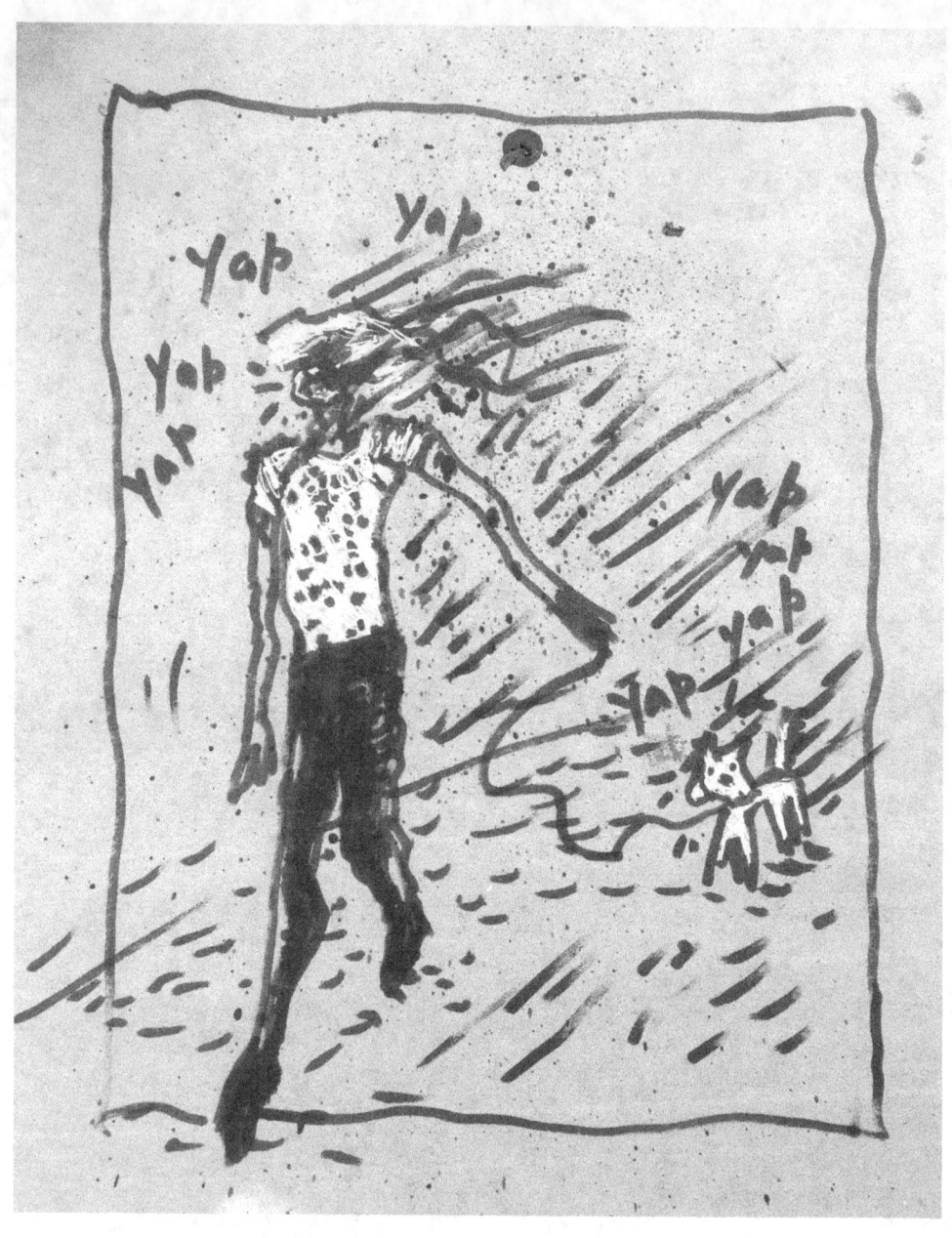

Yappers. Both of them.

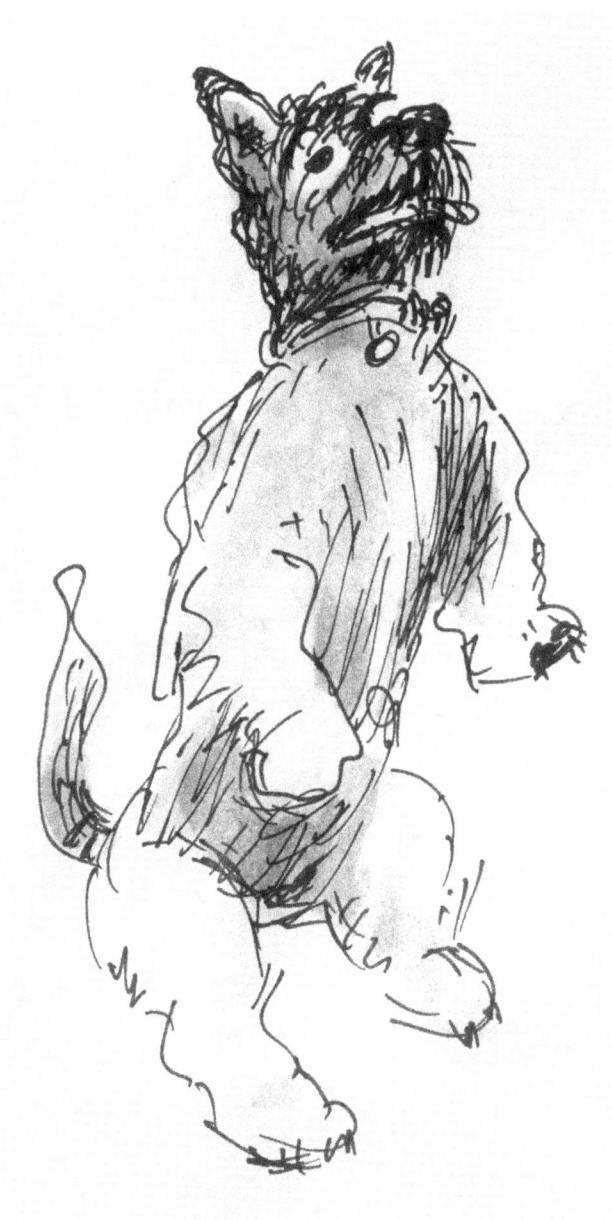

Treater time.

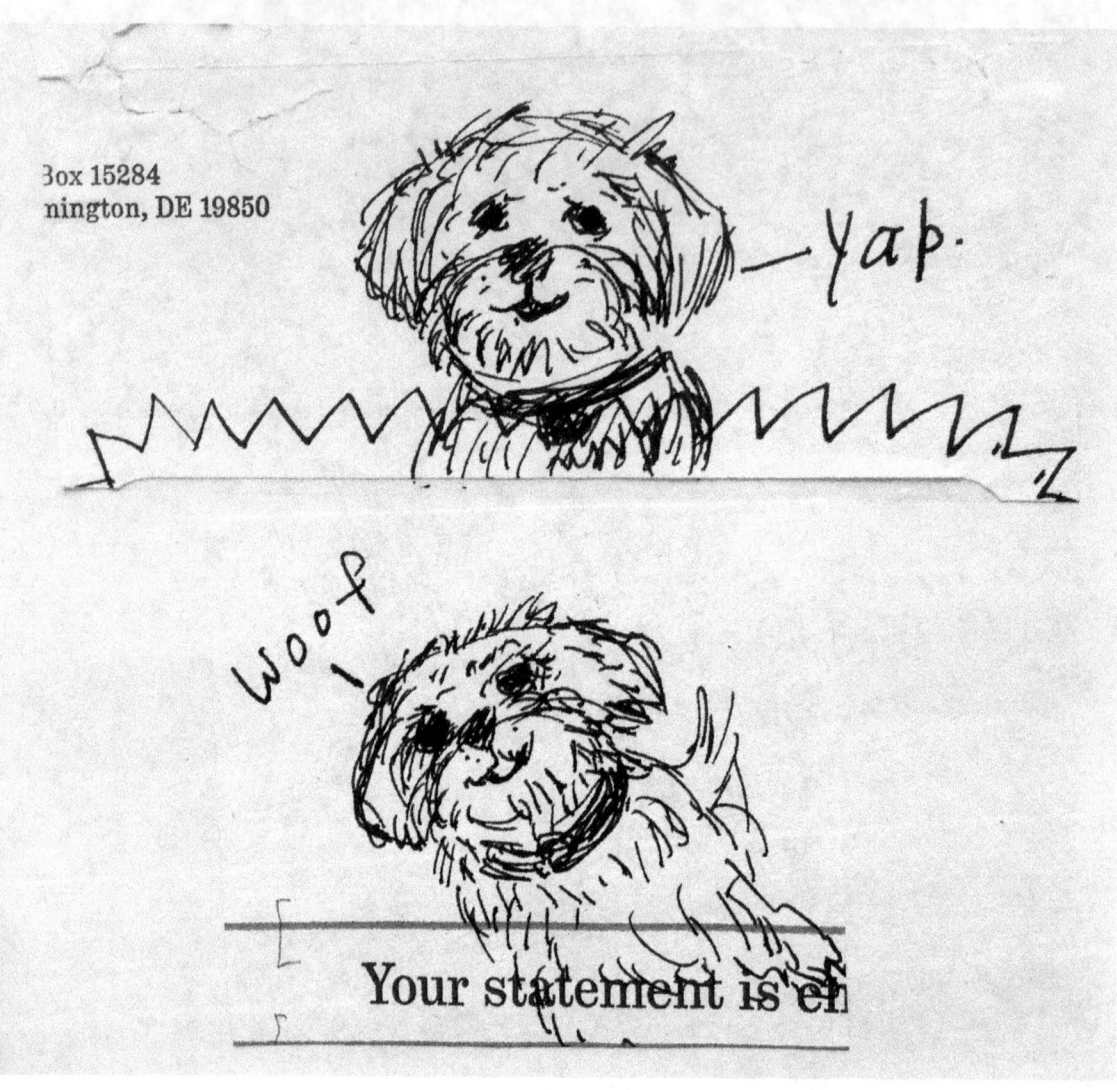

Dog statements.

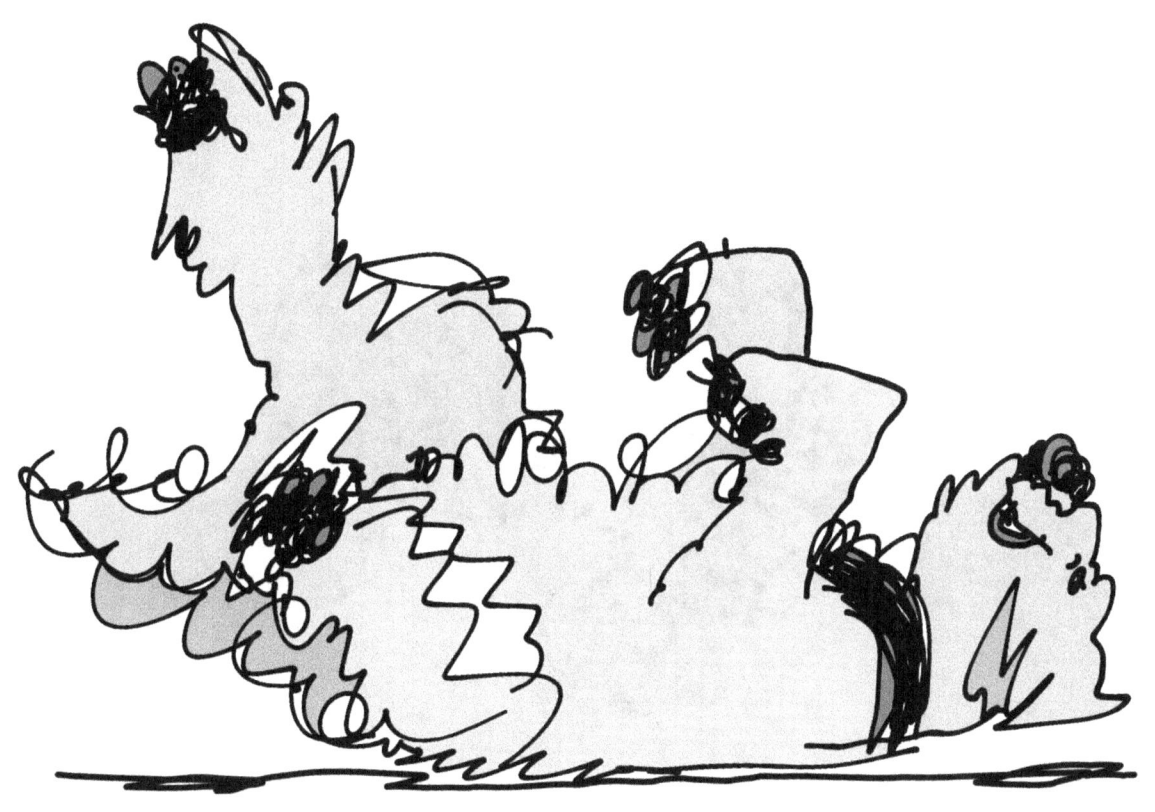

Afternoon delight.

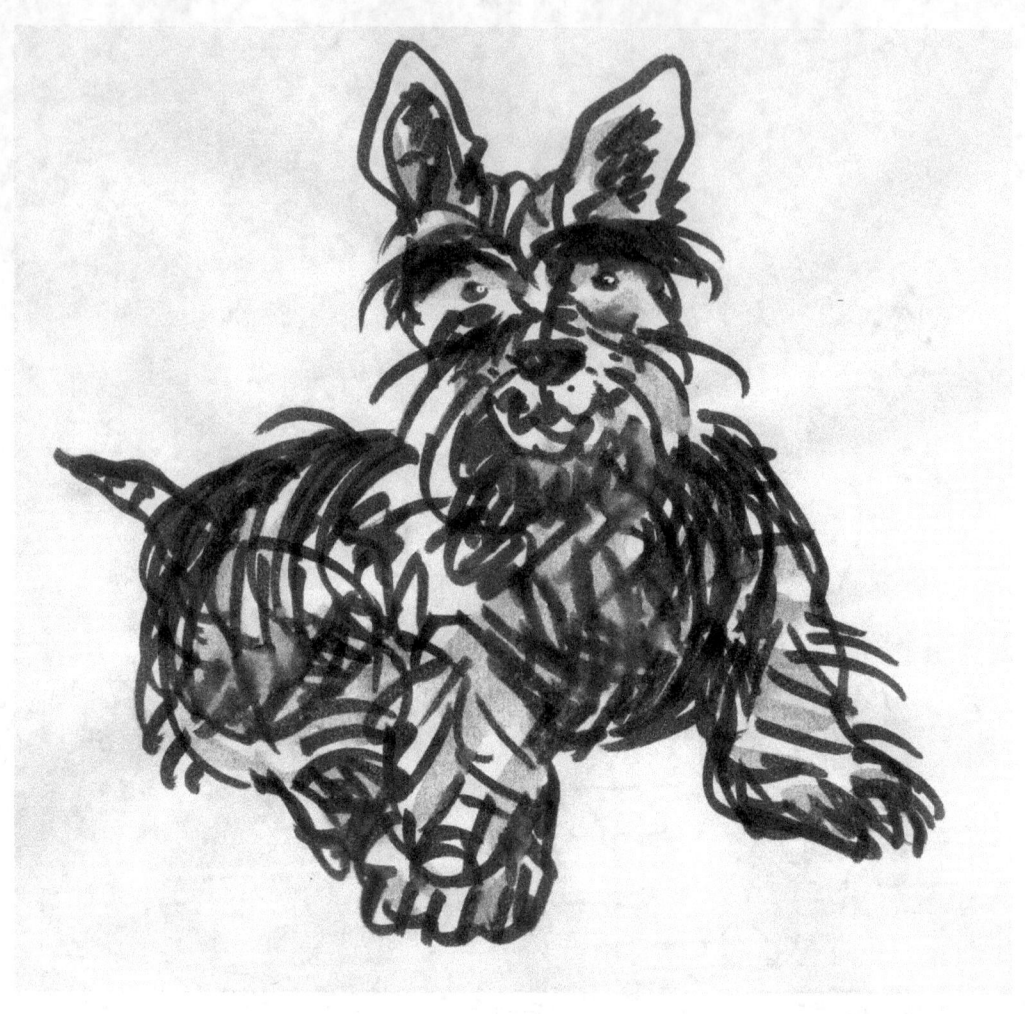

Scottie without his kilt.

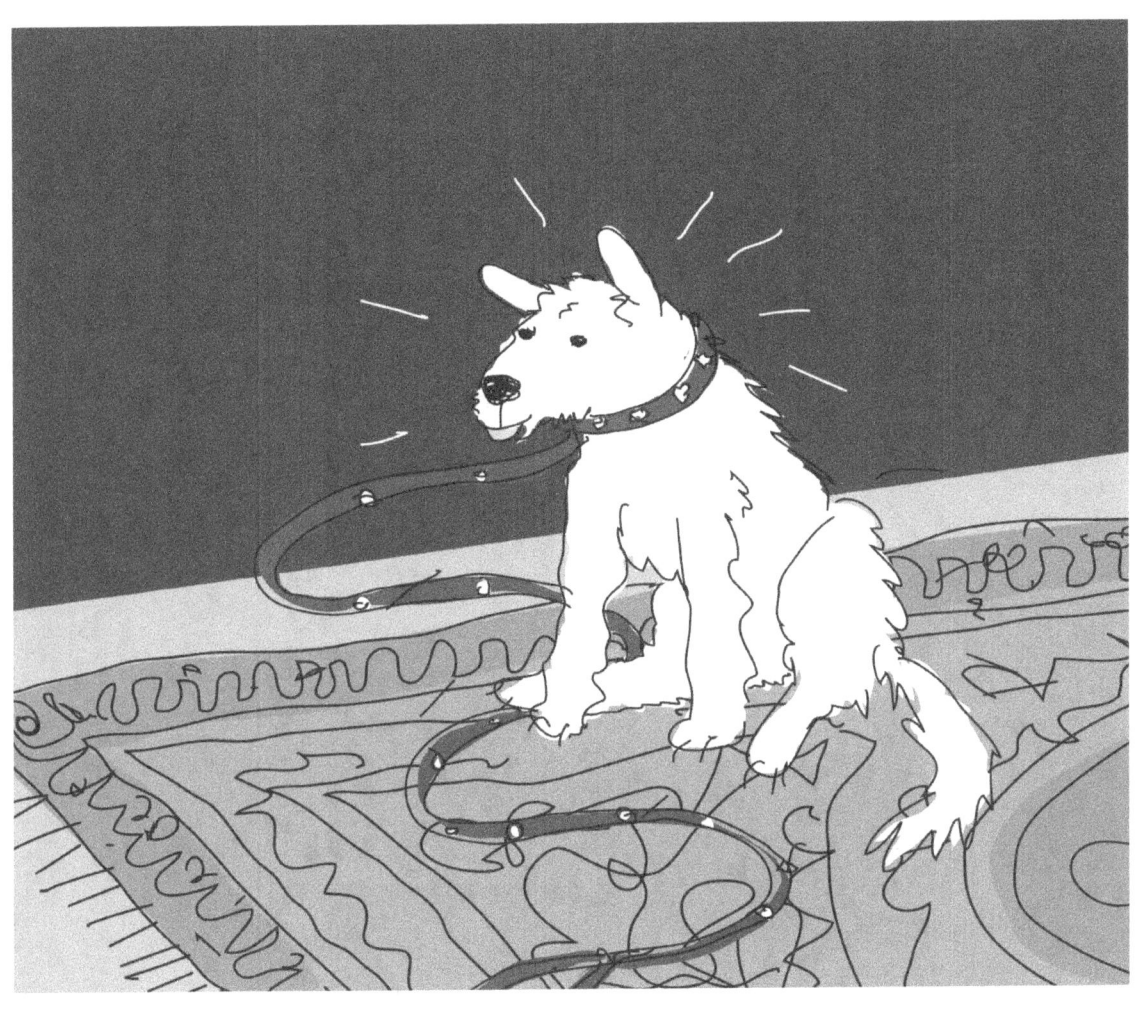

A bit of a worrier.

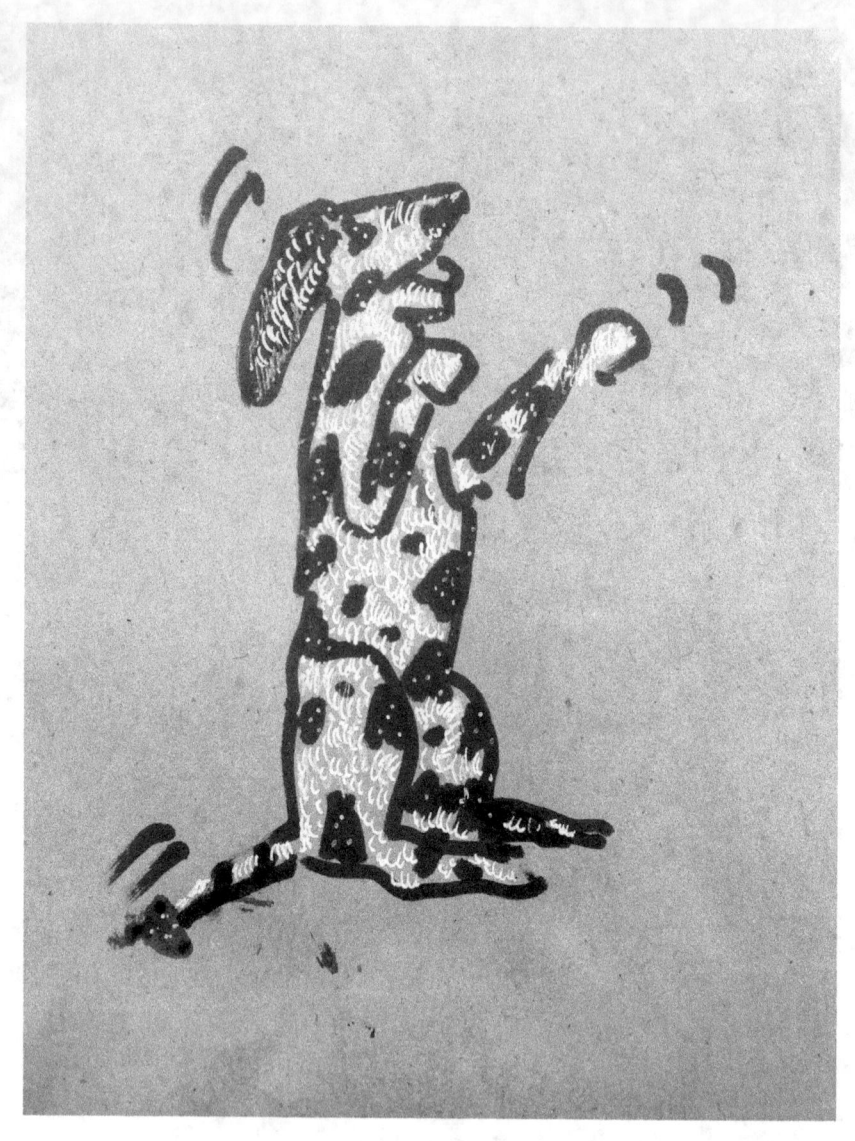

A boxer.

Not into wrestling.

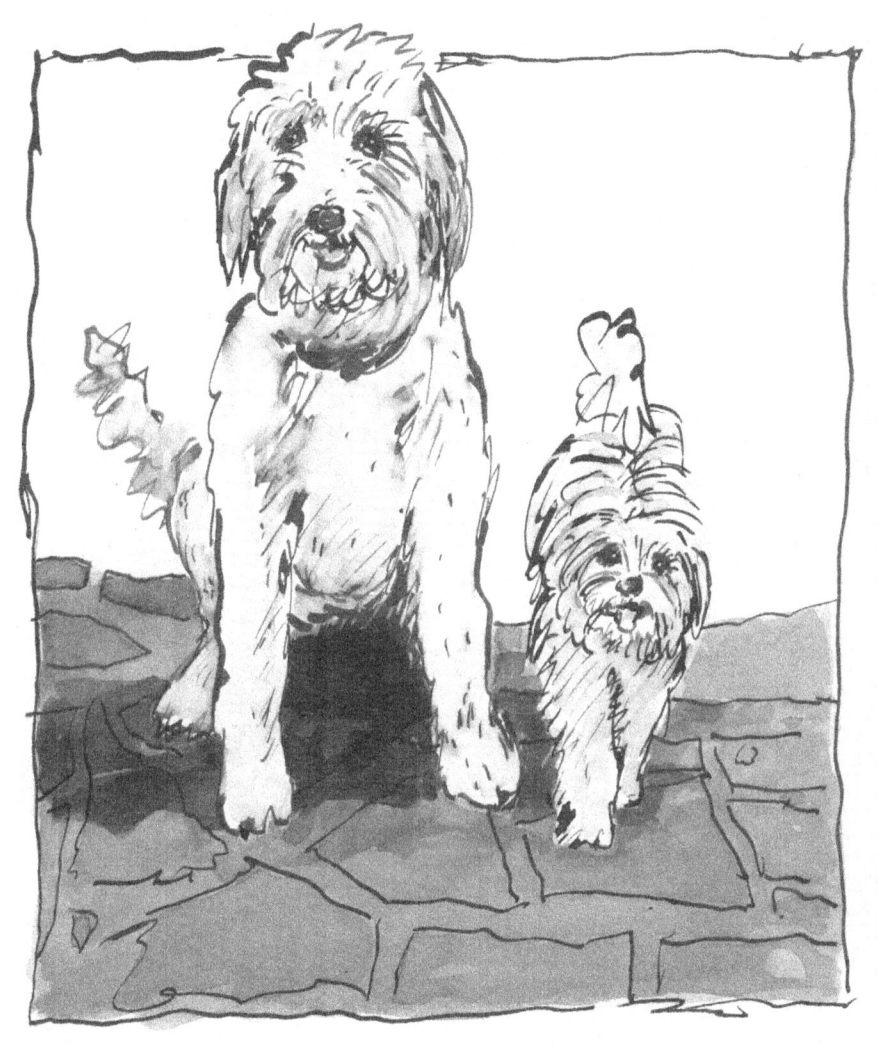

Sonny and Chloe.

Straight outta Malibu.

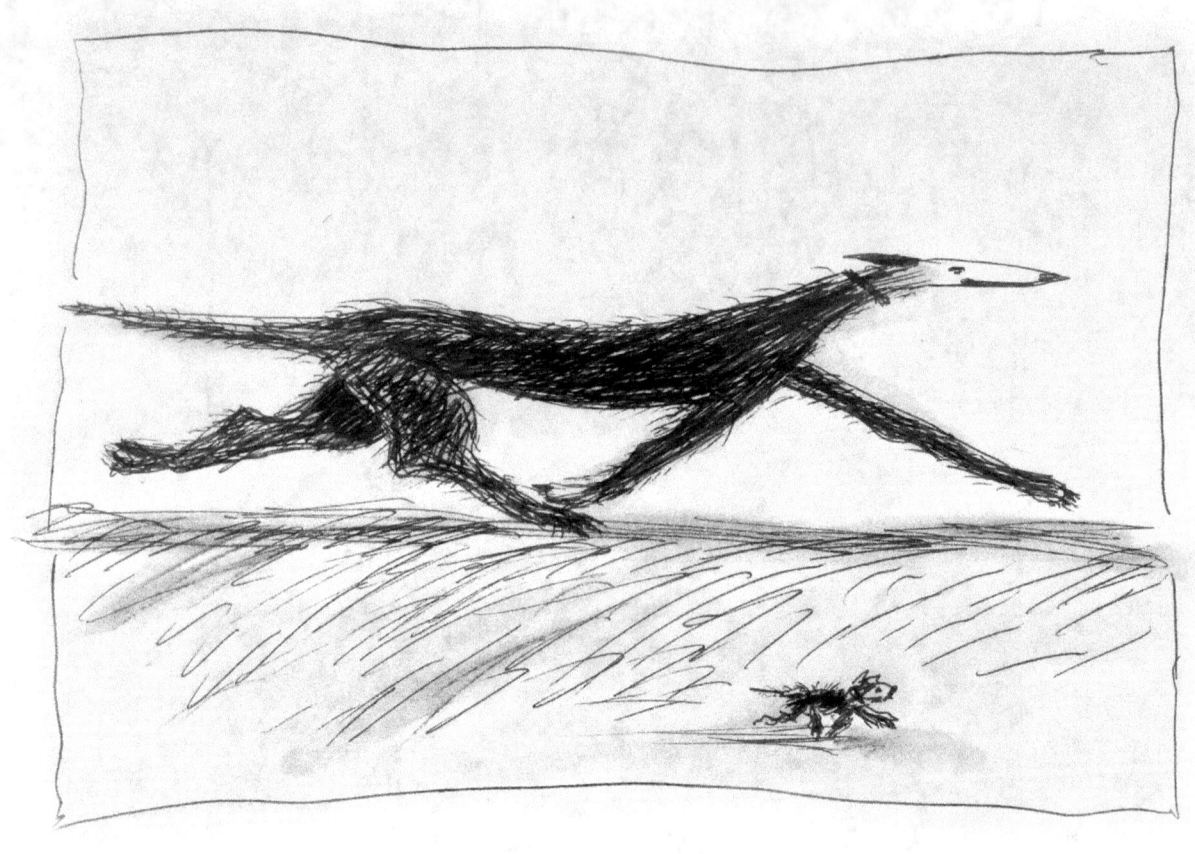

Go - getters.

On their way to go get.

Watchdogs.

One hundred percent Mongrel.

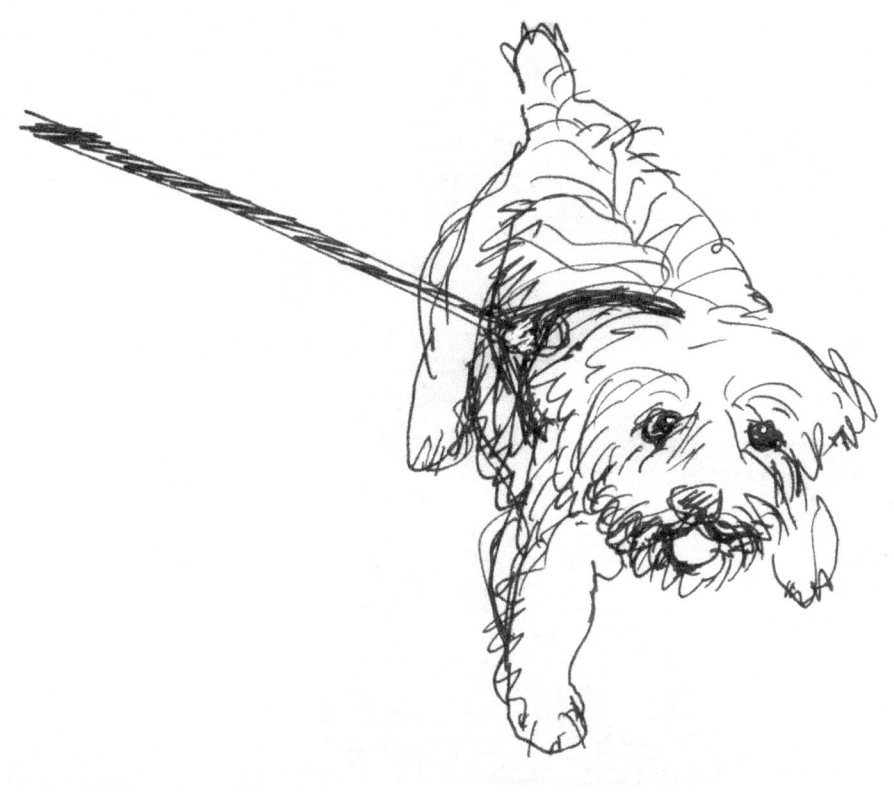

Easier to pull than to push.

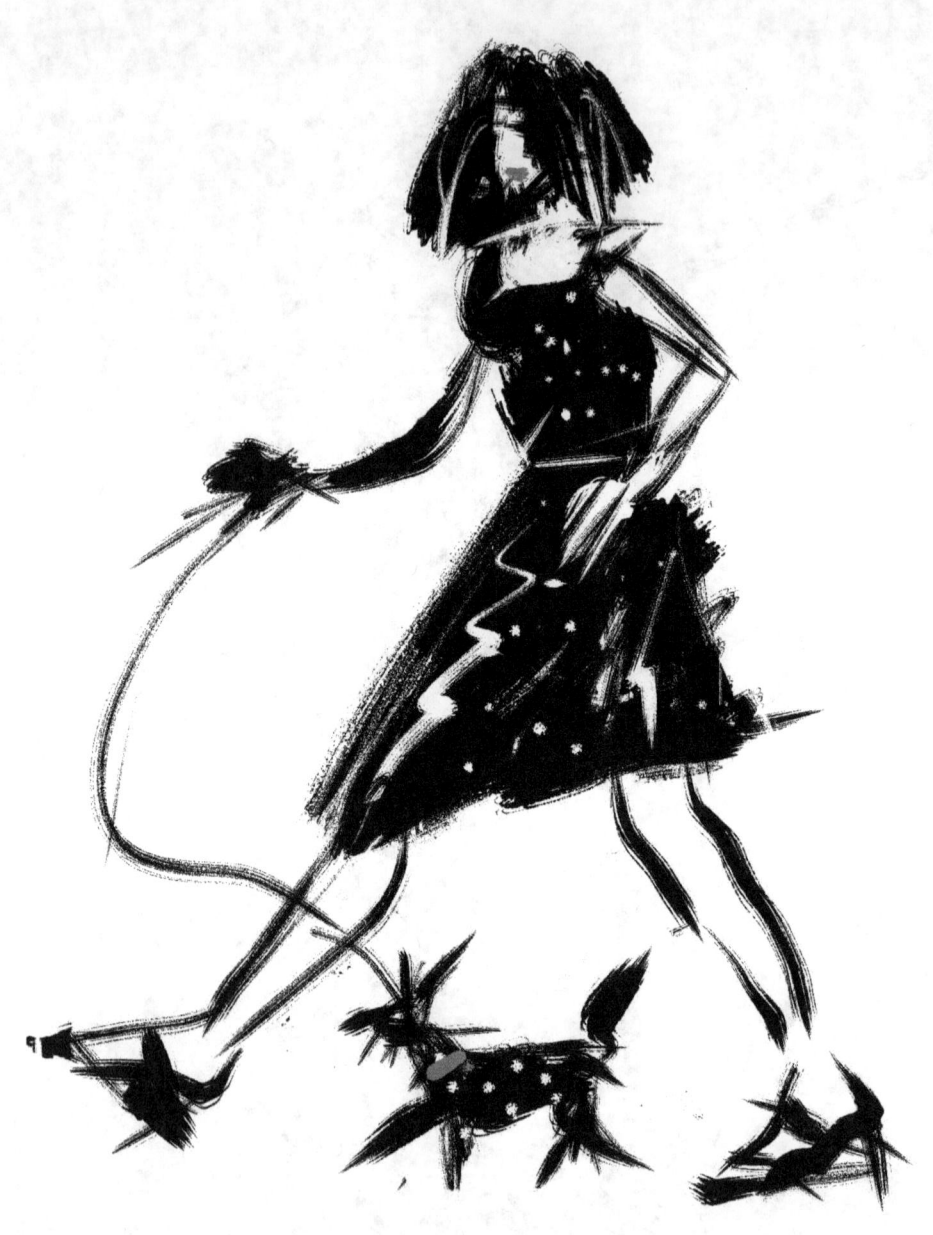

Matchy matchy.

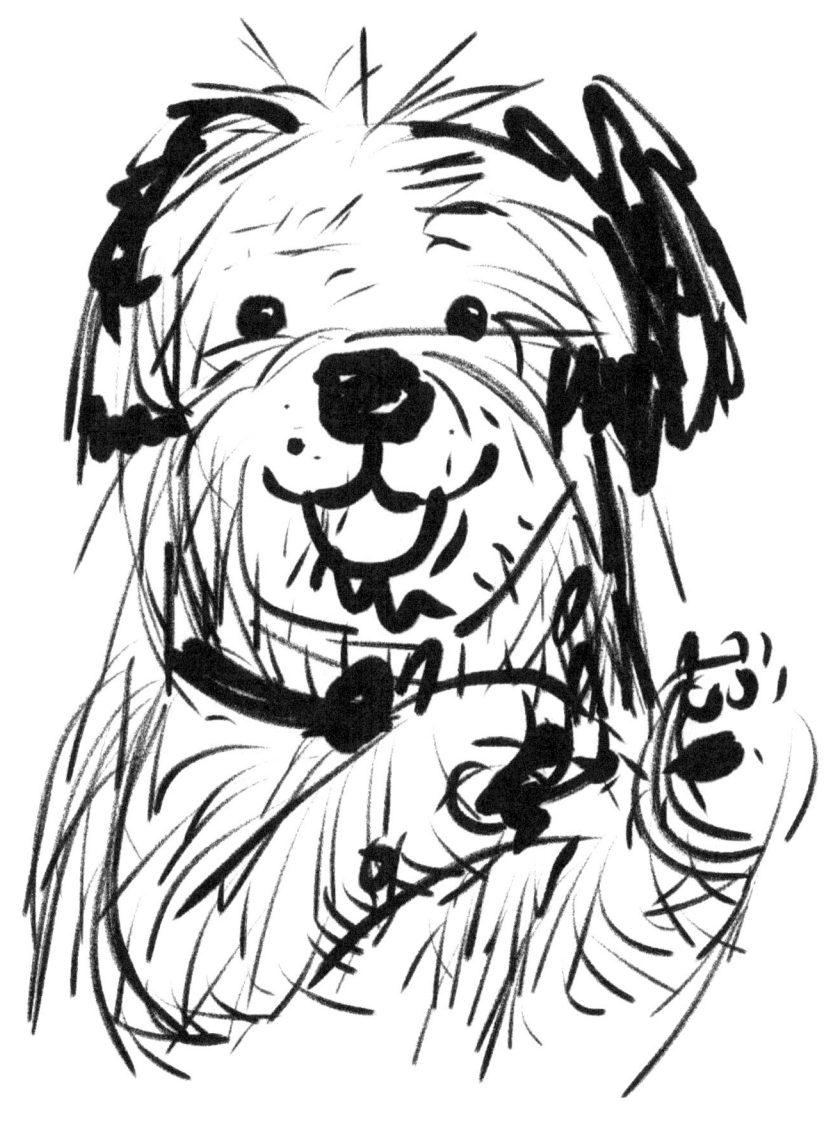

Portnifoy, the conducter.

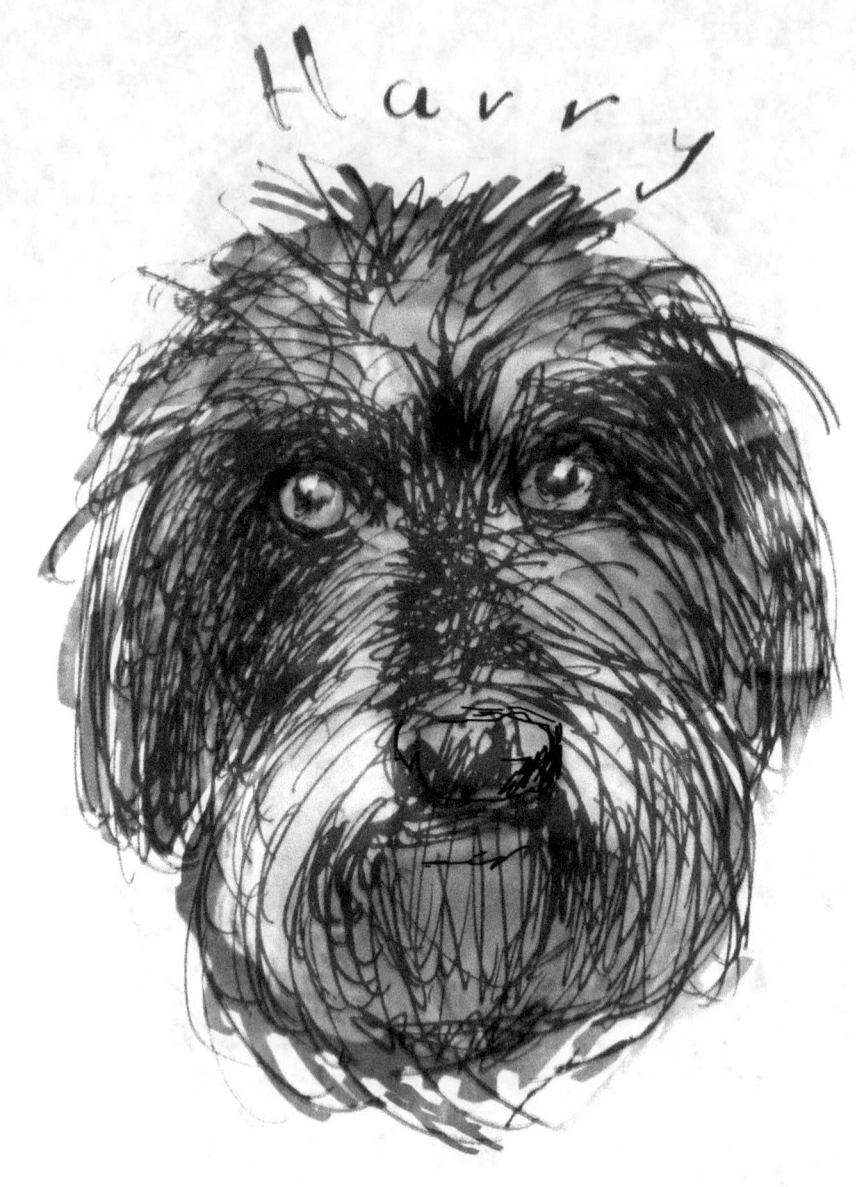

*When he looks at you,
you melt.*

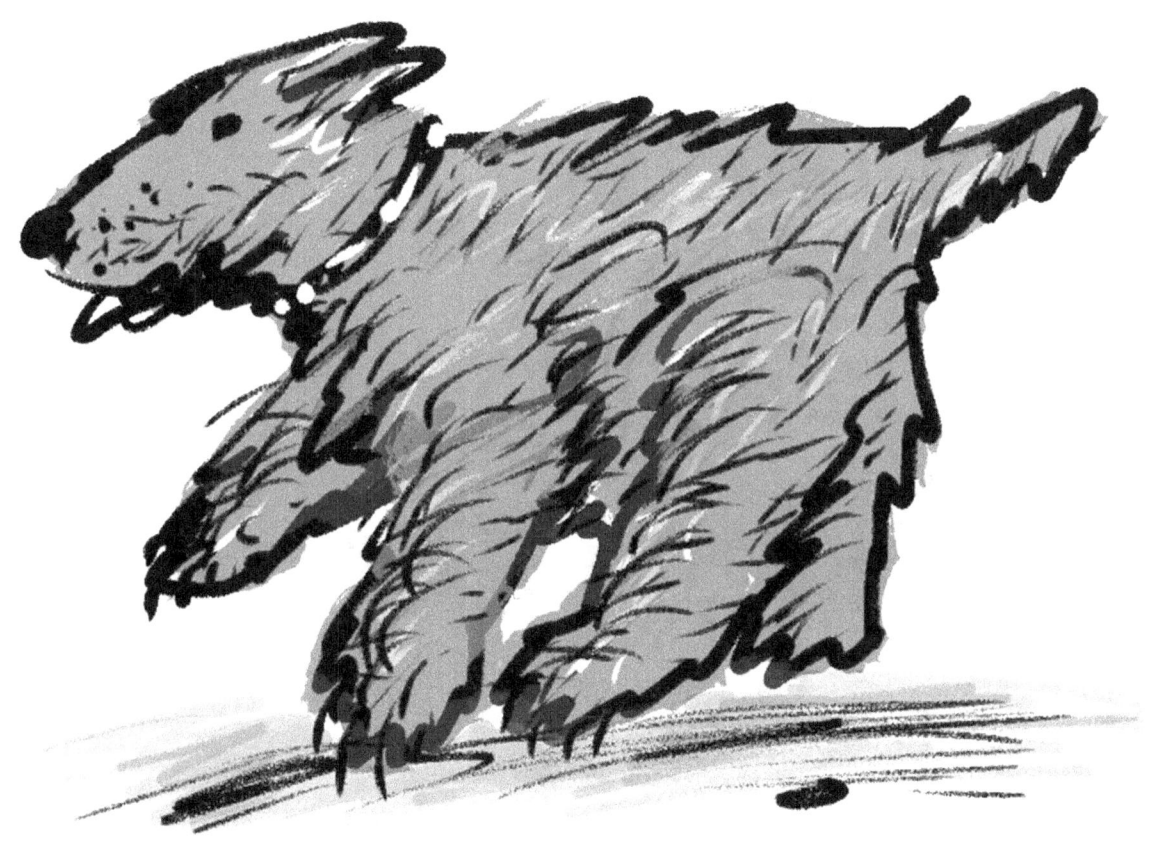

Charlotte the starlet.

Lives in Hollywood.
Loves it.

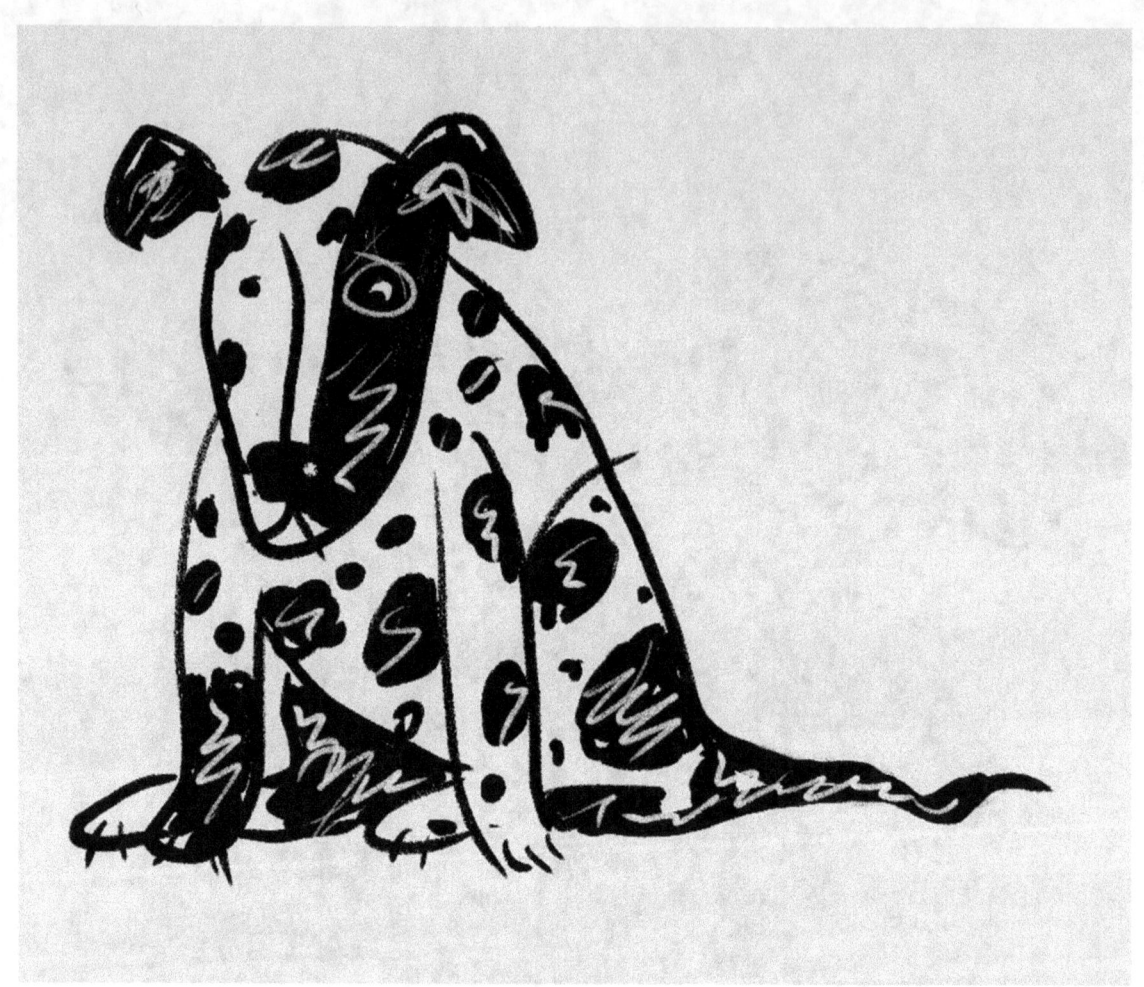

Covergirl.

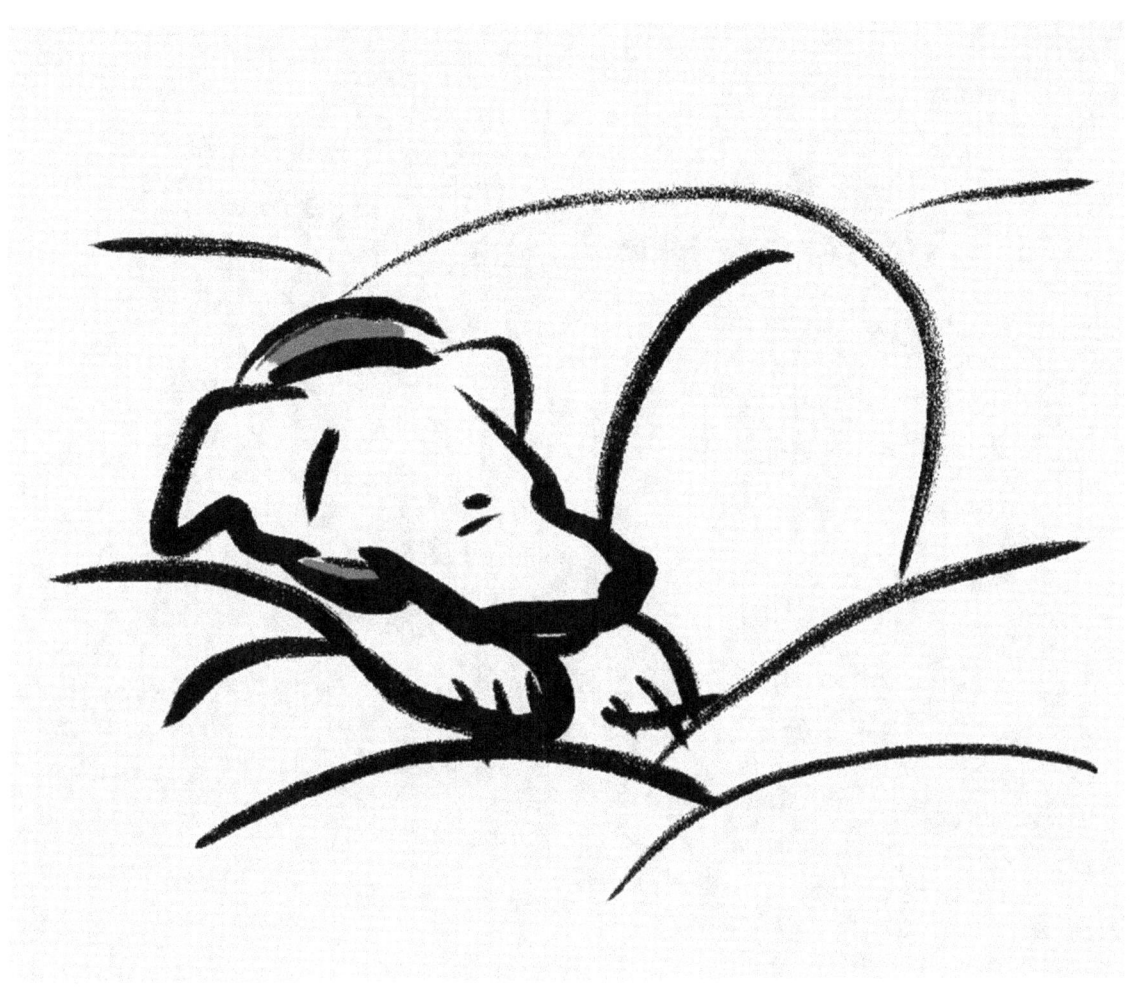

Sleeping beauty.

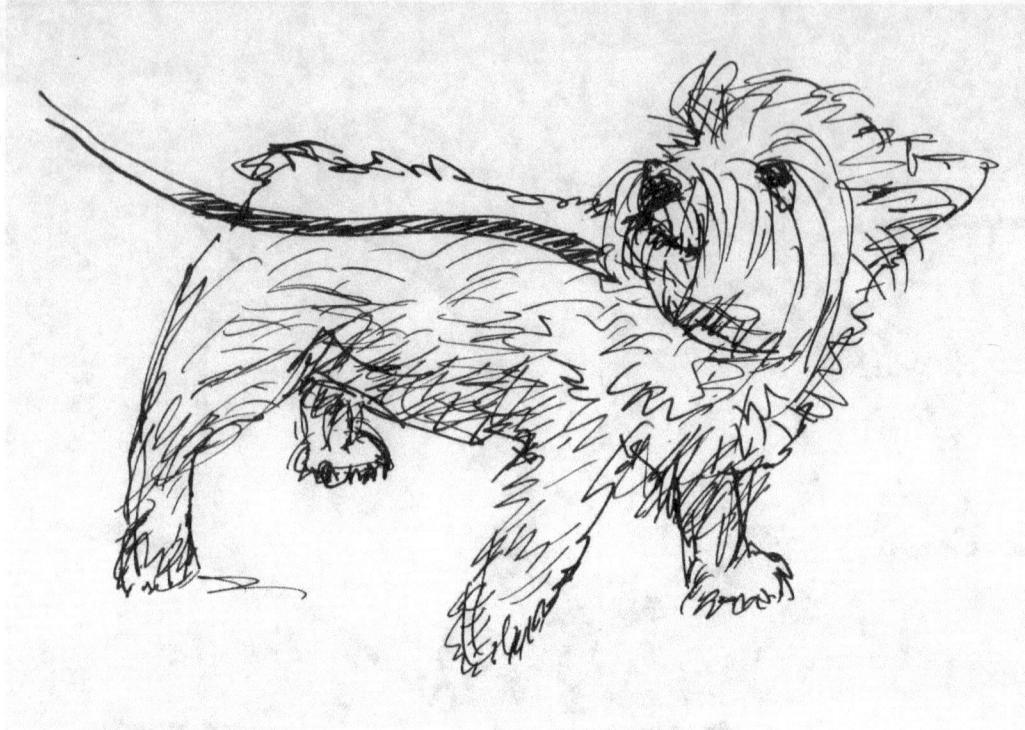

Did you say something Boss?

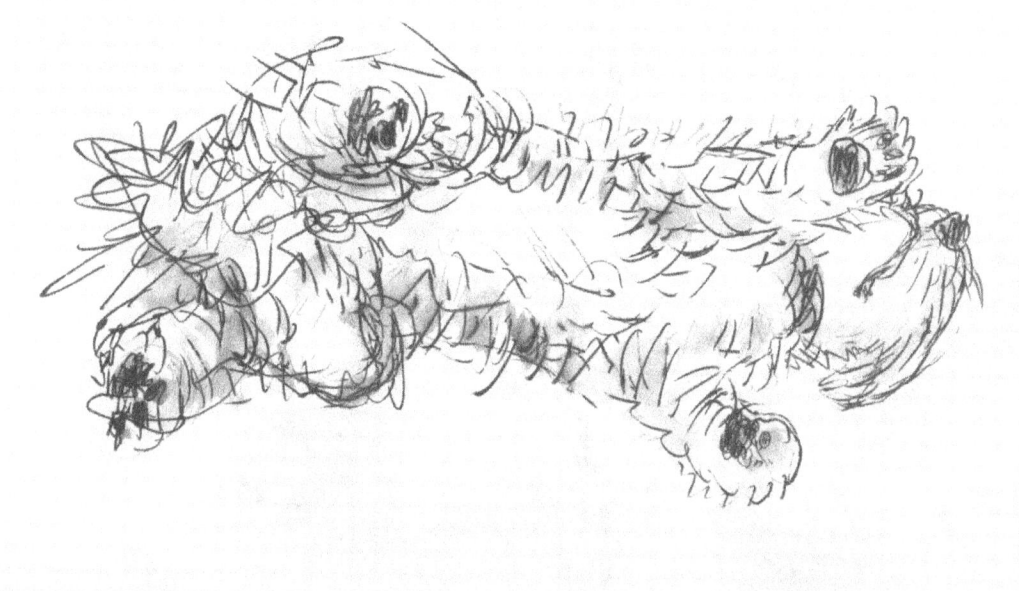

Portnifoy's fall back position.

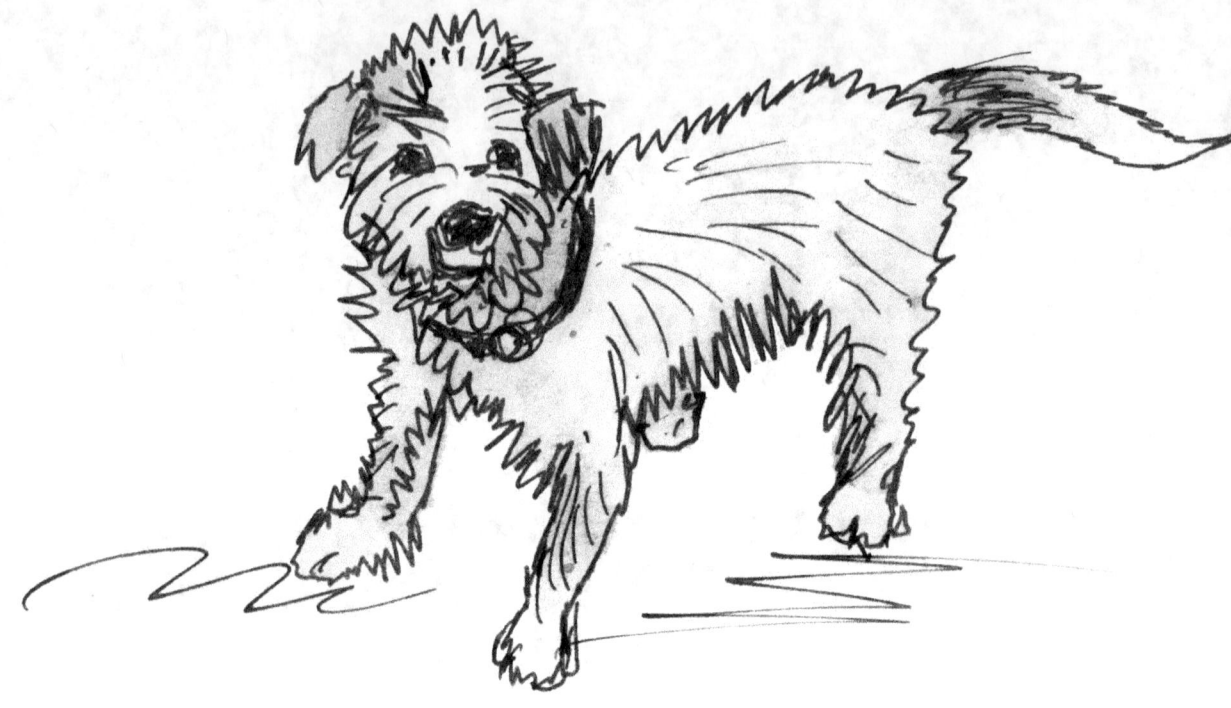

Penny, the peppy puppy.

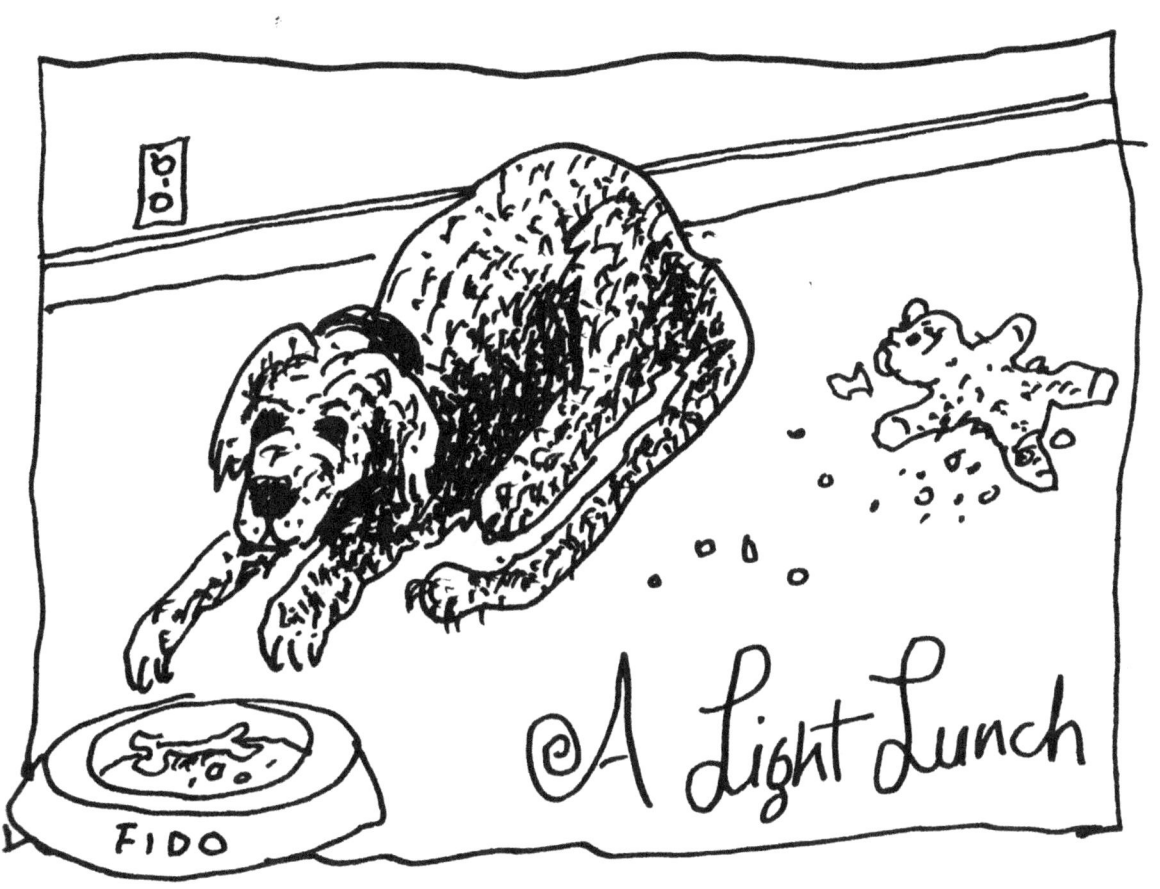

Fido had some bones and a teddy bear for lunch.

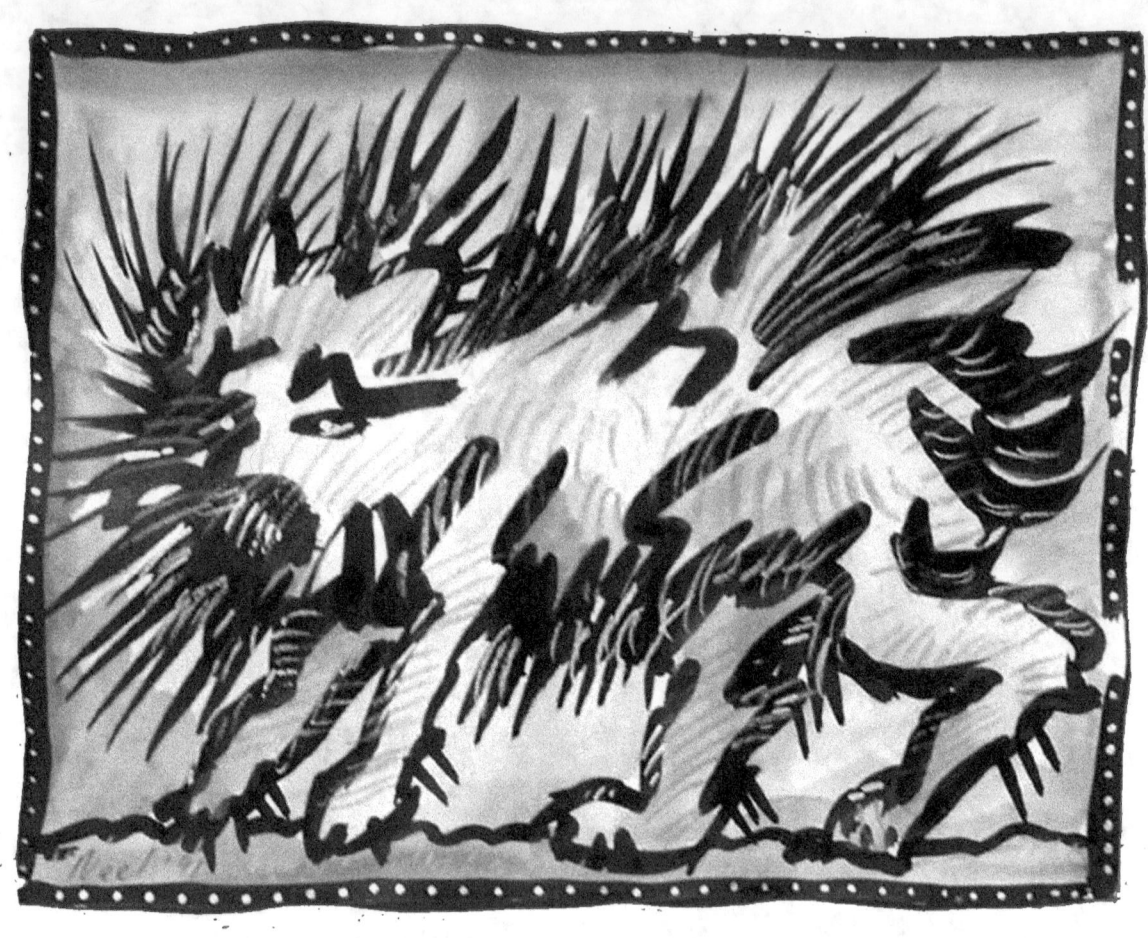

Cubbie plugged – in.

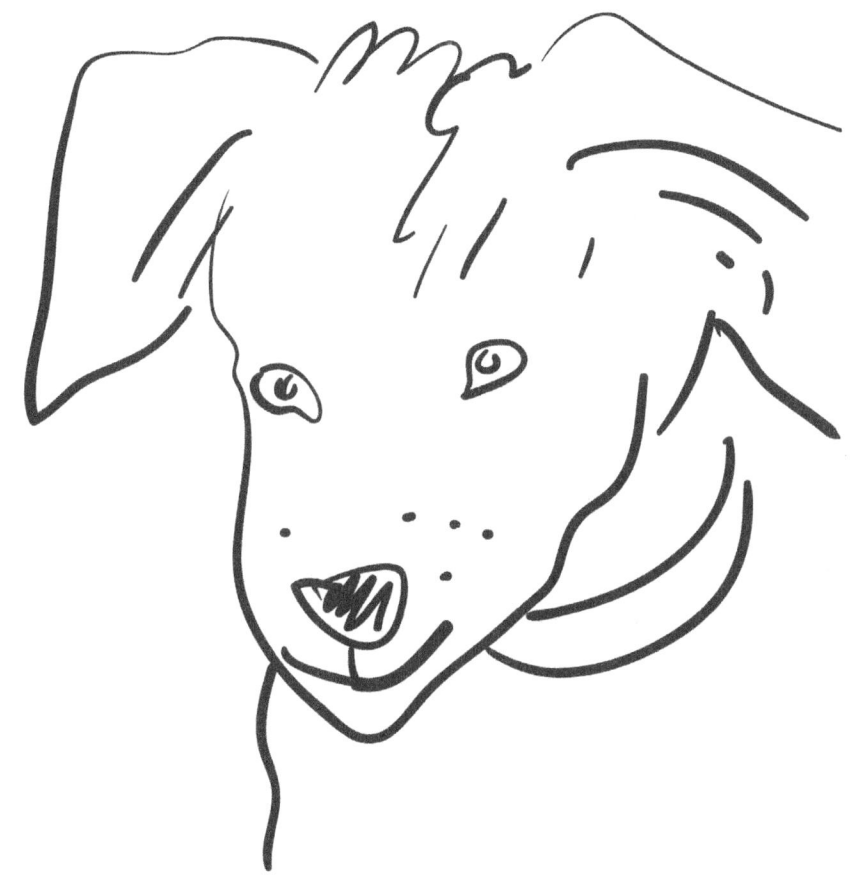

Simple drawing of a complicated dog.

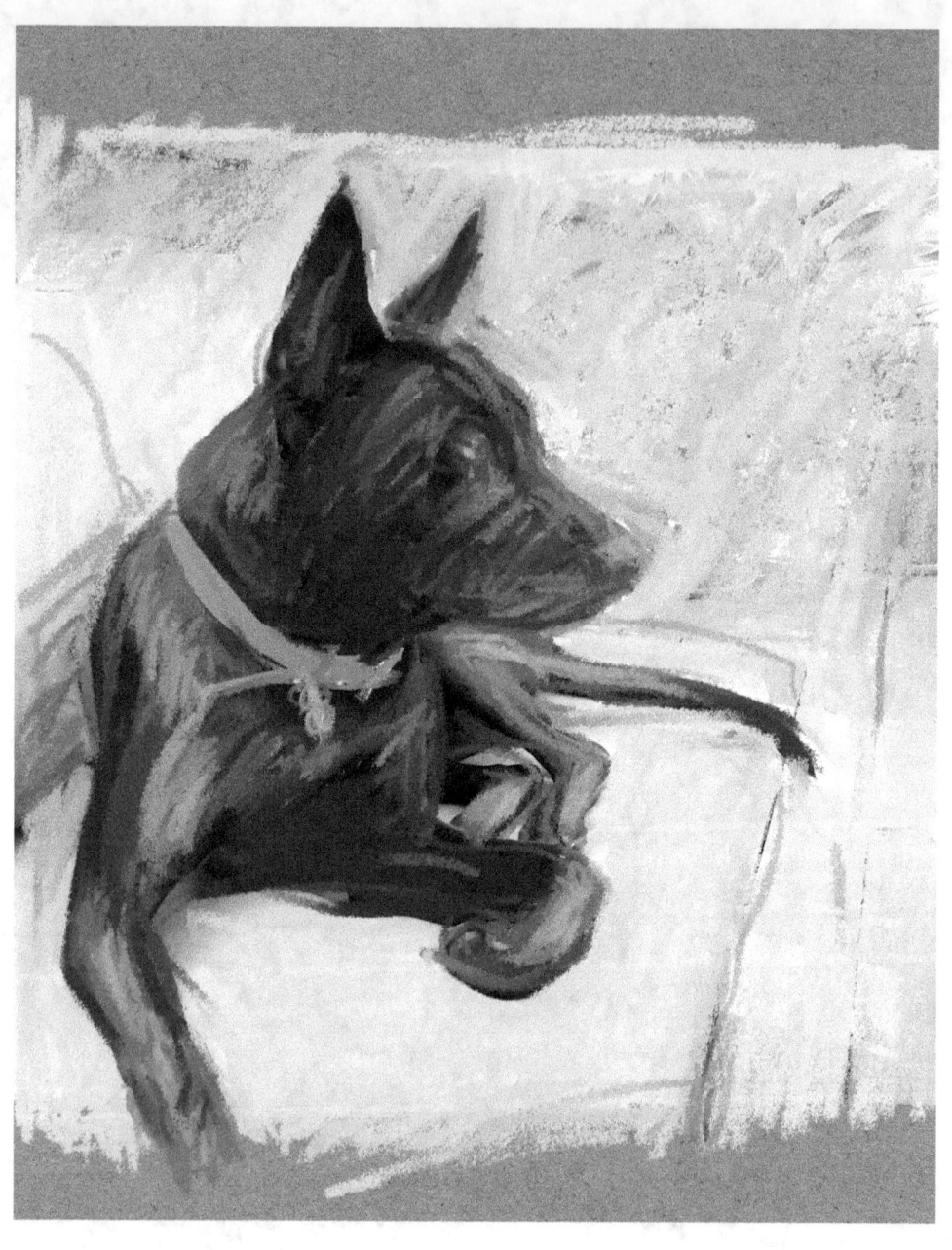

Rocco in basic black and white.

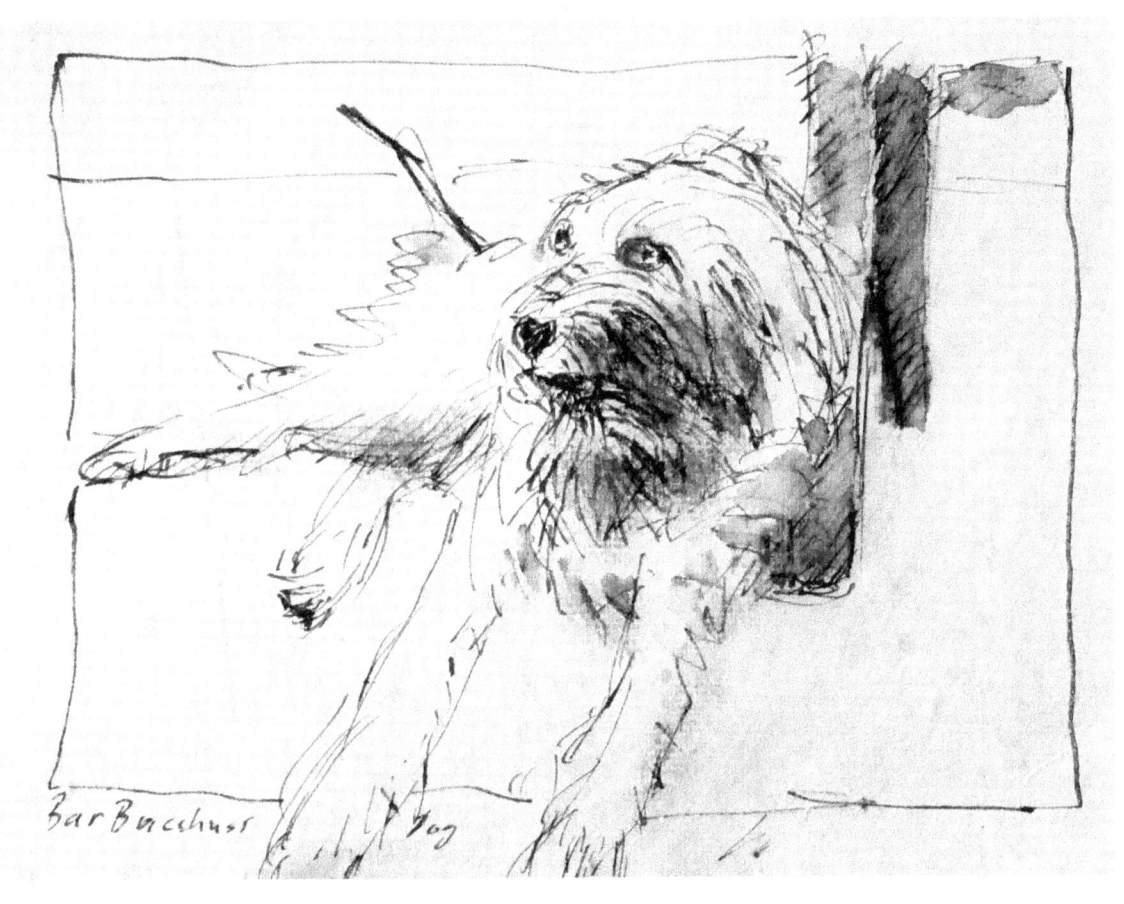

Met him in a bar.
Forgot his name.
But I'll never forget him.

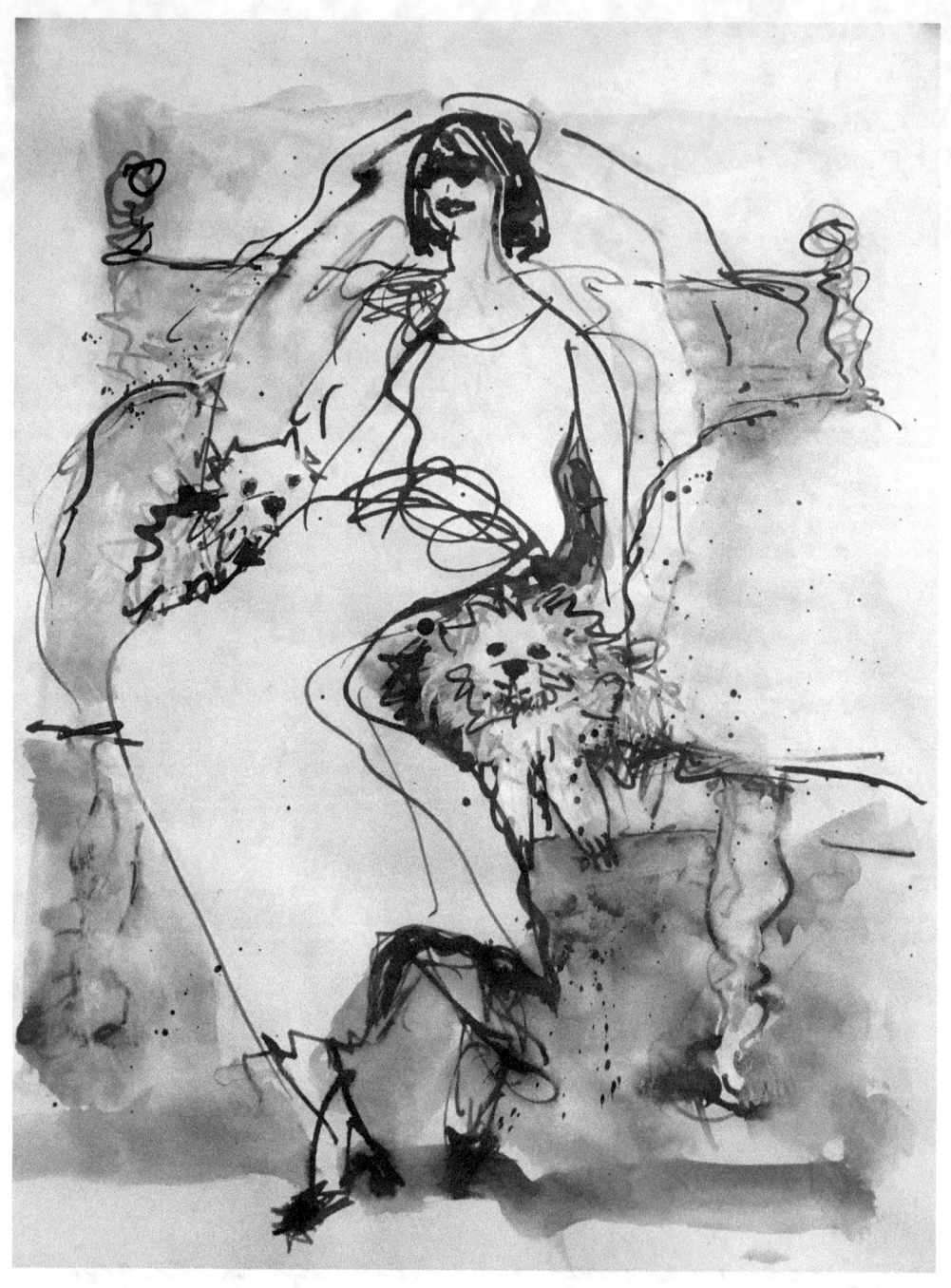

Married, with dogs.

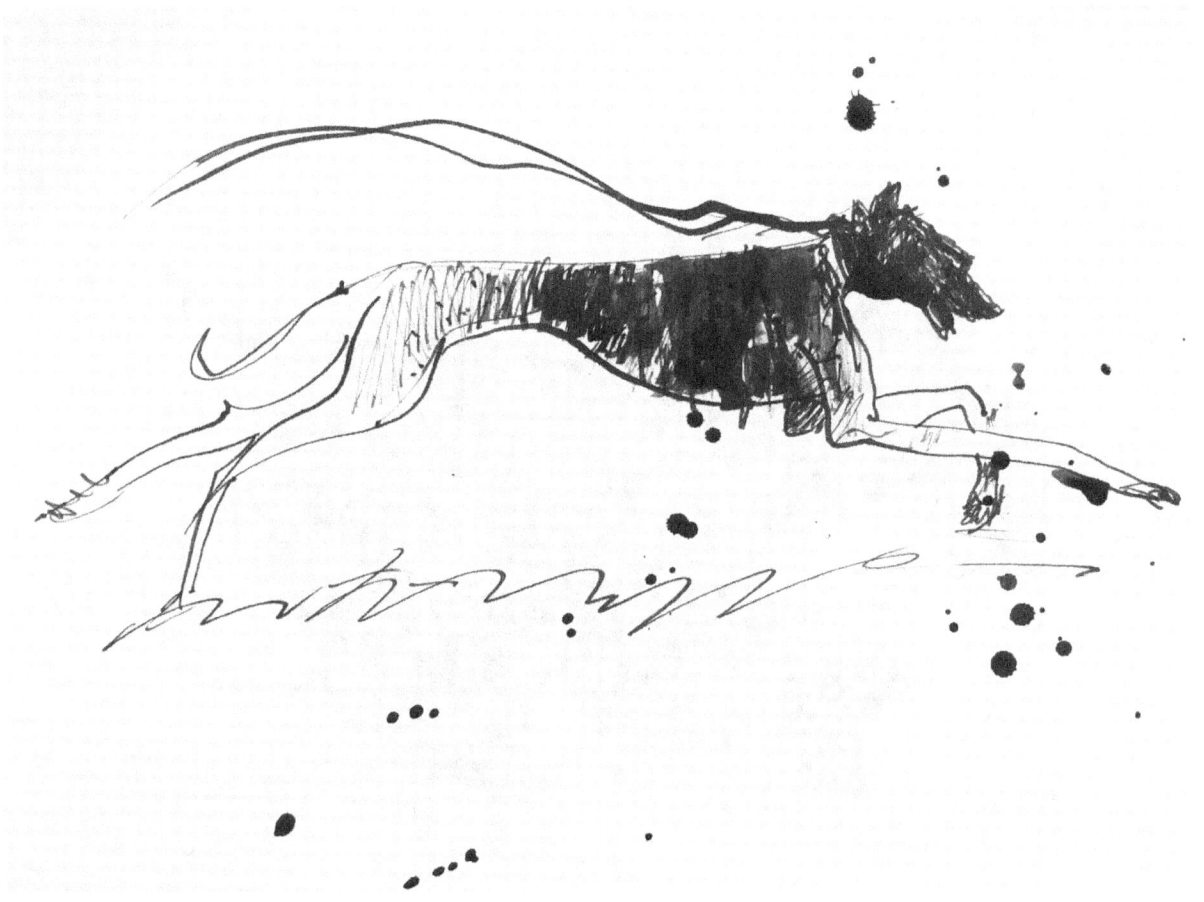

Flat out beautiful.

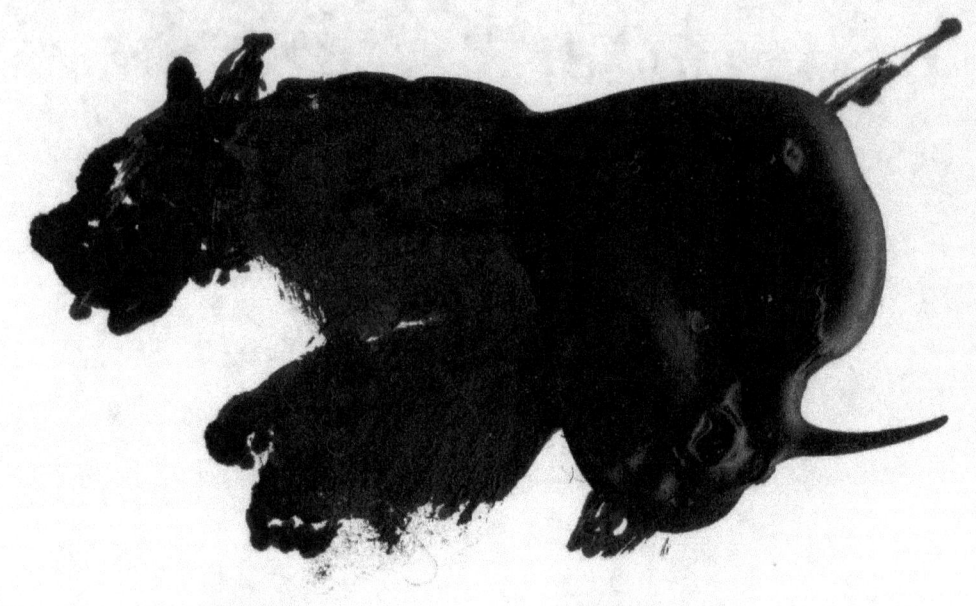

A blob named Bob.

*In loving memory of
Reefer, Mousey,
Fred, Moenja, Buschka, Cubbie
and Coco too.*

www.ingramcontent.com/pod-product-compliance
Lightning Source LLC
Chambersburg PA
CBHW062354220526
45472CB00008B/1801